CTA:

Creative Talk in Asia 亞│洲│創│意│對│話

是一本介紹亞洲地區不同領域但關於「創意」的刊物，內容包含創意人及作品收錄，

並精選亞洲創意活動與讀者分享。CTA 試圖透過這樣的對話交流平台，

提升亞洲設計活力，並挖掘創意人作品背後動人的故事。

CTA is an issue introducing various domains of creativities in Asia.

We collect creators and their works. Also,

pick out special creative activities for our readers.

CTA tries to promote the design energy in Asia and to discover more touching stories

behind the creators' works through such exchanging platform.

序 Introduction

亞洲近幾年在經濟上的卓越成長，帶動了許多產業上的快速提升，而設計與創意的發展上這幾年更是有著相當豐厚的成果。

因此我們試圖透過「CTA 亞洲創意對話」這樣的媒體平台，將如此精彩的設計師想像的火花和對於創作的激情記錄下來，透過簡要的訪談形式，讓更多對於亞洲設計創意有興趣的讀者們，更加能夠深入瞭解作品背後設計師的用心，並分享如何在兼顧自我理想與商業現實考量中取得完美的平衡。

21 世紀的亞洲除了延續東方美學與傳統哲學觀的美好價值，相信新世代的設計師們更想藉著創作去演繹出獨有於這個時代的新設計語彙，在一個變化無比巨大且溝通快速更替的時代，設計師為大家留下來細膩地優雅地的人文哲思相信更加值得我們去好好品味。

CTA 也希望能夠替擁有無比潛力的亞洲市場盡一份綿薄之力，祝福大家 !!

As the distinguished growth of Asia's economic in recent years, many industries are upgraded quickly, also the development of design and creative industry has generous achievement in recent years.

So we launched CTA, and tried to record the designers' sparks of imagination and passions of creating through this media platform. By a form of brief interview, readers who are interesting in creativity can more understand the designers' intention behind the works. Besides, designers can share how they strike the perfect balance between the ideal and commercial.

In addition to last the value of East aesthetics and traditional philosophy in 21st century, we believe that designers of new generation expect their works can interpret an unique and new design language in this era. In an age of change and the communicative modes replace rapidly, is the designers leave delicate and graceful philosophizing, and we believe it deserve to be tasted by everyone.

CTA group hopes to do our bit for the Asia market with endless potential, best wishes!!

CTA 總編輯 Chief Editor

CTA:

中
國

China

●
●

龔琳 *GONG, LIN*

霍楷 *HUO, KAI*

盧偉光 *Joey Lo*
合子品牌設計 *The Box Brand Design*

龍海亮 *LONG*

吳臻 *WU, ZHEN*

張貫健 *ZHANG, GUAN-JIAN*

周飛 *ZHOU, FEI*

中國 China

龔琳 GONG, LIN

www.gong-lin.com
gonglin@web.de

獨立平面設計師，插畫師。
graphic designer, illustrator.

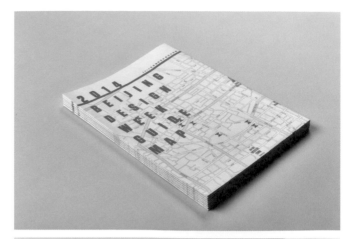

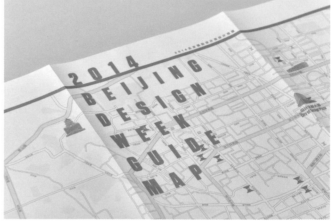

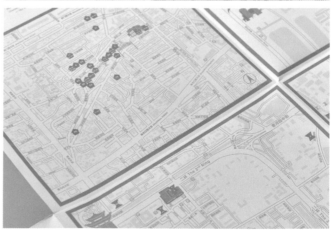

1. 2014 北京國際設計週設計地圖 *2014 Beijing Design Week Guide Map* / 2014

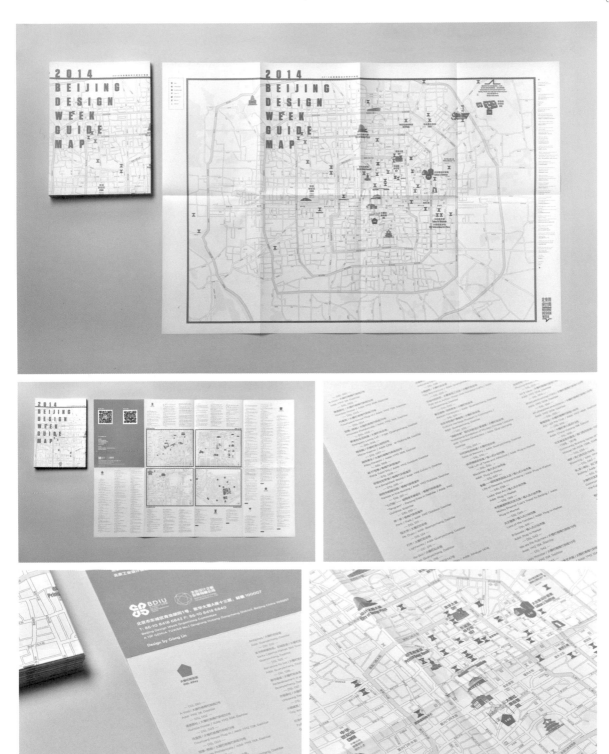

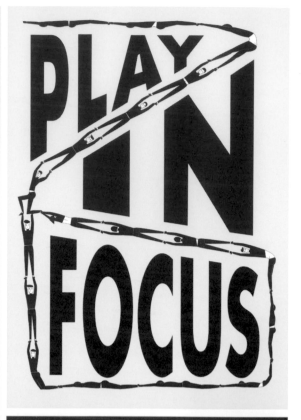

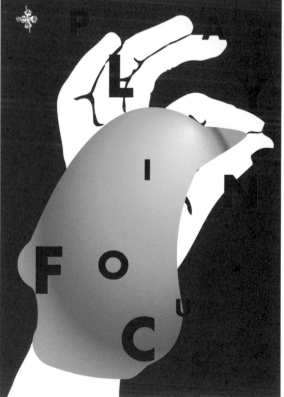

2. Play in focus / 2014

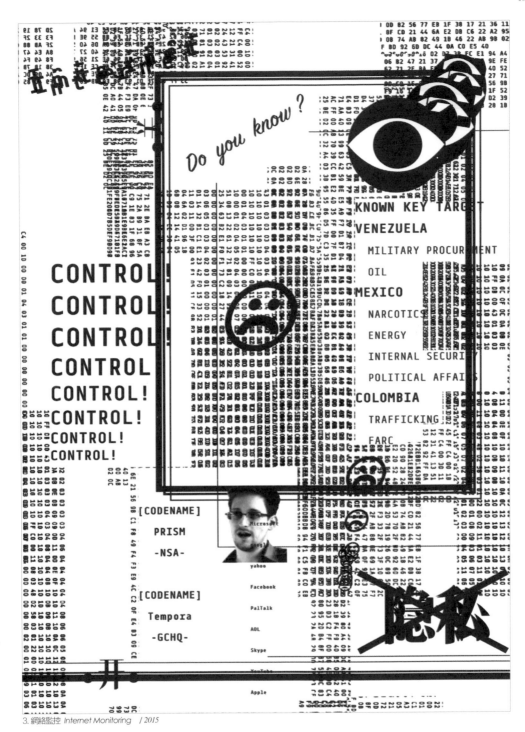

3. 網絡監控 *Internet Monitoring* / 2015

1 / 北京國際設計週設計地圖，為 2014 北京國際設計週設計的導覽地圖，對於北京市六環內的所有道路重新進行了繪製，通過數次校對修正，確保了道路信息及展覽信息的準確性。設計側重功能性及使用性，將所有信息落實於一張紙上，通過折疊，方便使用者對照道路信息及展覽信息。
The guide map designed for Beijing Design Week Guide Map, for all six ring roads in Beijing redrawn, proofreading and rectified for several times to ensure the accuracy of the road information and exhibition information. Focusing on functionality and usability, we will implement all of the information on a piece of paper, by folding, user-friendly control road information and exhibition information.

2 / 為全新的大畫幅相機品牌做的系列海報。
A series of posters for new view camera brands.

3 / 關於近年熱點的網絡安全問題進行的實驗性設計。
The experimental design about the cybersecurity issues of hotspot recently.

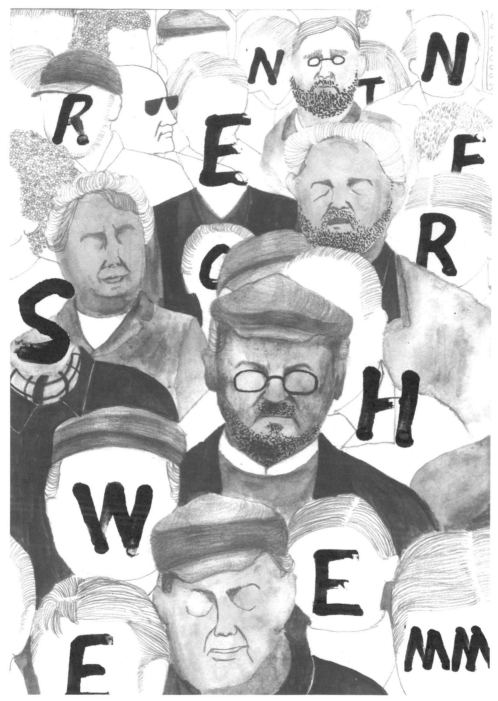

4. 人口老齡化 *Rentnerschwemme* / 2013

4 / 關於德國當代人口老齡化, 導致的退休職工氾濫的社會問題。
About contemporary German population aging, due to the proliferation of social problems of retired workers.

Q. 請問您認為該國最棒的是什麼?(如國家的特色或文化等)您的創作是否受其影響?

A. 柏林的反骨精神, 批判一切所謂的主流, 正是這種不服輸的創新精神, 支持著柏林這座設計之都。多少也是有受到這方面的影響, 但影響最多的還是在書籍, 這往往沒有什麼地域的限制。

Q. 請和我們分享您喜歡的書籍、音樂、電影或場所。

A. 喜歡看社科類的書籍, 最近還有在看一些日本作家的私小說。

喜歡的電影有《shirley - vision of reality》,《布達佩斯大飯店》。

Q. 請問您做過最瘋狂或最酷的事情是什麼呢?

A. 最酷的事情大約就是決定離開從小長大的故鄉, 來到異國生活學習這件事吧。

Q. 請問您最近最想做什麼事情?是否已經著手規劃下一階段的目標或突破了呢?

A. 除了繼續在平面設計上做更多的創新嘗試。

之後有計劃會涉足一些其他領域。

Q. 目前有許多行業正在被取代或是沒落, 請問您對於平面設計未來的發展有什麼看法?

A. 平面設計是一種溝通的語言, 只要人們還需要語言這種溝通的方式, 平面設計就不會消失。

在不同的時代背景下, 它會轉變形態來發揮其作用。

Q. 你對生活的細節上有什麼堅持嗎?(像是上廁所時一定要看詩集之類的)

A. 不要吃太飽, 保持一定程度的飢餓感, 可以促進思維的活躍。

Q.What is the best thing In your country? (likes features or culture) Have it ever influence your creation?

A. Berlin's anti-bone spirit, they try to anti all the mainstream things ,It is this spirit of innovation, which is supporting this design capital.
More or less that i have influenced by it, but i am most influenced by the books.

Q.Share good books/music/movies/places with us.

A. I like to read about philosophy and sciences, recently, I am also reading some books from Japanese writers.

The films i like: "shirley - vision of reality", "Grand Budapest Hotel"

Q.What is the craziest or coolest thing you have ever done?

A. The coolest thing, i think is the decision to leave my hometown.

Q.What are the things you want to do most these days? Have you started to set up new goals or breakthroughs for next period?

A.In addition to continuing to do more innovative attempts at graphic design.
i will have some other new attrempts at other design area.

Q.There are many industries are gradually being replaced or decline, what is your view on the future development of graphic design?

A. Graphic design is a method of communication, as long as people need the mothod to communicate, graphic design will not disappear.

Under different background, it will change the form to play its role.

Q.What is your insist on your life's details ? like toilet with your favorite poem?

A. Do not eat too much, to maintain a feel of hunger, will promote an active thinking.

中國 China

霍楷 HUO, KAI

Ln_huokai@163.com
283030868@qq.com

霍楷，任教於東北大學藝術學院，中國教育部·
日本電通高級廣告人才培育基金項目研究員，現
任國際平面設計協會 (ico-D) 會員，韓國現代設
計協會 (KECD) 會員，祕魯國際海報展國際評
委及祕魯 & 中國海報展官方策展人與推薦人，
義大利 A' 設計獎評委，中國包裝聯合設計委員
會全國委員，首都企業形象研究會 (CCII) 全權
會員，中國包裝創意設計大賽評審委員會成員，
中國設計師協會理事，國際商業美術設計師協會
高級設計師，《中國設計年鑑》編委；獲中國百
名傑出青年設計人才，全國高校美術名師獎，中
國高校設計教學名師獎，全國高校美術教育成果
獎，中國設計教育成果獎，中國設計 30 年先鋒
人物獎，中國平面設計教育獎，全國青年設計教
育成果獎，CDC 中國設計師稱號。作品獲獎與
入選美國、德國、伊朗、義大利、俄羅斯、日本、
韓國、秘魯等，獲國內外設計獎 400 餘項。

Huo Kai, taught at the College for Arts of
Northeastern University, the researcher
of Chinese Ministry of education ·
Japanese Dentsu advertising senior
personnel training fund, the International
Graphic Design Association (ico-D)
member, South Korean Modern Design
Association (KECD) member, jury of
Peru International Poster Exhibition
and Peru & Chinese international
poster exhibition official curator and
recommended, A'Design Award judges,
National Committee member of Chinese
Packaging Federation Design Committee,
member of the capital enterprise design
(CCII) , evaluation committee member of
Chinese packaging design competition ,
member of China Designers Association,
international commercial art designer
association senior designer, "Chinese
Design Yearbook" editorial board;
hundreds of outstanding young design
talents China, China College art teacher
award award, teachers design teaching
in College China, National College of Art
Education Achievement Award, Chinese
Design Education Achievement Award,
30 years Chinese design Pioneer Award,
Chinese Graphic Design Education
Award, the national youth education
achievement design award, CDC Chinese
designer. Winning entries and selected the
United States, Germany, Iran, Italy, Russia,
Japan, Korea, Peru, won the international
design award more than 400 items.

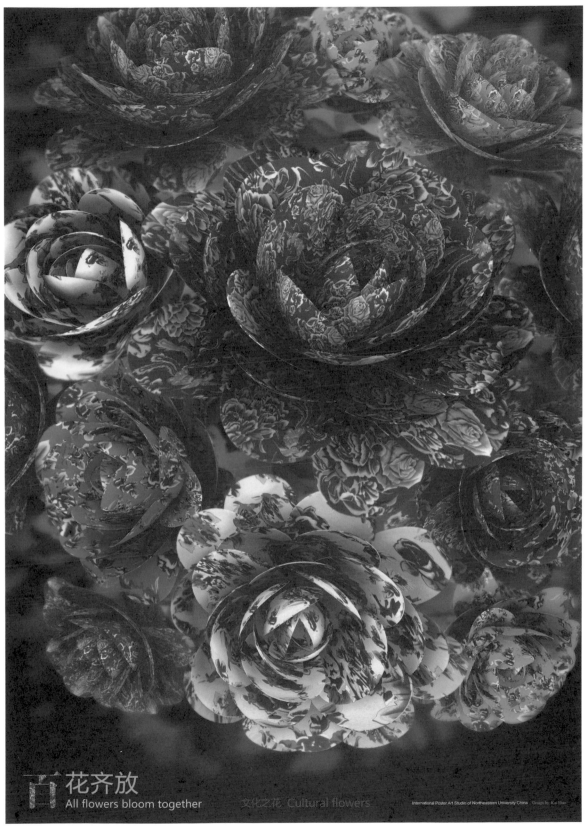

百花齐放
All flowers bloom together　　文化之花 Cultural flowers　　International Poster Art Studio of Northeastern University China　Design by: Kai Hao

1. 百花齊放 All flowers bloom together / 2013

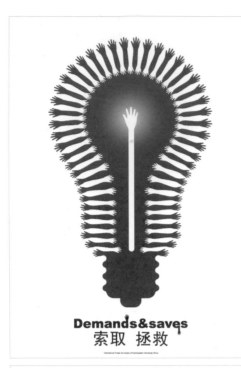
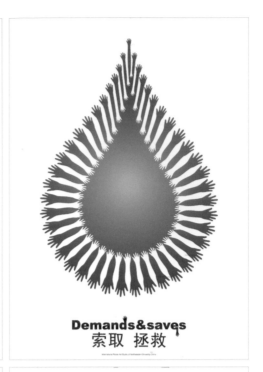

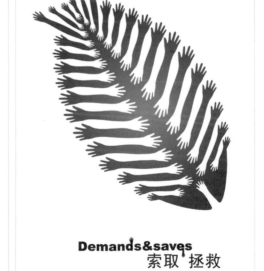

2. 索取與拯救 *Demands & saves* / 2013

1 / 海報設計採用中國傳統的花布與花卉組合設計。中國傳統的花布和花一起代表中國文化的美麗綻放，傳播中國傳統文化。五顏六色的鮮花盛開的多姿多采的中國傳統文化遺產，光芒閃耀。
The poster designs with the traditional Chinese cloth and flowers. Chinese traditional cloth and flowers mean the beautiful bloom of Chinese culture, to spread traditional Chinese culture. Colorful flowers blooming with colorful traditional Chinese culture heritages and shines continuously.

2 / 本海報採用正負形的手為設計元素，分別形成了一滴水、樹葉、魚骨和燈泡。正負形的手圍繞形成以上四種圖形，白色的手伸向內部，寓意人們向水資源、綠色、魚類和能源地索取而忽視對其保護與關注；向外伸展的手，寓意水資源、綠色、魚類和能源向人類呼救，發出求救信號；體現了索取與拯救的辯證關係；本海報呼籲人們在索取水資源、綠色、魚類和能源的同時應該對其關注和拯救。
This poster with positive and negative shape hand design elements, form a drop of water, leaves, bulbs and fishbone. Positive and negative shaped hand around the formation of the above four kinds of graphics, white hands toward internal, meaning people to the water resource, green, fish and energy demand and neglect of the protection and attention; outstretched hand, meaning water, green, fish and energy to human help to send out a distress signal; embodies the dialectical relationship between the claim and save the; the poster urged people to ask for water resources, green, fish and energy at the same time, we should focus on it and save.

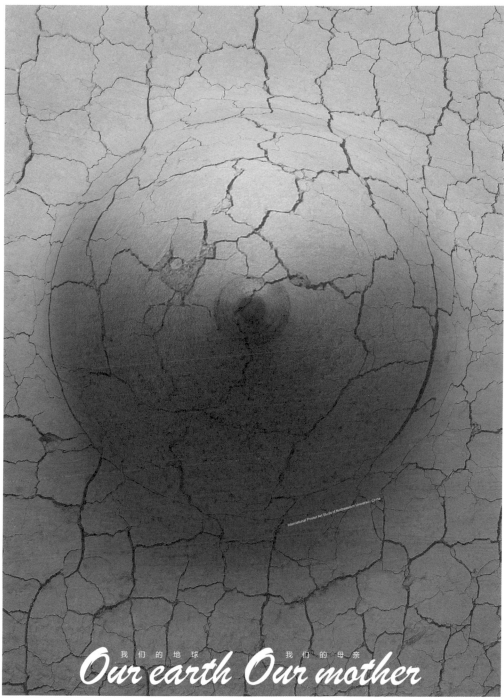

我们的地球　　　　我们的母亲
Our earth Our mother

3. 地球 母親 *our earth our mother* / 2013

3 / 本宣傳畫設計採用母親的乳房、乾裂的地球表面為設計元素。母親哺育下一代，體現了無私、偉大、奉獻的精神和無比的親和力；地球為人類提供和諧的生活環境，地球就猶如我們偉大的母親一樣，哺育著人類；而乾裂缺水的地球已經不能為人類提供生存環境。呼籲我們就像關愛我們的母親一樣來關愛我們的地球，保護水資源，保護我們的生命之源。

The posters design elements are the mother's breast and the dry surface of the earth. Mothers who are breastfeeding next generation, reflects the selfless, great, dedication spirit and extremely affinity; the earth for human provide a harmonious living environment, the earth is like our great mother, nurturing the human; and dry and water shortage of the earth has not for human provide living environment. Appeal to us as caring for our mother as to care for our earth, to protect the water resources, to protect our source of life.

4. 生命永流傳 *Life will never be handed down* / 2014

4 / 本招貼採用戒子為原型，和綠葉、水滴、地球組合設計。戒子象徵著高貴和魅力，上面鑲嵌著鑽石更具尊貴特點；將鑽石轉變為綠葉、水滴、地球造型，用以表現綠葉、水滴、地球的無限魅力與尊貴，需要人們對綠葉、水滴、地球更加珍愛和關注，就像珍愛鑽戒一樣，因此，主題以綠葉、水滴、地球恆久美麗為著眼點，凸顯久留傳的深刻涵義。本招貼呼籲人們要珍愛和保護我們身邊的綠葉、水滴、地球。

This poster by ring as the prototype and the green leaves, water, earth combination design. Rings symbolize nobility and charm, inlaid with diamond more distinguished characteristics; will change diamond leaves, water drops, the earth's shape, to the infinite charm of the performance of green leaves, water, earth and noble and need people to the green leaf, a drop of water, the earth more cherish and attention, like precious ring like. As a result, the theme to leaves, water drops, the earth forever beautiful focus, highlighting long circulated on the profound meaning. This poster calls for people to cherish and protect our earth, water and greenery around.

Q. 請問您認為該國最棒的是什麼 ?(如國家的特色或文化等) 您的創作是否受其影響 ?

A. 悠久的歷史和光輝燦爛的文化

Q. 請和我們分享您喜歡的書籍、音樂、電影或場所。

A.《三國》、《中西方百年廣告設計藝術》

Q. 請問您做過最瘋狂或最酷的事情是什麼呢 ?

A. 登上獲獎舞台並接受媒體採訪

Q. 請問您最近最想做什麼事情 ? 是否已經著手規劃下一階段的目標或突破了呢 ?

A. 和學生一起參加頒獎會。正在組織學生一起參與比賽。

Q. 目前有許多行業正在被取代或是沒落 , 請問您對於平面設計未來的發展有什麼看法 ?

A. 未來的平面設計是綜合的、多元的、新技術、個性化的。

Q. 你對生活的細節上有什麼堅持嗎 ?(像是上廁所時一定要看詩集之類的)

A. 生活細節堅持每天必須瀏覽完華文新聞和朋友圈。

Q.What is the best thing In your country? (likes features or culture) Have it ever influence your creation?

A. The long history and culture shine with great splendor.

Q.Share good books/music/movies/places with us.

A. "Romance of the Three Kingdoms"," Old Advertisement Design Chinese And West 100 Years"

Q.What is the craziest or coolest thing you have ever done?

A. Boarded the winning stage and media interviews.

Q.What are the things you want to do most these days? Have you started to set up new goals or breakthroughs for next period?

A. Attending the awards with students together. We are organized with students and involved in the competition.

Q.There are many industries are gradually being replaced or decline, what is your view on the future development of graphic design?

A. Future of Graphic Design is comprehensive, diverse, new technology and personalized.

Q.What is your insist on your life's details ? like toilet with your favorite poem?

A. After the details of every day life must navigate Chinese news and circle of friends.

盧偉光
合子品牌設計有限公司
Joey Lo / The Box Brand Design

www.boxbranddesign.com/
info@boxbranddesign.com

Joey Lo 在香港從事設計行業十數載。初期曾涉足不同類型的設計項目，後期專注於企業設計項目及品牌設計，如公司年報，企業形象，商標設計，品牌管理等…。曾參與香港及海外企業的不同設計項目，亦曾為客戶取得多個國際性獎項。現為香港設計師協會會員。於 2009 年成立 The Box Brand Design 主力於品牌設計項目，曾榮獲德國紅點獎、台灣國際平面設計競賽評審特別獎、HKDA 環球設計大賽視覺形象系統設計銅獎、第九屆澳門設計雙年展入選獎。美國 Creativity International Award 優異獎。作品亦收錄於第 24 及 25 屆日本字體設計年鑑。

Joey Lo worked on the design industry more than ten years, involved in different types of design projects in the early time. And after focus on the enterprise design project and branding design, such as, corporate annual reports, brand image, LOGO design and brand management etc. Participated in Hong Kong and overseas enterprises of different design projects, meanwhile has obtained many international awards for his customers. Currently he is a member of Hong Kong designers association.
Joey founded The Box Brand Design in 2009, which is major in brand design projects, has won RedDot Award 2014, Taiwan International CI Design Award – Judges' Special Award, HKDA Global Design Award Visual Identity System - Bronze, The 9th Macao Design Biennale- Honorary, American Creativity International Award- Merit. Works has recorded in the 24th and 25th Applied Typographer, Japan.

1. 嬰肌坊 包裝設計 *BéBé Packacing Design* / 2014

2. Furrenz Pet Sitters 品牌設計 *Furrenz Branding Design* / 2013

20

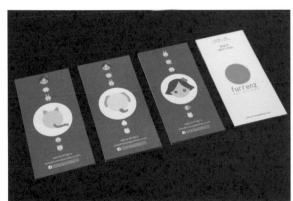
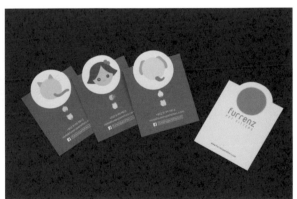
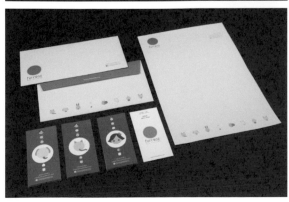

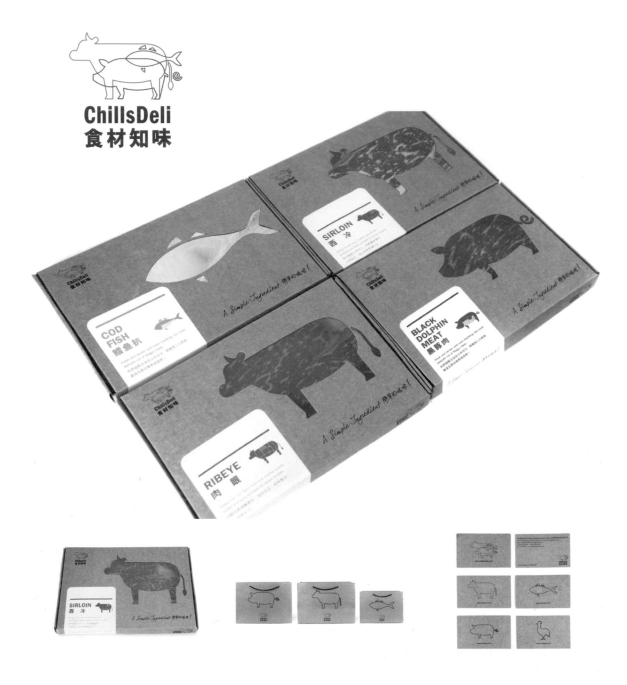

3. 食材知味 品牌設計 *Chillsdeli Branding Design* / 2010

1 / 嬰肌坊，一個全新嬰兒護膚品品牌。使用韓國授權的泰迪熊為主形象元素，品牌核心價值為 " 陪伴 "。為能更好的體現 " 陪伴 " 這個概念，標誌設計是一個笑臉作出發點，喻意陪伴過程當中的愉快氣氛，有如母子相伴相連的溫馨感。
包裝設計上，為更好體現產品特點和傳達品牌理念，我們設計了一套以天然元素的字體。每一個字母都是根據產品賣點來設置的場景，與泰迪熊產生和諧互動。
Bébé Peáu, a new baby care product brand has used Teddy bear license from Korea. The core value behind bébé péau is "accompany." Therefore, we create a smiley face as well as a hand holding hand mark as the brand logo. We also develop a set of typography as scenery illustrations for teddies on the package, as well as match up each product feature.
2 / 為寵物提供專業的保姆護理服的 Furrenz Pet Sitters，如其名，創辦人希望成為各毛毛動物的好朋友。所以在創作其品牌形像時，因應這有趣的行業和其服務理念，設計了以一個毛毛球的品牌標誌，再延伸成不同的動物形象，同時更為創辦人創作了一個卡通頭像，表達充滿親和力及貼心的品牌形像。
Furrenz Pet Sitters provide professional pet care service and be the best of all our pets. Insprit from their interesting business nature and naming, we creative a fur ball as their logo. And extent to different animals image, as well as create a character for founders to delivery a full of affinity and intimate expression of the brand image.

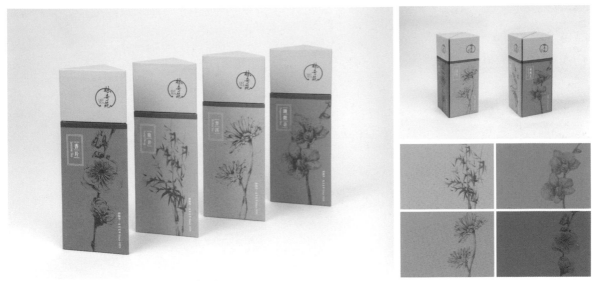

4. 茶系列 包裝設計 *LKY Tea – Tea Set Packaging Design* / 2012

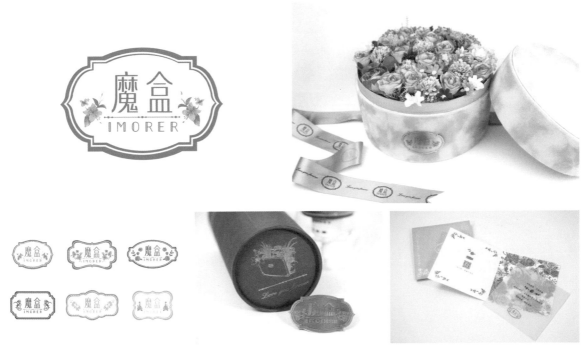

5. 魔盒 品牌設計 *Imorer Branding Design* / 2015

3 / " 食材知味 " 是專營進口和牛及餐酒等高級食材專門店。合子品牌以 " 簡單的滋味 " 品牌語為概念，直接以牛，豬，魚三種最基本食材為元素，配以簡約風格，把品牌風格從平面到空間立體呈現。讓顧客從進入店後每一環節都能感受品牌傳遞的訊息。" 食材知味 " 首店成功後，現正積極拓展業務，把店擴展至廣東省內不同地區。
"ChillsDeli" is exclusive of imported cooking ingredients in high quality. Box Brand Design created"A Simple Ingredient" as their marketing concept. 3 basic ingredients in sophisticated style are served as main design elements. The brand message is delivered to the customers by the graphic design and interior design in their retail shops. Success of first store is well-recognized and now they are expand their business actively, expand the stores to different areas in Guangdong province.

4 / 以年輕市場為目標群，培育年輕一代愛上茶的味道；以中國植物中的四君子（梅，蘭，菊，竹）的手繪插圖，配上年輕活力的色彩，突破傳統框框，帶出清新感覺；用上組合式的售賣方式，讓年輕人能同時品嚐四種茶的味道，同時亦能帶動整體銷售。
Focus on attract youth to have a try of traditional tea, even make them turn to be fascinated. We invite the top four gentlemen act on the package : Mr.Plum flower, Mr. Orchid, Mr.Bamboo and Mr.Chrysanthemum, they are from Chinese millenary figure of analogy, we wear these gentlemen in bright colors, dress them up to a modern and lively feeling. If you have the "gentlemen group", you will not miss the four different tea tastes, and the set package is also a helpful method to Increase sales.

盧偉光 Joey Lo 合子品牌設計有限公司 The Box Brand Design

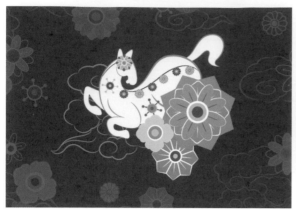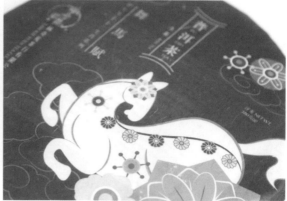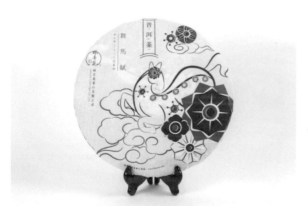

6. 甲午馬年茶餅 *KY Tea – Tea Cake of Horse Years Design* / 2014

5 / 在本品牌項目創建之初，客戶帶來的核心問題是：「如何利用強勢產品『植物』帶動行內相似度高，銷量低的鮮花產品。」因此，合子為魔盒品牌建立起一套品牌策略及相應的品牌視覺系統。以舊上海的氛圍定下品牌形象的基調。賦予鮮花和綠植各自演義，代表不同的情感狀態。由於魔盒僅在線上銷售，為作出更大的差異化，合子同時設計了提供給消費者進行文字或視頻留言的微信 " 郵箱 "，強化品牌電商形象同時增加品牌的個人訂製能力。除微信留言訂製平臺外，在包裝上也加強了定製範圍，例如銅牌或木墊的雕刻上購買者指定字句服務，以獨有的附加值增強了品牌產品獨特性。讓魔盒在競爭激烈的同類形鮮花電商品牌中更具鮮明個性。

An interdisciplinary team of box faced the exciting mission of understanding e-commerce in terms of fresh flowers & plants. Considering the fanatic growth that online selling and shopping happens in China, our challenge was make a new brand that stands out of thousands of similar florist brand and fundamentally, to be able to transmit a clear promise.

Imorer has an advantage in potted plant sales and hope to pull up the sales of fresh flower. We came up the idea of 1+1 more than 2 by combining potted plants, which representing everlasting company, and fresh flower, that seize the attention of dramatic love, together as a bundled product. By adding more values to Imorer, we assist our client to develop a wechat message platform including upload your intimate video or message to your beloved receiver. The whole brand image is wrapped up by a Shanghai retro atmosphere delivering romance&love in every detail.

6 / 歷史上以 " 馬 " 為主的藝術品，唐三彩馬可算當中的佼佼者。甲午馬年的茶餅風格便以唐朝的特色為設計背景。圖案、色彩、以至馬的畫風都藏著唐朝的風格。在沿用傳統元素的同時，也注重混合現代的處理手法，使其更具別具特色。

Once we talked about the artwork related to horse,Tri-color glazed pottery horse should be the top of the best. The design of horse tea cake is based on the background of Tang dynasty. Patterns, colors and even drawing style of horse is follow characteristic of Tang. We inject some modern elements while we use traditional items, in order to make it distinctive and special.

Q.請問您認為該國最棒的是什麼？(如國家的特色或文化等) 您的創作是否受其影響？

A.中國傳統的文化，它在發展與演變的歷程中，既有自己一貫的脈絡，又有多姿多彩的風貌，因此它可以使用在創作上的元素很多。另外，香港在中國文化的延伸背景下，又受到西方文化的衝擊，因此有著自己很獨特的本土文化。而作為土生土長的香港人，在我的作品不僅很常的使用到中國文化的元素，還更多的糅合了外來文化的結合。

Q.請和我們分享您喜歡的書籍、音樂、電影或場所。

A.我喜歡閱讀關於文化和經濟類的書籍，像最近我對日本經濟方面的感興趣。回顧日本在上世紀八十年代。"泡沫經濟"還沒爆破前的鼎盛時期，人們的生活水平之高以及對奢侈品大量需求讓我聯想到與今日的中國相似。通過宏觀的了解世界經濟，能幫助我更好的了解現今中國市場的發展趨勢。

Q.請問您做過最瘋狂或最酷的事情是什麼呢？

A.我也像很多同齡的青少年一樣，在年少時做過很多瘋狂而至今回憶起來還會微笑的事。

但要說到最瘋狂的事，就是建立了合子品牌。在 09 年之前我獨自一人從香港回到內地，在一家內地的品牌設計公司里工作，可是由於工作方式有差異和理念上的格格不入，我毅然辭職了。2009 年我在沒有任何人際網絡下，建立了符合自己理念的品牌設計公司。

Q.請問您最近最想做什麼事情？是否已經著手規劃下一階段的目標或突破了呢？

A.Box 已經成立五年了，接下來準備開展下一個五年的計劃和方向。在創作方面，會想要嘗試一下新的項目，在作品上有新的挑戰，為了保證項目的質量，可能會減少一定的產量。另外合子有計劃在未來更專注於一些非營利性的項目，不分國界的慈善與非營利性的項目。例如之前設計香港童軍的吉祥物，與非營利性的組織合作設計關愛自閉症兒童的項目等。通過用自己的專業技能幫助有需要的人群。

Q.日前有許多行業正在被取代或是沒落，請問您對於平面設計未來的發展有什麼看法？

A.電子時代的來臨，導致紙印刷大幅度減少。以往我們會接到很多大型公司的年報設計，以及一些印刷性的宣傳紙頁項目。但近年因為電子行業的發展和公眾環保意識的提高，這類項目的數量減少了許多。當然平面設計需求還是存在的，只是轉換成另一種形式——電子版來代替。我們可以調整自己的心態，和改進自己的技術，這是非常重要的。如果不想被時代淘汰，只能跟緊時代的步伐去適應時代的轉變。而作為設計師，要更加勇於打破陳規，創新是設計師該秉持的行業精神。

Q.你對生活的細節上有什麼堅持嗎？(像是上廁所時一定要看詩集之類的)

A.我不喜歡在一個混亂的環境下工作，我喜歡事情是有條理的進行，在私底下我對生活的安排也是要有條理的劃分。像我們做設計師這個行業，有很多人都誤以為我們每天無止境的加班。對我而言，勞逸結合才是該有的態度。高產量的工作不代表是高質量，適當的休息才能始終保持思路清晰，頭腦清醒得以保證工作質量。無論再忙也堅持收拾去保持整潔的環境，和有條理的安排工作，拿捏好工作和生活的平衡。

Q.What is the best thing In your country? (likes features or culture) Have it ever influence your creation?

A. For me Chinese culture and traditions are the best things because no matter how much it evolves over time, elements can still be used within designs. As a born and bred Chinese growing up in Hong Kong, I was able to understand and embrace Hong Kong culture, the city where western culture influenced Chinese traditions greatly forming a strong standing local culture. From that I am able to incorporate traditional Chinese elements into my creations as well as adding touches of other cultures around the globe.

Q.Share good books/music/movies/places with us.

A.I like reading books about culture and the economy. Recently, I've grown an interest in reading about the Japanese economy. Looking back at Japan's 1980s fast development, where people's living standards were high and they demanded a lot of luxury goods, made me think about today's China. I am fascinated by how much that period resembled China today. Looking at the world through macro, could understand the trend of China market. This will impact my design as I can grasp the consumer's perspective when buying a good.

Q.What is the craziest or coolest thing you have ever done?

A. I have done my fair share of wild things as a youth but the most memorable one, because it was the craziest, was setting up Box. I moved from Hong Kong to Guangzhou all by myself to work in a large company designing branding like I am today but I found it difficult to adjust to the work culture in mainland China. I left that company, but as I was resilient and took my initiative to the next level. In 2009, I created Box with zero social network, from then on I become my own boss as I started my own brand design company.

Q.What are the things you want to do most these days? Have you started to set up new goals or breakthroughs for next period?

A. Box is already five years old, I have planned my main goals for the forthcoming five years. I want to design something new, more extraordinary and would surpass my previous designs, naturally that is the goal of nearly all designers. Whilst designing, I want to ensure the quality of my company. Previously we have worked with some Hong Kong charity, like Scout Association of Hong Kong helping them design adorable character logos, and Bliss Art Gallery which a non-profit organization for children with autistic to help them recover. I hope to accept more of these projects, not just from Hong Kong or mainland China but from all around the world. I feel the importance of having an ethical stance within my company, not entirely for profit but for something which I think is worthwhile.

Q.There are many industries are gradually being replaced or decline, what is your view on the future development of graphic design?

A. In the past graphic design was done by printing but now as the generation of technology advances that has been reduced. Before, we received jobs from many large co-operations asking us to design their annual report but now as technology becomes more convenient and the awareness grew stronger of the environmental impact with printing, those jobs have decreased massively. However, the need for graphic design is still there, just in another form, like a virtual version. Therefore, we need to advance with technology and not get left behind, if it change, we will change our perspective and skills. As long as we keep our wits about it and carry on thinking outside the box, this industry will not be replaced.

Q.What is your insist on your life's details ? like toilet with your favorite poem?

A. I like to keep things being organized, I can't work under chaotic environment. Many people think as us as endless overtime working every day. For me, I believe in combining exertion and rest is the only way to keep high quality of work. A proper rest can maintain a clear mind, to guarantee the quality of work. Whether in the busy, I still stick up to clean and tidy my place.

中國 China

龍海亮 LONG

www.e6brand.com
liang85920@163.com

龍海亮 | Long
深圳 E6 設計創作指導
畢業於江西科技學院藝術系

從事設計工作多年，曾任多家知名設計與廣告公司創作總監、美術指導等職。2013 年以聯合創始人的身份加入 E6 設計，並任創作指導。善於將國際化視覺趨勢與本土市場相結合，注重與客戶的深度溝通，服務領域涵蓋餐飲酒店、金融地產、時尚消費、電子科技、文化創意等多個領域，同時廣泛參與行業交流，致力為客戶提供適應全球化市場競爭的創意設計服務。

曾服務過長城電腦、中興、創維、百事可樂等品牌和企業。作品在國內外權威設計賽事受到廣泛認可。

作品收錄 2011 第七屆 APD（Asia-Pacific Design）亞太設計年鑑。
作品榮獲 2011 台灣國際平面設計大賽優勝獎 / 作品收錄。
作品收錄 2013 第九屆 APD（Asia-Pacific Design）亞太設計年鑑。

Shenzhen E6 Design Creative Director.
Hunan, Zhuzhou.

Graduated from Jiangxi University of Technology Art Department. Engaged in design work for many years, he served as creative director of several well-known design and advertising agencies, art director and other staff. 2013 in his capacity as co-founder to join E6 design, and served as Creative Director. Combined with the international visual trends and local market, concentrate on the depth of communication with customers. Service areas covered hotel restaurant, financial, fashion consume, electronics technology, cultural and creative, etc. Meanwhile, participate industry exchange widely, we are committed to providing customers adapt to the globalization of market competition for creative design services. We has served the Great Wall Computer, ZTE, Skyworth, Pepsi and other brands and businesses. Works at home and abroad is widely recognized authoritative design competitions.

Works included 2011 and 2013 APD (Asia-Pacific Design), won the 2011 Taiwan International Graphic Design Award and works included in.

1. 百花深圳 *Shenzhen with Flowers* / *2013*

2. 3號攝影工作室 *Photography Studio Number 3* / *2015*

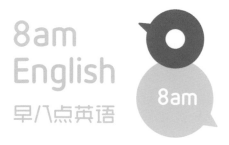

3. 早八點英語 *8 a.m. English* / *2011*

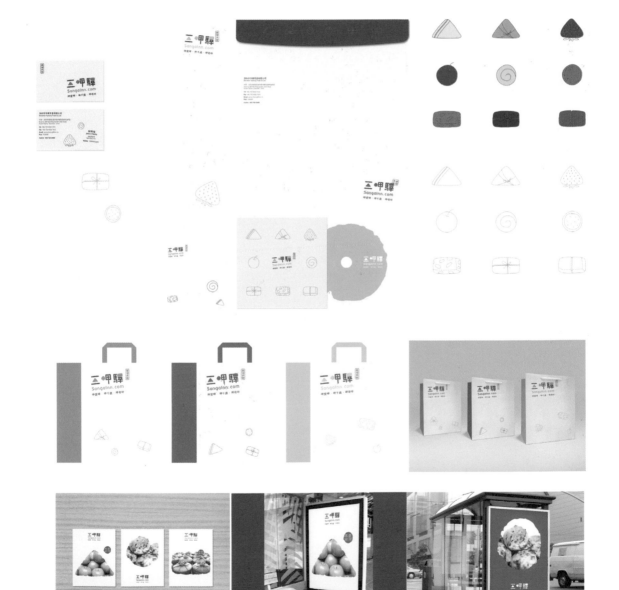

4. 三呷驛 – 台灣休閒食品網超 *Three Eating Station- Taiwan Leisure Food Network* / 2012

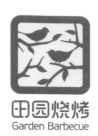

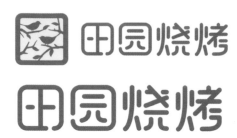

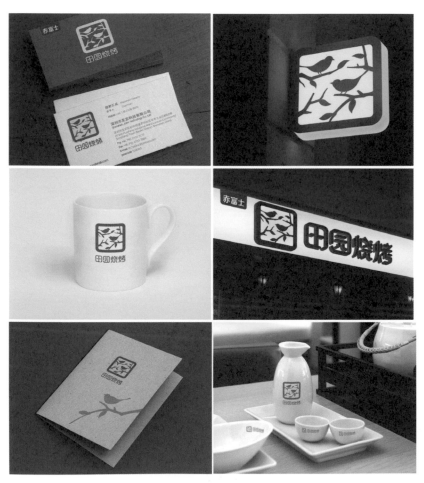

5. 田園燒烤 *Garden Barbecue* / 2012

2 / 數學邏輯：0+3=3 物理邏輯：0+3= 號 三號影像，簡潔、清晰、單純的圖形符號及字體的自然形成。
Mathematical logic: 0 + 3 = 3 Physical logic: 0 + 3 = No. Image No.3 , simple, clear, pure graphic symbols and fonts.

3 / 早八點青少年英語培訓機構，語言即說話，語言框是表達的象徵，提煉品牌符號 "8"。巧妙的形成小鳥的圖形，與品牌名稱 " 早八點 " 形意相合。
8 a.m. English training institution, language is speaking, language is a symbol of the expression, refining the brand of "8" , become bird pattern cleverly then consistent with the brand name "8:00."

4 / 台灣本土休閒食品閩南語 " 呷 " 即 " 吃 "。天然、綠色。
以圖形飾字的手段形成標識，以三種不同圖形作為區分其三種系列產品 (呷愛呷、呷千歲、呷奇咔)，並衍生作為品牌輔助形。輕快、自在。
Taiwan local snack foods in Taiwanese "jia" is "eat". Natural and green. As word decorated with graphic means forming logo, use three different graphic to distinguish each snack product (eat what you like, eat for long-lived, eat something fantastic), and extend as brand assistance. Light, comfortable.

ZPOWER Brand Design

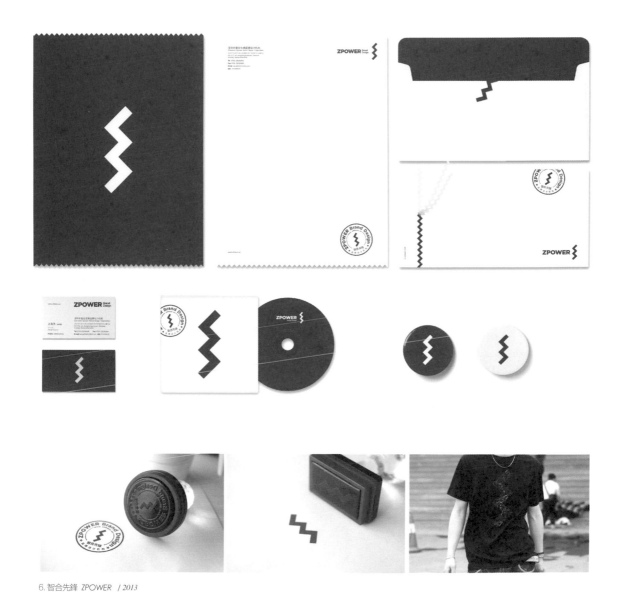

6. 智合先鋒 ZPOWER / 2013

5 / 田園燒烤是一家傳承日系風味赤富士旗下的燒烤美食品牌，我們每天面對的是：擁擠的城市、快速的消費。繁忙之餘，我們需要一個開適的空間，慢的生活方式，以" 蘇州園林造景 "、窗花為素材，塑造整體形象的田園氣息強調自然之美，生靈之善。方框造型亦與 " 田園 " 二字結構相呼應。
Garden Barbecue is a food brand inherited Japanese-style barbecue "Red Fuji". Every day we face are crowded city, fast consumption. In addition to the busy, we need a quiet space, slower lifestyle, using "Suzhou Garden Landscaping" and window grilles for the material, create overall image of the idyllic atmosphere emphasis on beauty of natural and good of creatures. Shape of block also fit the word "Garden".

6 / POWER 一能量：蒸蒸日上。圖形的高度概括。物理世界中賦予能量的物像如：閃電、熱量、震動、彈性 ...
亦如思維的無限延伸，設計即是將思維轉換為無限的能量繼而產生價值，單純的圖形序列感，簡潔易識別。
POWER - Energy: flourishing. Highly generalize of graphic. It energized the physical world was like as: lightning, heat, vibration, elastic, etc. Also like unlimited of extension of thinking, design is convert the thought to unlimited energy and produce value. Simple sequence sense of graphic, clear and easy to identify.

Happlay 开心玩

PLAY　　　　STOP　　　　OVER　　　　LOVE

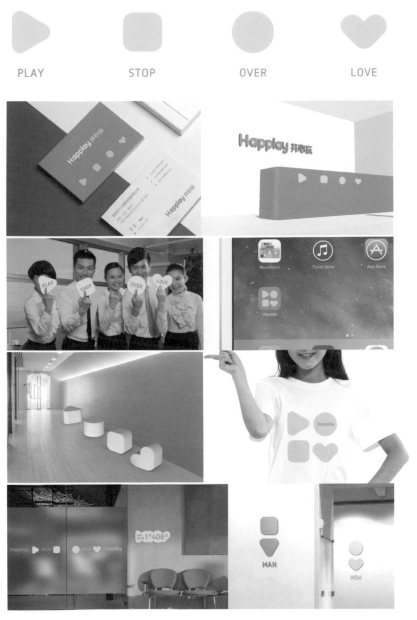

7. 開心玩 HAPPLAY / 2015

7 / 基於移動終端的 APP 遊戲開發。將七巧板的概念轉化為可變化形態的設計語言。同時，在重新組合時可得到不同的驚喜。玩，那就要玩的態度！
Based on the mobile terminal APP game development. The concept of the Tangram transform to a language with design what can change shape. Meanwhile, you can get different surprise when you reset. Play what you would have to!

Q. 請問您認為該國最棒的是什麼?(如國家的特色或文化等)您的創作是否受其影響?

A. 最棒的我不敢妄言,但經歷了幾千年還能夠保存下來的哲學與美學觀點,我覺得應該是我們寶貴的東西。我們這個時代,接受各種信息的爆發式衝擊。我不斷在受各種環境與觀點的影響。

Q. 請和我們分享您喜歡的書籍、音樂、電影或場所。

A. 我喜歡讀科幻探索類書籍。喜歡民謠,尤其是中國的西北民謠。電影就無所謂。場所的話比較安靜些的地方。

Q. 請問您做過最瘋狂或最酷的事情是什麼呢?

A. 我好像是一個比較規矩的人。我渴望瘋狂但一直平淡。哈哈!

Q. 請問您最近最想做什麼事情?是否已經著手規劃下一階段的目標或突破了呢?

A. 想嘗試著做一些貼近生活,回歸本質的產品。最近一直在參與和學習這方面是知識。為自己能成為跨界設計師努力。

Q. 目前有許多行業正在被取代或是沒落,請問您對於平面設計未來的發展有什麼看法?

A. 生產力變革往往都是技術的革新,創造力思維方式不可能被取締。平面設計在未來可能會以更多元化的形態呈現。我們多加學習,試目以待。

Q. 你對生活的細節上有什麼堅持嗎?(像是上廁所時一定要看詩集之類的)

A. 這好像是一種強迫症的表現?抽煙算嗎?我一直在堅持著,哈哈!

Q. What is the best thing In your country? (likes features or culture) Have it ever influence your creation?

A. I can not tell what is the best, but the experience of thousands of years can also be saved in the philosophy and aesthetic point of view, I think it should be our valuable things. Accepted the explosive impact of a variety of information in our times. I constantly affected by various environmental and perspectives influence.

Q. Share good books/music/movies/places with us.

A. I like to read fiction books of science and explore. Also like ballads, especially folk songs of China's northwest. Movie does not matter. Relatively quiet place.

Q. What is the craziest or coolest thing you have ever done?

A. It seems like I am behaved, I desire crazy but always flat, haha!

Q. What are the things you want to do most these days? Have you started to set up new goals or breakthroughs for next period?

A. I want to try to do some product close to life, return to nature. I have recently been involved in this area of knowledge and learning. Try to become a cross-border designer.

Q. There are many industries are gradually being replaced or decline, what is your view on the future development of graphic design?

A. Productivity changes are often innovative technology, creativity way of thinking can not be banned. Graphic design may be presented in multivariate forms in the future. We learn more, wait and see.

Q. What is your insist on your life's details ? like toilet with your favorite poem?

A. It seems to be a manifestation of OCD? How about Smoking? I always persist in, haha!

中國 China

吳臻 WU, ZHEN

wuzhen@outlook.de

2003/04~2004/10 德國 法蘭克福大學藝術教育
Magisterstudiengang

2004/10~2014/03 德國 奧芬巴赫藝術設計大學
視覺傳達碩士學位

2009/10~2010/03 德國 奧美德國見習藝術指導

2009~2014 德國 Tobias Rehberger Studio,Frank-
furt/Main

2003/04~2004/10 Germany
Universität Frankfurt Kunstpädagogik,
Magisterstudiengang

2004/10~2014/03 Germany Hochschule für
Gestaltung Offenbach,Diplom Designer

2009/10~2010/03 Germany Ogilvy&Mather
Frankfurt/Main, Art director internship

2009~2014 Germany Tobias Rehberger
Studio Frankfurt/Main.

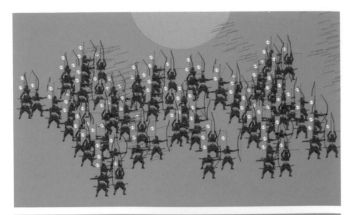

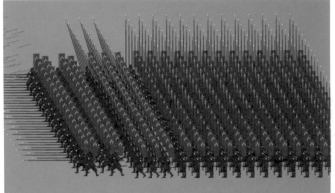

1. Furinkazan / 2013

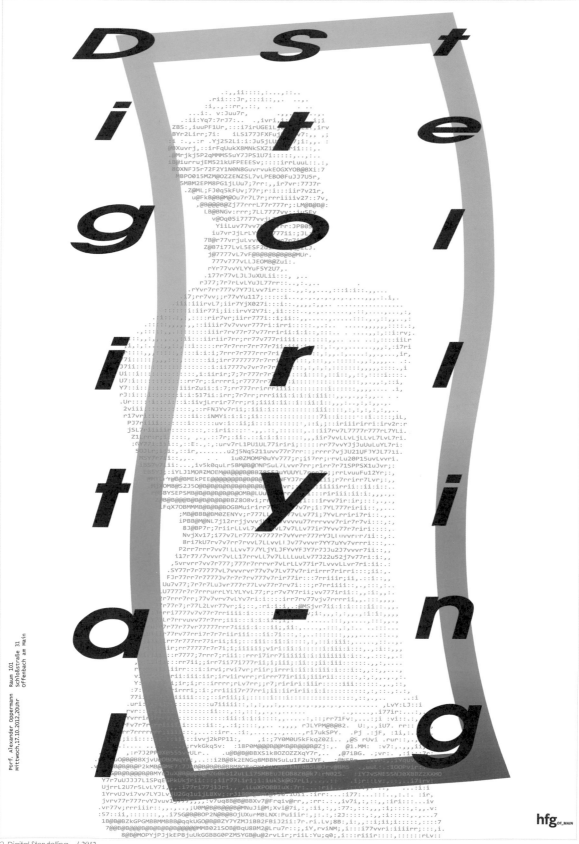

Porf. Alexander Oppermann Raum 101
Mittwoch,17.10.2012,20Uhr Schloßstraße 31
 Offenbach am Main

hfg OF_MAIN

请勿酒驾 请勿酒驾 请勿酒驾
请勿酒驾 请勿酒驾 请勿酒驾
请勿酒驾 请勿酒驾 请勿酒驾
请勿酒驾 请勿酒驾 请勿酒驾
请勿酒驾 请勿酒驾 请勿酒驾
请勿酒驾 请勿酒驾 请勿酒驾
请勿酒驾 请勿酒驾 请勿酒驾
请勿酒驾 请勿酒驾 请勿酒驾
请勿酒驾 请勿酒驾 请勿酒驾
请勿酒驾 请勿酒驾 请勿酒驾
请勿酒驾 请勿酒驾 请勿酒驾
请勿酒驾 请勿酒驾 请勿酒驾
请勿酒驾 请勿酒驾 请勿酒驾
请勿酒驾 请勿酒驾 请勿酒驾
请勿酒驾 请勿酒驾 请勿酒驾

3. Don't Drink & Drive / 2015

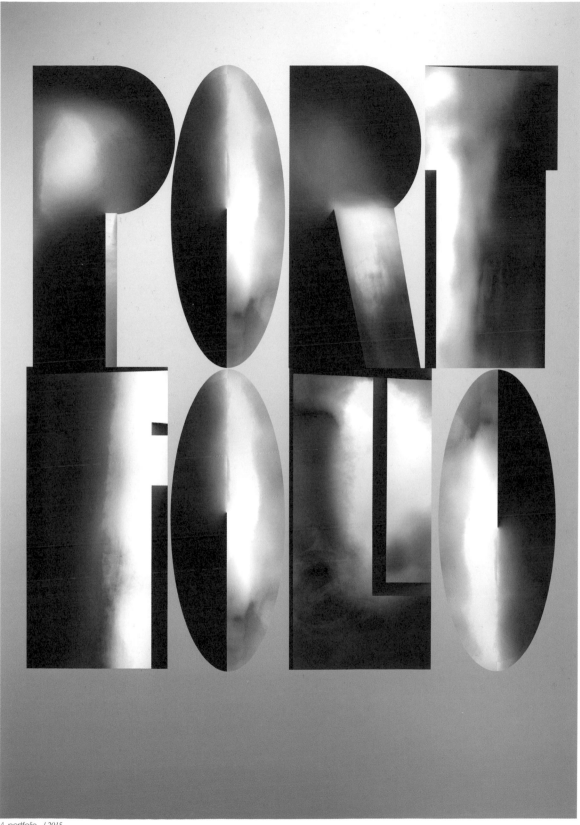

4. portfolio / 2015

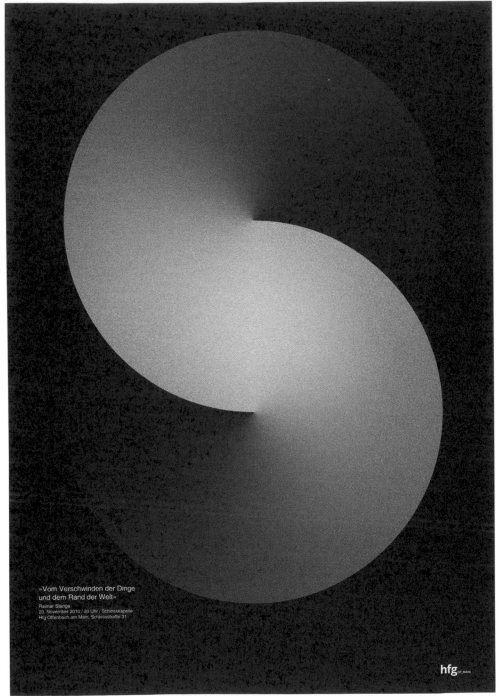

»Vom Verschwinden der Dinge
und dem Rand der Welt«
Raimar Stange
23. November 2010 / 20 Uhr / Schlosskapelle
Hfg Offenbach am Main, Schlossstraße 31

hfg_{OF_MAIN}

5. Der Rand der Welt / 2013

1 / " 風林火山 " 來自孫子兵法。繪製四個不同陣型，圖形化和符號化的詮釋了這四字真言。
Furinkazan literally means "Wind, Forest, Fire, Mountain", the four phrases from Sun Tzu's The Art of War: "as swift as wind, as silent as forest, as fierce as fire, as unshakeable as mountain." The 4 different military formations represent "Furinkazan" graphically and symbolically.

2 / 奧芬巴赫藝術設計大學交互設計講座海報，實用和美觀的結合。
A lecture about interactive design at University of Art and Design Offenbach, a combination of aesthetic and practice.

3 / 視幻藝術公益海報。
Op Art commonweal poster.

4 / 字體設計實驗。
An experimental typographic design.

5 / 奧芬巴赫藝術設計大學攝影專業講座，＂關於物體的消失和世界的邊緣＂。
A series of lectures about photography at University of Art and Design Offenbach, "The Disappearance of objects and the edge of the world"

Q. 請問您認為該國最棒的是什麼?(如國家的特色或文化等)您的創作是否受其影響?

A. 喜歡德國設計的大器的風格,簡潔嚴謹以及富有力度的美感。中國的經史子集,琴棋書畫同樣也孕育了其獨特的東方審美情趣。這兩種文化都對我的設計有影響。

Q. 請和我們分享您喜歡的書籍、音樂、電影或場所。

A. 書籍:" 一個廣告人的自白 "、"Die Minute mit Paul McCartney"

　　電影: 黑澤明的所有作品,"天堂之日","鬼婆","紫色姐妹花","毛髮","失衡生活"

Q. 請問您做過最瘋狂或最酷的事情是什麼呢?

A. 為了戒菸,連續數日凌晨 2 點獨自一人在法蘭克福的 Nidapark 森林裡跑步。

Q. 請問您最近最想做什麼事情?是否已經著手規劃下一階段的目標或突破了呢?

A. 我想好好休整一下,多鍛鍊身體,旅行並戀愛。下一階段將會進行更深入的跨專業領域性的視覺設計方面的實踐和研究。

Q. 目前有許多行業正在被取代或是沒落,請問您對於平面設計未來的發展有什麼看法?

A. 未來屬於電子媒體,紙質媒體的衰弱是必然的,但是它不會被電子媒體所取代,正如照相技術的發明和發展無法取代架上繪畫一樣,平面設計不會因為承載它的傳統媒介的衰弱而消失,而是會在新的媒介之上迎來更快、更廣泛和更好的發展機會。

Q. 你對生活的細節上有什麼堅持嗎?(像是上廁所時一定要看詩集之類的)

A. 游泳是每天早上必做的功課。

Q.What is the best thing In your country? (likes features or culture) Have it ever influence your creation?

A. I love the German design which carries an aesthetic combination of elegance, simplicity and power. (I also love) the unique Chinese aesthetic values which stemmed from Confucianism and other philosophical classics, traditional music, chess, calligraphy and painting. My design was influenced by both of them.

Q.Share good books/music/movies/places with us.

A. **Books** : "Confessions of an Advertising Man"、"Die Minute mit Paul McCartney"

Films : The films of akira kurosawa,"Days of Heaven, 1978"、"Onibaba, 1964"、"The Color Purple, 1985"、"Head, 1968"、"Koyaanisqatsi, 1982"

Q.What is the craziest or coolest thing you have ever done?

A. In order to quit smoking, I was jogging in Nidapark Frankfurt at 2 o'clock in the morning for several days in a row.

Q.What are the things you want to do most these days? Have you started to set up new goals or breakthroughs for next period?

A. I am thinking of taking some time for fitness training and travelling, as well as, some personal life. And then, I'd like to work, and do some further research on interdisciplinary visual design.

Q.There are many industries are gradually being replaced or decline, what is your view on the future development of graphic design?

A. The future belongs to electronic media. But I don't think the print media will be replaced by electronic media even though it's diminishing in popularity. Just like the invention camera and development of photography having never taken over easel painting, graphic design will not die simply because of the declining print media which used to be its major carrier. On the contrary, graphic design will gain more opportunities for better, more extensive development with the help of the new media.

Q.What is your insist on your life's details ? like toilet with your favorite poem?

A.I swim every morning.

張貫健 ZHANG, GUAN-JIAN

微信平台 / WeChat：kczbrand
kczbrand@163.com

張貫健，品牌設計師。
弓長張（KongChangZhang）品牌設計事務所創辦人，CDA 會員。曾任職於著名的韓家英設計公司，品牌研究中心，後創辦弓長張品牌設計事務所。設計作品被《中國大學生美術作品年鑑》、《中國創意設計年鑑》、《亞太設計年鑑》等業內權威年鑑收錄，斬獲諸如全國平面設計大展等數十項國內外設計賽事大獎，曾接受中國創意同盟、視覺中國等多家媒體專訪。

Zhang Guanjian, brand designer and the founder of KongChangZhang brand company. He is a member of the CDA and has served in the brand research center of Han Jiaying Design. After that he established KongChangZhang Brand Company. His design works is included by many authoritative yearbook like <Chinese Undergraduate Fine Arts Yearbook>, <China Creative Design Yearbook> and < Asia-Pacific Design >. He also won tens of design awards and was interviewed by China Designers Association and www.shijue.me.

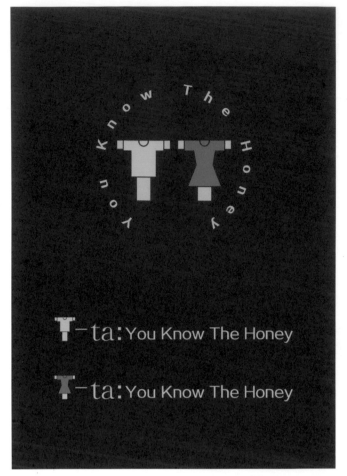

1. T-ta 主題情侶裝品牌形象設計 *The brand image design of T-ta lovers pack* / 2014

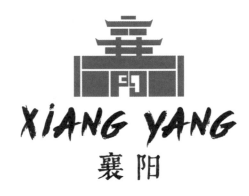

2. 襄陽城市形象標誌 *The city image logo of Xiangyang / 2013*

1 / T-ta 是針對高校市場的主題情侶裝飾服品牌，logo 以字母 T 為基礎，分別用男裝女裝的造型樣式進行設計，簡潔易懂，形象鮮明。為配合形象塑造，為其量身設計的卡通形像以鮮明的造型個性成為品牌識別的又一重要元素。卡通形象會配合每一期服飾的主題展現出不同的造型形態，並搭配相應的個性化廣告語，成為包裝的一大亮點。
T - ta is aimed at the market of sweethearts outfit clothing brand. The theme of the logo is based on the letter "T", respectively, with men's and women's clothing modeling design style. For image creation, the cartoon images on the T-shirt have distinctive modeling personality, which becomes another important elements of brand identity. Cartoon image will appear different modeling to cooperate with the theme of each period, and match with the corresponding personalized slogans, which becomes a bright spot of the packaging.

2 / 標誌遵循漢字 " 襄陽 " 基礎架構，藝術化處理，造型成古城樓樣式，以此展現襄陽歷史文化名城的特色。
This logo follows the infrastructure of Chinese character "Xiangyang". With artistic processing, this logo was modeled into ancient tower style, to show the historical and cultural characteristic of Xiangyang.

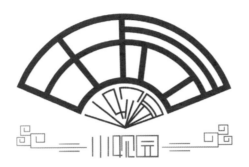

3. 田園 · 小觀園標誌 *The logo of Tianyuan Xiaoguanyuan / 2013*

3 / 田園 • 小觀園為武漢大學校區內一家高檔餐廳，標誌設計直接以餐廳名稱入手，造型成折扇，彰顯文化氣息；扇面又似古代花棱窗飾，傳遞餐廳典雅氣質。
Tianyuanxiaoguanyun is a high-grade restaurant located in Wuhan University. With a folding fan modeling, this logo design is based on the Chinese characters of its name and highlights the cultural atmosphere. Besides, the cover of the fan looks like the ancient window decoration, transferring the elegant temperament of the restaurant.

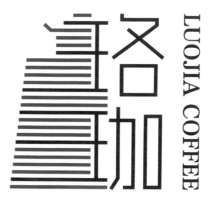

4. 珞珈咖啡標誌 *The logo of Luojia Cafe / 2015*

4 / 作為由武漢大學畢業生眾籌的一家校友咖啡品牌，鮮明的傳達出 " 武大元素 " 與 " 眾籌 " 兩個概念成為設計的重點。因此，其形象設計將武漢大學標誌性建築櫻花城堡的剪影與漢字 " 珞珈 " 融為一體，塑造出具有濃濃武大氣息的造型形象。同時，長短不一、造型不盡相同的線條相互交織累積，寓意年歲不同、行業各異的武大學子共聚一處，合力眾智完成夢想的情懷。

The design focus of this logo is to express "WHU elements" and concepts of "crowdfunding", because Luojia Café is an alumni coffee brand funded through crowdfunding. Therefore, its image design integrates "Sakura castle", the landmark building of Wuhan university, with Chinese characters "Luo Jia" to create a image with thick WHU Atmosphere. At the same time, the line of different length, different modeling are interwoven, which means the WHU students of different age and industry come together to complete this dream.

Q. 請問您認為該國最棒的是什麼?(如國家的特色或文化等)您的創作是否受其影響?

A. 作為一個擁有五千年文明的歷史古國,博大精深的中華文明無疑是我們的一筆寶貴財富。而漢字作為記錄千年文明的載體,可以說是華夏文明的精粹。作為一名品牌設計師,以漢字架構為藍本進行創作,探尋 "字" 與 "畫" 之間的微妙關聯,一直是自己的偏愛,很多滿意的作品也正是由此而生的。

以標誌設計為例,是否以最簡練的符號語言傳達出最形象的精神特質是評判其優劣的重要標準。而作為象形文字的典範,漢字恰恰是對某一具象的高度概括,這很好地契合了標誌的設計基本原則。對於標誌設計者而言,是十分有利的靈感寶庫。

Q. 請和我們分享您喜歡的書籍、音樂、電影或場所。

A. 對於設計而言,像是參禪悟道,擁有一顆平和的心態才能探得真知,成就優秀作品。"以平常之心,做非常設計" 也是一直以來對自己的告誡。所以,平時喜歡聽久石讓的曲子多一些。尤其是為宮崎駿動漫所創作的插曲,每每聆聽,彷彿置身漫畫之中所描繪的美好情境之中,會給內心帶來無比平靜的體驗。

Q. 請問您做過最瘋狂或最酷的事情是什麼呢?

A. 當屬前不久辭去在韓家英設計公司的工作選擇獨立創業了吧。無論是剛畢業就可以加入韓司重要部門,接受大師的指導,還是到可以參與一些重要項目的設計任務,似乎都是讓人稱羨的事情。在韓司的工作中,也的確學到了很多,成長了很多。但內心對於 "走出去闖蕩一番" 的無比渴望最終使得自己忍痛割愛,做出了選擇。

如果青春不放肆,老來何以話當年!創業之路固然走的艱辛,可是能夠從心而動,又何嘗不是一種幸福呢?

Q. 請問您最近最想做什麼事情?是否已經著手規劃下一階段的目標或突破了呢?

A. 這個可以接著上面的問題。已然開始了創業之路,目前最想做的當然是簽下幾個早已被自己 "收錄在案" 的目標客戶咯!

當然,想要簽到單子,最主要的還是要讓大家看到作品水準。所以,我們的作品集正在製作過程之中。與此同時,也開始與一些靠譜的媒體平台洽談合作,希望可以帶來更廣泛的傳播效果。

Q. 目前有許多行業正在被取代或是沒落,請問您對於平面設計未來的發展有什麼看法?

A. 這也是最近思考比較多的問題。當下互聯網大行其道,大家熱衷的也是所謂的 O2O、大數據等等新鮮詞彙。而對於像平面設計這類印象當中偏向傳統的行業似乎並沒有什麼熱度。但是這並不代表平面設計就要趨於沒落。

我們可以看到,自從人類意識開始覺醒至今,平面設計一直貫始終。只不過從最初的岩壁、樹皮等載體,轉變成了紙張乃至於網絡而已。科技的進步革新的是工具,而使用工具的理念是不會淘汰的。與此同時,借助更為完善的工具輔助,我們可以從實操中解放出更多的精力轉向創作層面的考量,這無疑會有助於未來的平面設計可以有更深層次的思考與表達。

Q. 你對於生活的細節上有什麼堅持嗎?(像是上廁所時一定要看詩集之類的)

A. 自己對於吃其實並不感興趣,但卻熱衷於下廚,而且做每一種飯菜都必須備好與之相匹配的廚具、餐具,只有這樣才有下廚的慾望。因為於我而言,炒菜做飯似乎跟唱 K、打牌一樣,是一項可以拿來娛樂的消遣。既然要娛樂,當然得盡興,所以配套要跟上,絕不可以湊合。

Q. What is the best thing In your country? (likes features or culture) Have it ever influence your creation?

A. As a historical country, China has five thousand years of civilization, and profound Chinese civilization is undoubtedly a valuable asset for us. As the carrier of the millennium civilization record, Chinese characters can be said to be the essence of Chinese civilization. As a designer, designing based on Chinese architecture, exploring the subtle association between "character" and "painting" has always been my own preference. Many satisfied works done out of this.

Taking the logo design as an example, whether the most concise symbol language conveys the most vivid spirit is the important criterion to judge the merits and qualities. As a model of hieroglyphics, characters are precise generalization of a concrete, which highly fits the basic principle of the logo design. For logo designers, it is a very favorable treasure house of inspiration.

Q. Share good books/music/movies/places with us.

A. Design is like practice meditation. Only when you have a peaceful mind, can you explore the knowledge and finish excellent works. "With normal heart, do extraordinary design" is always my motto. So I like to listen to Hisaishi's songs. Especially the songs created for the episode of Hayao Miyazaki's animation. Listening to them makes me feel like homing to the beautiful scene depicted in the cartoon, which will bring me a very peaceful experience.

Q. What is the craziest or coolest thing you have ever done?

A. Not long before I resigned from Han Jiaying Design and start entrepreneurship on my own. Joining an important apartment of Han Jiaying Design and receiving master's guidance right after graduation seems quite admirable and I did learned a lot through this period. But the heart for "going out for an adventure" is so eager that make me to do this choice.

If the youth is not presumptuous, there is no doubt that I will regret when I am old! Although the road is hard to go, following my heart to do things is still a kind of happiness for me.

Q. What are the things you want to do most these days? Have you started to set up new goals or breakthroughs for next period?

A. I have started the road of entrepreneurship. At present, the most important target is to signed more target customers!

Of course, if you want to receive business, the main point is to let everyone see the level of your work and ability. So, our work collection is being produced. At the same time, we also begin to discuss cooperation with some media platform, hoping to bring a wider range of communication results.

Q. There are many industries are gradually being replaced or decline, what is your view on the future development of graphic design?

A. This is also a question that I think over recently. Nowadays, with the popularity of Internet, people are keen to talk about O2O, big data these new vocabularies. And for traditional industry like graphic design, it seems not that heat. But this does not mean that the graphic design tends to decline.

We can see that, since the awakening of human consciousness, the graphic design has always been through. From the original rock and bark carrier into paper and network. The progress of science and technology is a tool, and the idea of using new tools will never be eliminated. At the same time, with the help of more perfect tools, we can save more energy from the practical operation to pay more attention to the creative aspects, which will undoubtedly be helpful in the future graphic design to have a deeper level of thinking and expression.

Q. What is your insist on your life's details ? like toilet with your favorite poem?

A. Though I am not very interested in enjoying delicacy, I am keen on cooking. Each cuisine must be prepared with appropriate kitchen utensils, only with these utensils can I have desire to cook. For me, cooking is a good way for recreation and entertainment like playing cards and KTV. If you want to enjoy yourself by cooking, you must have perfect equipment.

ZHOU, FEI

www.pro_ad.com.cn
zoufeiha@163.com

周飛，男，1986 年生於重慶，畢業於西南大學
美術學院。現任職於廣州 pro-ad 設計公司並擔
任創作總監，致力於品牌視覺基因圖形研究和原
創性概念開發，解決品牌在銷售環節中的問題，
提升品牌價值和銷售力。

Zhou Fei, male, born in 1986 in
Chongqing, graduated from Southwest
University of Fine Arts. Works in
Guangzhou pro-ad design company as
creative director, is committed to brand
visual graphics gene and originality
concept development, problem solving
in the sales cycle of brand, enhance
brand value and sales force.

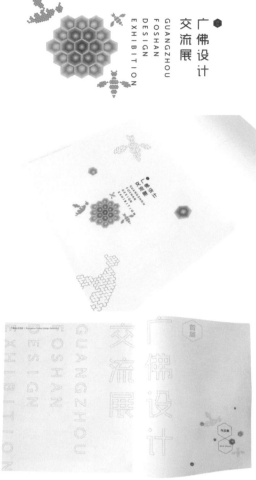

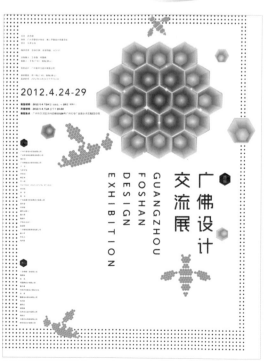

1. 首屆廣佛設計交流展 *Guangzhou Foshan Design Exhibition* / 2012

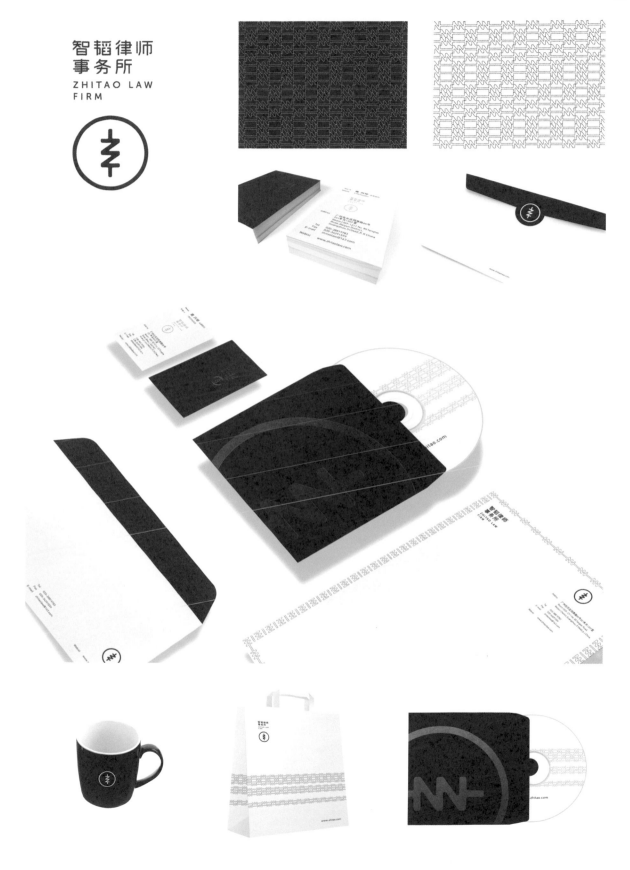

智韬律师
事务所
ZHITAO LAW
FIRM

2. 智韜律師事務所 Zhitao Law Firm / 2013

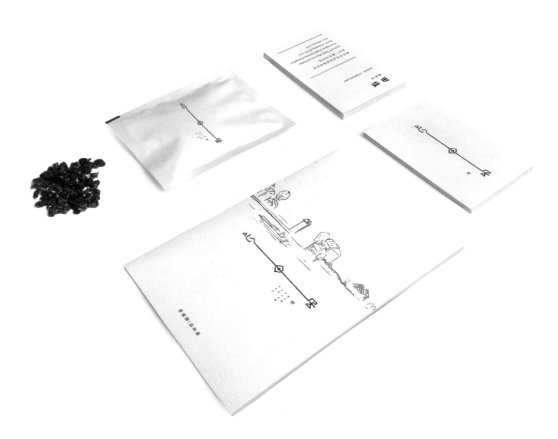

3. 心田居茶室 *Xin Tian Ju Tea House* / 2014

1 / 廣佛設計展主要目的在於推動廣州、佛山兩地的創意文化產業發展。為此需要一個強而有力的視覺圖形去體現這一主旨。我們的核心概念來自於 " 蜂巢 " 寓意 " 築巢引蜂 " 希望更多的優秀設計師能夠參與其中，互相分享、交流，推動兩地設計的發展，完美的契合了此次展覽的主題。

Guangzhou Foshan Design Exhibition main purpose is to promote the development of creative and cultural industries in Guangzhou, Foshan two places. This requires a strong visual graphics to reflect this theme. Our core concept from the "honeycomb" meaning "improve soft environment for investment". I hope more and more excellent designers to participate, share with each other, exchanges, and promoting the development of the two places designs, perfect fit the theme of the exhibition.

2 / 我們借用物理學中的 " 電阻 " 來進行視覺設計，精準傳達事務所處理問題的能力。這一核心概念充分融入了標誌設計中，使得極具圖形感。

We borrow physics "resistance" to design the visual, convey accurately the office 's ability of dealing problem. The core concept of fully integrated into the logo design, make it full of feeling of graphic.

4. 蓮悅茶薈 *Happy Lotus Tea* / 2013

3 / 自古飲茶、參禪皆為心中所想、所悟。一禪一茶，如水光山影，自然相生。意到即形到，標誌形象由此而來。
Since ancient times, tea and Zen are all what you thoughts and understanding. Thinking quietly and sipping on tea, such as water, light, mountain and shadow, together with natural. It is intended to form, that is how logo designs.

4 / 標誌設計中融入傳統文化中的山水圖形元素，體現意境性和茶的醇厚品質。
Through combining the font with the graphical elements, to embody the profound artistic conception of Zen tea blindly and the mellow tea quality.

5. 如意空間設計 *Ruyi Space Design Office* / 2014

5/點、線、面的構成元素，符號化的處理手法，力求簡潔、直觀。在視覺應用方面，通過標誌延伸出來的輔助圖形準確傳達了建構和諧空間的重要性。
Incorporating the elements of points, lines and planes into the logo, and applying symbolic technique to strive for simplicity and intuitive. In terms of the visual application, the auxiliary graphics extended from the logo accurately conveys the importance of constructing a harmonious space.

Q. 請問您認為該國最棒的是什麼?(如國家的特色或文化等)您的創作是否受其影響?

A. 中國具有深厚的文化積澱,作為當下的一位設計師,如何吸收、萃取這種文化的精髓運用現代的設計手法,提升設計的價值推廣設計的理念是至關重要的。這是我從業至今並堅持努力為之奮鬥的重要初衷。

Q. 請和我們分享您喜歡的書籍、音樂、電影或場所。

A.《毛姆短篇小說集》是我最近看過的一本書,我很喜歡毛姆敘事的驚人的能力,如何把一個故事講好,是需要很多的技巧和方法以及語言的感染力等等,這與我從事的工作是有一些想通之處的。

Q. 請問您做過最瘋狂或最酷的事情是什麼呢?

A. 我性格比較平和安靜,如果真要算的話我想應該是離開重慶到廣州這邊來發展,因為做這個決定想了很長的時間,可能我比較糾結吧!!!

Q. 請問您最近最想做什麼事情?是否已經著手規劃下一階段的目標或突破了呢?

A. 目前主要是盡力做好手頭的案子,平時閒暇的時間我會做自己的一些創作,這對於我來說是一個很好的平衡。

Q. 目前有許多行業正在被取代或是沒落,請問您對於平面設計未來的發展有什麼看法?

A. 隨著互聯網多媒體的發展和衝擊,平面設計面臨的挑戰會越來越大,我覺得平面設計需要更多的跨界合作才能有更多的生存和發展空間。設計師需要不斷的提升素質,反思與重新定位才能有更多的空間發揮設計師的價值。

Q. 你對生活的細節上有什麼堅持嗎?(像是上廁所時一定要看詩集之類的)

A. 好像沒有,不過在生活中,我決定要做一件事哪怕是極細小的,都會全身心的投入進去做好。

Q.What is the best thing In your country? (likes features or culture) Have it ever influence your creation?

A. China has a rich cultural heritage, as a designer today, how to absorb and extract the essence of this culture with modern design techniques to enhance the value of design to promote the design concept is essential. This is why I work so far and persevere in my efforts to fight for the vital mind.

Q.Share good books/music/movies/places with us.

A. "Maugham short story collection" I recently read, I really like the amazing ability Maugham narrative, how to tell a good story, need a lot of skills and methods and appealing language, etc., which I am engaged in the work of the office there are some figured.

Q.What is the craziest or coolest thing you have ever done?

A. My personality is calm and quiet, if you really want me tell then I think it should be left Chongqing to Guangzhou to develop, because making this decision took very long time, I might have more tangled !!!

Q.What are the things you want to do most these days? Have you started to set up new goals or breakthroughs for next period?

A. Now mainly try to do the case in hand, usually leisure time I will do some of my own creation which is a good balance for me.

Q.There are many industries are gradually being replaced or decline, what is your view on the future development of graphic design?

A. With the Internet and the impact of the development of multimedia, graphic design challenges faced will be more and more, I think graphic design needs more cross-border cooperation in order to have more space for survival and development. Designers need to constantly upgrade the quality of reflection and repositioning in order to have more space to play value designer.

Q.What is your insist on your life's details ? like toilet with your favorite poem?

A. It seems no, but in life, I decided to do something even it is very small, will devote all my energies into it and doing well.

香港

Hong Kong

●
●

Hanson Chan

伍啟豪 *Roger NG*

明日設計事務所 *Tomorrow Design Office*

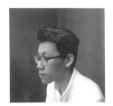

香港
Hong Kong

Hanson Chan

www.voyrd.com
hanson@voyrd.com

陳康生是一名富有想像力的創意人，主要從事視覺傳達設計。在他看來，與才華橫溢的創意人士一起工作是一種樂趣，可以一起分享精彩而激烈的視覺媒體詞彙。他致力於提供品牌形象與傳播、動態／互動平面方面的設計工作，為生活帶來各種類型的項目。

Hanson Chan is an imaginative creative specializing in visual communication. He has the pleasure of working with talented creative who each share the compulsion to speak in the wonderful, fierce vocabulary of visual media. He's dedicated to direction, design, interactive, and representation services to bring all manner of projects to life.

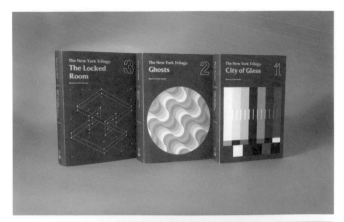

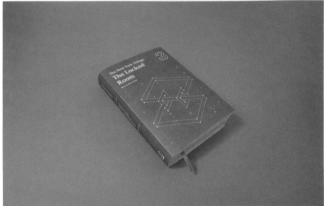

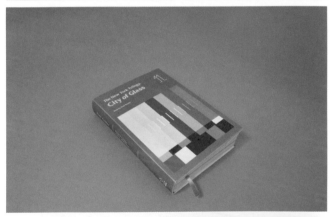

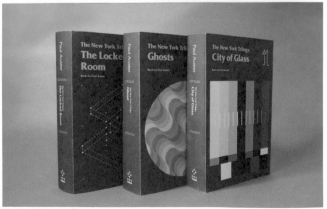

1. 紐約三部曲 *The New York trilogy* / 2014

2. 字體檔案 2014 Type Archive 2014 / 2014

3. Walk-on Typeface / 2014

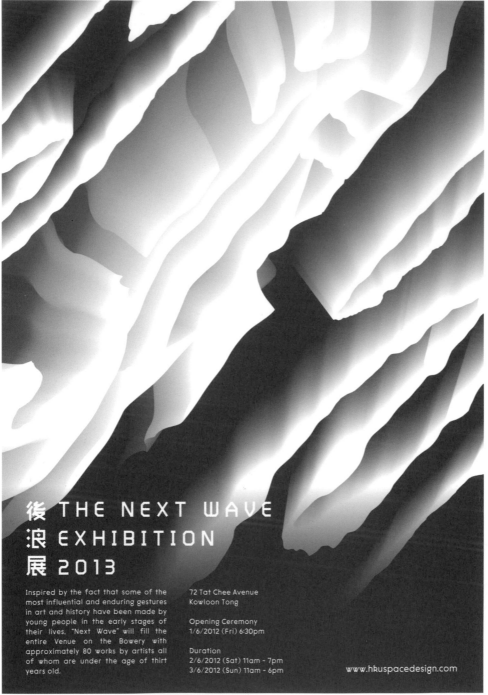

4. 長江後浪推前浪 一代新人勝舊人 *Time make it inevitable that* / 2013

1 / 紐約三部曲是一系列的小說，作者是保羅‧奧斯特。最初出版的依次為玻璃之城（1985 年），鬼（1986 年）和上鎖的房間（1986 年）。 Voyrd 被要求重新設計封面系列，使它看起來神秘但優雅，就像故事中的一樣。
The New York Trilogy is a series of novels by Paul Auster. Originally published sequentially as City of Glass (1985), Ghosts (1986) and The Locked Room (1986). Voyrd were asked to redesign the cover for the series, make it looks mysterious but also classy just like the story.

2 / 這個字體檔案展示了廣大的 42 種字體，反映了現今在 tendollarfonts.com 流行的字體設計。這本大型書籍是由許多書及小冊子集結而成，有 42 種字體範本，其中一本是設計師的專訪，而使用的是其設計之字體。
This type archive exhibits a wide spectrum of 42 typefaces that reflect current flows of typeface design in tendollarfonts.com, which again reflect today's graphic design. This big book is composed of many books and a booklet; a type specimen of 42 typefaces, a book of designers' interview on their typeface.

3 / "Walk-On" 最初作為企業字體像品牌 ACKE 所設計。設計靈感來自於裝飾藝術和新藝術風格的時代但卻使用現代的方法。這種復古字體擁有簡潔的造型和減少裝飾性的結構，但整體仍擁有裝飾藝術的外表和感覺。理想的編排，High Times 由於備用字母形式、數字和字母繁多還可以用來編輯副本，給用戶多種靈活的選擇和令人興奮的文字設計。
"Walk-On" was originally created as a corporate typeface for the Furniture brand ACKE. It takes its inspiration from the eras of Art Deco and Art Nouveau but with a radically contemporary approach. This retro font boasts simple shapes and reduced ornamental structures, yet still yielding an overall art deco -influenced look and feel. Ideal for headlines, High Times can also be utilized for editorial copy due to a vast array of alternate letterforms, numerals, and initials, giving the user multiple options for flexible and exciting text design.

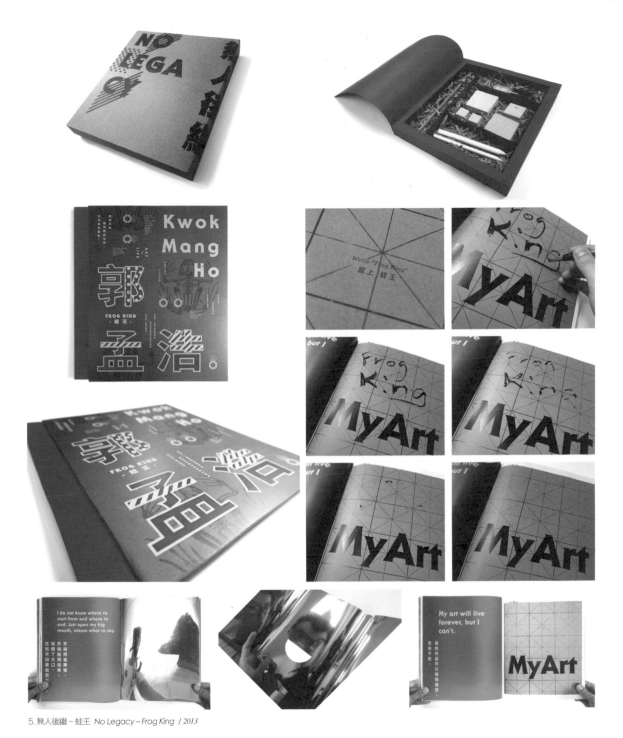

5. 無人後繼 – 蛙王 *No Legacy – Frog King* / 2013

4 / 展覽想法的重點是如何強調設計師未來得到他個人的舞台。因此，引用中國古話形容下一代 " 長江後浪推前浪 一代新人勝舊人 "。針對視覺我們用排版來融合 " 浪 " 這個詞，呼應最初的概念。
The idea of the exhibition is to emphasis the up and coming designer who's going to get his stage in the near future. Therefore we use the Next Wave as the concept as Chinese have a saying "Time make it inevitable that in every profession, young men replace the old". For the visual we use a typographic treatment to blend in the word - wave into the wave pattern to echo with the initial concept.

5 / 蛙王是一個多才多藝的藝術家，特別著名的是他的行為藝術，因此，我想強調這一點，並作出一本書可以與讀者互動，讓他們一邊讀卡並執行。
Frog king is a multi-talented artist, as he is especially well known of his performance art, hence i would like to emphasis this, and make a book can interact with the readers and let them perform while reading it.

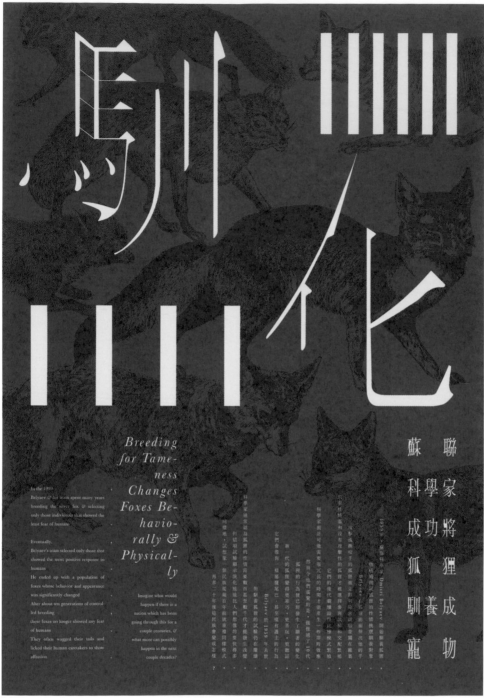

6. 馴化 Acclimation / 2013

6 / 在 1959 年，別利亞耶夫與他的團隊花了許多年的時間養殖銀狐，選擇性地飼養比較不畏懼人類的銀狐們，最後別利亞耶夫團隊只留下最溫和順從人類的銀狐，結果銀狐的行為和外貌都有相當大的改變。經過大約十代的選擇性飼養，這些狐狸不再畏懼人類，搖著尾巴舔拭飼養者以表示親愛的情感。想像如果有一個國家也經歷過像這樣的實驗幾個世紀，那麼未來幾十年內會發生什麼事呢？

In the 1959 the Belyaev & his team spent many years breeding the silver fox & selecting only those individuals that showed the least fear of humans. Eventually, Belyaev's team selected only those that showed the most positive response to humans . He ended up with a population of foxes whose behavior and appearance was significantly changed.

After about ten generations of controlled breeding. these foxes no longer showed any fear of humans. They often wagged their tails and licked their human caretakers to show affection.

Imagine what would happen if there is a nation, which has been going through this for a couple centuries, & what more can possibly happen in the next couple decades?

Q. 請問您認為該國最棒的是什麼?(如國家的特色或文化等)您的創作是否受其影響?

A. 其中一個很大的影響, 是從老粵劇的海報, 因為奶奶的牆壁上有很多的海報貼, 我想這些海報對年輕的我有一些影響。他們的排版都是如此完美, 手寫的中國文字, 字型都非常漂亮, 加上充滿活力的色彩搭配, 也影響我在作品中會去玩那些比較少被使用的顏色。

Q. 請和我們分享您喜歡的書籍、音樂、電影或場所。

A. 瘋狂麥斯:憤怒道、滑結樂團、華富邨

Q. 請問您做過最瘋狂或最酷的事情是什麼呢?

A. 裸體在大街上遊蕩!

Q. 請問您最近最想做什麼事情?是否已經著手規劃下一階段的目標或突破了呢?

A. 一些有關社會和燈泡的事。

Q. 目前有許多行業正在被取代或是沒落, 請問您對於平面設計未來的發展有什麼看法?

A. 平面設計將會比以往更加重要和網路再擴大。

Q. 你對生活的細節上有什麼堅持嗎?(像是上廁所時一定要看詩集之類的)

A. 做設計時聽重金屬音樂。

Q.What is the best thing In your country? (likes features or culture) Have it ever influence your creation?

A. One of the great influences is from the Poster of Old Cantonese opera (粵劇), as my grandmother have so many of those poster stick on the wall, i guess those poster have a influences on me when i was young. The typography on them are so prefect as each Chinese character were hand written beautifully, plus the vibrant mix of colour lead me to play with rarely used colour in my work as well.

Q.Share good books/music/movies/places with us.

A. Mad MAX: fury Road, Slipknot, and Wah Fu Estate

Q.What is the craziest or coolest thing you have ever done?

A. Walk down main road naked!

Q.What are the things you want to do most these days? Have you started to set up new goals or breakthroughs for next period?

A. Something about Social and light.

Q.There are many industries are gradually being replaced or decline, what is your view on the future development of graphic design?

A. Graphic design will be more important than ever and the internet expand.

Q.What is your insist on your life's details ? like toilet with your favorite poem?

A. Listen to Heavy metal when I am doing my design.

香港
Hong Kong

伍啟豪　Rogerger NG

www.noonhappyhour.com
noonhappyhour@gmail.com

伍啟豪 (b.1988) 於 2010 年獲香港浸會大學視覺藝術院視覺藝術 (榮譽) 文學士學位。他的作品常被觀者誤以為是無聊的行徑，但每每能深入淺出地揭示社會的荒誕。擁有視覺藝術背景的他融合設計與藝術，他認為設計不應只限於商業用途，好的設計甚至可以引發社會創新，為社會發聲。其作品《公民海報》同時奪得香港設計師協會環球設計大獎 2013 (2014) 及香港國際海報三年展 2013 (2014 中的專題海報金獎及評審之選。) 伍氏於同年獲香港設計中心頒發「青年設計才俊獎」，將赴海外設計公司進行交流。

Rogerger Ng (b.1988) obtained his Bachelor of Arts (Hons.) in Visual Arts from the Academy of Visual Arts at Hong Kong Baptist University in 2010. His works reveal a surreal and irrational approach that draws especially on the twisted phenomena of our contemporary society. With a Visual Arts background, Roger works on a interdisciplinary practice which allows him to explore boundary between Art and Design. He believes Design is not limited to commercial use, a good Design can speak for the society and motivate social innovation. His poster work Civil Poster received the Gold Award (Poster-Thematic), Hong Kong Best and Judge's Choice at the Hong Kong Designers Association Global Design Awards 2013 (2014) and Gold Award (Ideology category) and Judges Awards of Hong Kong International Poster Triennial in 2014 (2014). In the same year, Ng received the Young Design Talent Award presented by Hong Kong Design Centre, and will undertake overseas work exchange programme at renowned design companies.

1. 公民海報 *Civil Poster* / 2010 - now

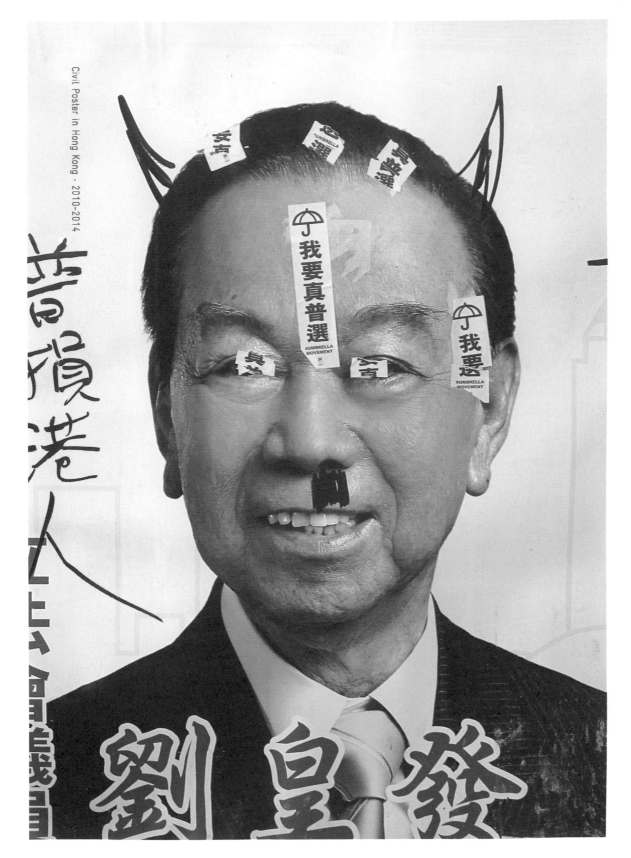

因出版限制，图像未能刊登
The image could not be printed subject to publication restrictions

二零一肆 深港設計雙年展 視覺傳達設計展

雙
城
計

1 / 鋪天蓋地的政治橫額本是為議員或政黨建立形象、展示立場和宣揚政績而掛滿街頭，不少卻落得被割破毀壞的下場。由它們被掛在公共空間開始，功用早已不再純粹，它們的每道傷痕均透露了市民的心聲，是一幅幅由社會共同擁有，並與社會互動的公民海報。
Political banners are commonly seen on streets all over the world. They are supposed to be means of propaganda, presenting or creating a positive image and expressing the positions of political parties. Surprisingly, we would very often find damages on the banners. These damages not only destroy the banners physically, but alter the function of the posters at the same time. The banners are not simply for political use when they appear in public space. They interact with people, creating a platform for the citizens to leave their views. It becomes a poster owned by the society.

2 / 我們受「深港設計雙年展」大會邀請，以深港兩地的設計和文化為題，進行海報創作。「創作自由」是兩地文化上的一大差異。曾經有一次，一份政治敏感的作品於內地出版的圖錄中突然被刪走，只剩下「出版所限，不能刊登」字眼。我們以此為靈感，透過自我審查自己的海報作品，諷刺內地對創作自由的打壓。
In 2014, our politically sensitive work was being erased when showcased in a catalogue published in Mainland China. The wording 'The image could not be printed subject to publication restrictions' written in simplified Chinese characters, which is commonly used in China, was the only thing left on my pages. Few months later, we were invited to create a poster about the cultural difference between Shenzhen and Hong Kong in the 1st Hong Kong - Shenzhen Design Biennale. Inspired from the experiences of being censored in Mainland China, we express the discontent to the oppression of Creativity Freedom, which is also a major difference in two cities, through self-censoring my own poster.

2. 因出版限制，作品名稱未能刊登 *Poster title could not be printed subject to publication restrictions* / 2014

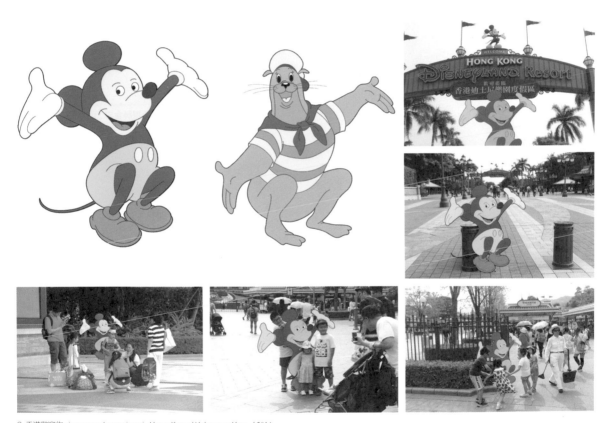

3. 香港歡迎你 xiang gang huan ying ni *Hong Kong Welcomes You* / 2014

3 / 自由行政策開放以後，內地客成為香港旅遊及零售業的重要支柱。為吸納更多內地客，賺更多的錢，不少傳統和具特色的店舖都相繼結業。取而代之的，盡是供內地客消費購物的商店。旺角街頭滿藥房、金行，尖沙咀廣東道名店林立。一些店舖甚至乾脆以簡體字製作他們的指示牌。種種一切，令我們覺得香港變得很陌生。我們把香港主題樂園的角色都製成內地的山寨版本，抹去本來的顏色，去迎合和歡迎內地旅客。

After opening the free exercise of policy, Mainland visitors have become an important pillar of the tourism and retail in Hong Kong. To attract more mainland visitors, make more money, a lot of tradition and distinctive shops are closing down. Instead by shops for the mainland visitors shopping. Mongkok street full pharmacy, goldsmith shops, Canton Road, Tsim Sha Tsui boutiques everywhere. Mongkok street full pharmacy, goldsmith shops, Canton Road, Tsim Sha Tsui boutiques everywhere. Some stores even simply to simplified characters production of their signs. All kinds of everything, so we feel that Hong Kong has become very strange. The role of Hong Kong theme park we have made cottage version of the mainland, to erase the original color, to cater to and welcome mainland visitors.

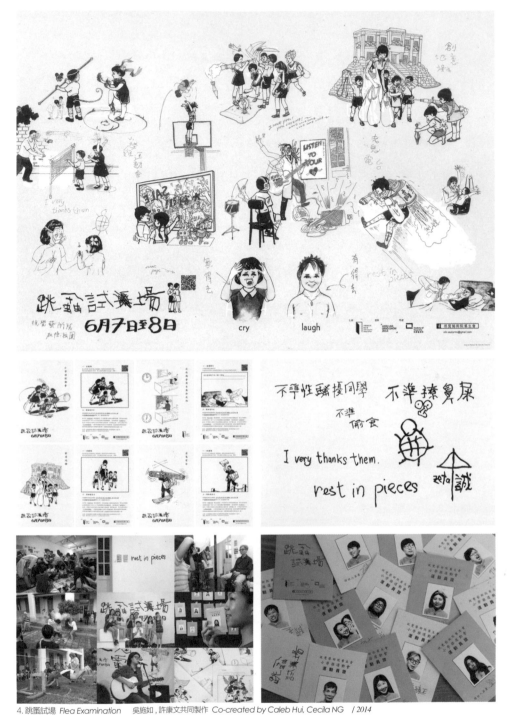

4. 跳蚤試場 *Flea Examination*　吳施如，許康文共同製作 *Co-created by Caleb Hui, Cecila NG* / 2014

4／「跳蚤市場」為香港浸會大學視覺藝術院舊生會一年一度的重點活動，今年以學校試場為主題，命名為「跳蚤試場」，希望帶大家回到過去的青蔥歲月。參加者除了在「跳蚤市場」購物之外，亦可參加大會舉辦「小學雞（小學生）運動會」和「校園老鬼（畢業生）電台」。我們以不常用的左手寫出一手仿小學生的醜字，並應用在整個活動的識別系統上。為配合主題，我們還以這些醜字制作出一些文法錯誤的英文、捉弄同學的塗鴉和字句，應用在場地佈置。

Inspired by the similarity in the Cantonese pronunciations of the words 'Examination' and 'Market', AVA Flea Market 2014 takes the title Flea 'Examination'. With 'Examination" as theme this year, our design resembles the drawings that every student, art students in particular, might have scribbled on their textbooks or even exam papers during examination or boring lessons in the old days. The original illustration on the books were often remade or defaced in a nonsensical way. Like our childhood, we altered the original pictures in old text books to remake a series of humorous illustrations to describe and introduce the highlighted programmers in the market. Children's handwriting with wrong grammar is used in the poster and the venue decoration as well.

Q. 請問您認為該國最棒的是什麼?(如國家的特色或文化等)您的創作是否受其影響?

A. 到目前為止,香港仍是一個自由的地方,這對任何類型創作都有正面的影響。過往幾年,多了機會在中國大陸做展覽和交流,意識到創作自由很大程度上影響著一個地方的設計走向。我喜歡觀察社會上光怪陸離的事情並反映在創作中,所以更需要一個自由的氛圍去培育和展示這些作品。此外,中西文化夾雜的香港,亦為我的設計帶來很多的靈感,不中不英的風格反而造就了很多驚喜的作品。

Q. 請和我們分享您喜歡的書籍、音樂、電影或場所。

A. 身為香港的年輕人,周星馳的電影一定榜上有名吧。我愛八、九十年代的港產片,我認為這個年代的電影有着一層浪漫,亦牢牢扣連着本土的歷史,如我最愛的《秋天的童話》。我也愛看低成本製作或離經叛道的電影,如《力王》、《伊波拉病毒》、《一蚊雞保鑣》等,劇本越瘋狂,越低成本,越見創意。

《阿濃說故事100》是我第一本接觸的文學巨著,阿濃為經典的童話故事續寫結局,當時認為他很無聊,但反而成為我創意的啓蒙。

Q. 請問您做過最瘋狂或最酷的事情是什麼呢?

A. 小學五年級時住在七樓,我每晚都會用紅外線筆,捉弄在樓下公園集結的童黨。

Q. 請問您最近最想做什麼事情?是否已經著手規劃下一階段的目標或突破了呢?

A. 在未來的數年我希望可以出國走走,看看這個世界,累積工作的經驗和找尋創作的靈感。回港後,希望可以策劃到一個認真而值得討論的設計展覽。

Q. 目前有許多行業正在被取代或是沒落,請問您對於平面設計未來的發展有什麼看法?

A. 我認為平面設計將進入一個概念主導的年代,我們所認知的設計美學和格式將會革新。藝術與設計的界線會日漸模糊,跨界的創作成為設計的主流。平面設計師的工作會更全面並超越於平面媒介。

Q. 你對生活的細節上有什麼堅持嗎?(像是上廁所時一定要看詩集之類的)

A. 我不拘小節呢。

Q.What is the best thing In your country? (likes features or culture) Have it ever influence your creation?

A. Until recently, Hong Kong remains a free and liberal city and that has a great deal of positive impact on any form of artistic endeavor. Over the past few years, I have been engaged in exhibitions in mainland China and have realized that artistic freedom played a big part in deciding the development of design at a certain place. As a keen observer of interesting phenomenons in my society, I believe it is of critical importance to work in an open and free environment in order to nurture and to exhibit my works. Also, living in a city like Hong Kong which embraces both Chinese and Western culture, I find that very inspiring to my design. The diversity and complexity of Hong Kong culture has enabled me to spring a few more surprises in my works.

Q.Share good books/music/movies/places with us.

A. As a youngster in Hong Kong, the comedy movies by Stephen Chow must be the choice. I also enjoy the Hong Kong films in 90s, I think 90s was the age full of dream and romance, the movies were deeply reflected and inspired from the local culture and history. One of my favorite is 'An Autumn's Tale'. The Cult Movie, especially some with low-budget, is also my favorite, we can always see how creative the production could be when the team got no budget. 'Riki-Oh: The Story of Ricky', 'Ebola Syndrome', 'Fighting to Survive' are definitely my choices.
'Ah Nong shares his 100 stories' is the one of the great classical works of children literature which inspires me a lot. I used to think it is quite non-sense that Ah Nong continued writing the story after the ending of the classical fairy tales, however, it becomes the enlightenment of my creative thinking .

Q.What is the craziest or coolest thing you have ever done?

A. I used to live on the 7th floor when I was a child. I like to hide behind the window and shot the young gangsters, who gathered at the park, by laser pen.

Q.What are the things you want to do most these days? Have you started to set up new goals or breakthroughs for next period?

A. In order to gain more working experience and get inspiration of my creative works, I am always planning to work or study abroad to broaden my horizon. Curating an Design exhibition is one of my objective to achieve in coming years.

Q.There are many industries are gradually being replaced or decline, what is your view on the future development of graphic design?

A. I believe we are approaching an era in which the field of graphic design will be driven primarily by concept and our understanding of design aesthetics and format will be renewed. The boundary between art and design will become increasingly blurred and the crossover approach will become the norm in graph design. The job of a graphic designer will cover much more ground and will go beyond the scope of the print media.

Q.What is your insist on your life's details ? like toilet with your favorite poem?

A. I care little about little things.

明日設計事務所
Tomorrow Design Office

www.tomorrowdesign.hk
info@tomorrowdesign.hk

劉建熙－明日設計事務所之創辦人及設計總監，
專注於視覺傳意、品牌形象、包裝及書刊的設計。
於 2010 年用了一年時間走訪中國不同城市及歐
洲不同國家探索當地藝術、設計及文化活動。完
成旅程後返港並於 2012 年創立「明日設計事務
所」。

深受瑞士設計風格影響，他透過將此風格融入其
日常設計當中，從而探索設計本質。同時提倡簡
約設計，追求簡單、實用而具創意的設計，達至
感染我們身處的社會，塑造一個更美好的未來。

Ray L. is the design director and founder
of Tomorrow Design Office, specializing
in visual communication, brand identity,
packaging, marketing collateral and
publication. In 2010, he spent a year
travelling to different cities in China and
countries in Europe to study arts, designs
and cultural activities. He started up his
own studio "Tomorrow Design Office" in
2012 after his journey.

Mostly influenced by "Swiss Style", he
has been integrating this style into his
design for the purpose of exploring the
fundamental nature of design. He is a
strong advocate of simplistic design,
aiming at creating minimal, but practical
and innovative designs that can influence
our society and build a better tomorrow.

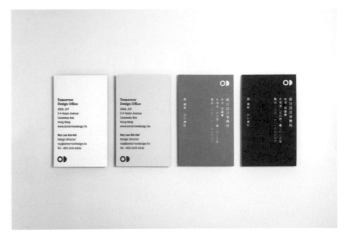

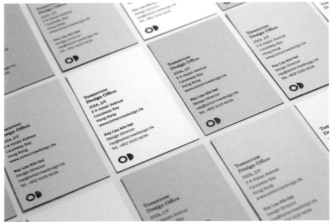

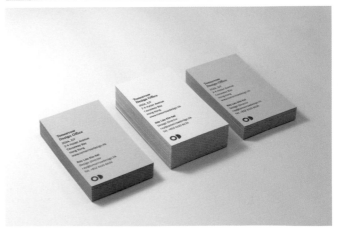

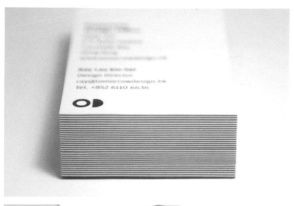

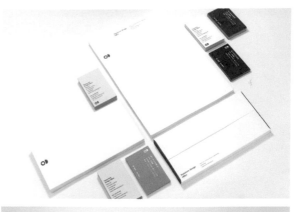

1. 明日設計事務所 *Tomorrow Design Office* / *2013*

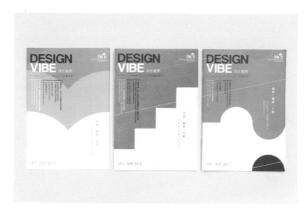

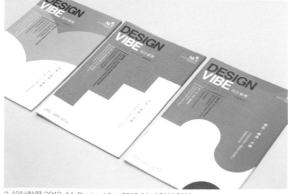

2. 設計動曆 2013–14 *Design Vibe 2013-14* / *2013-2014*

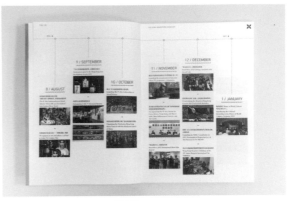

3. 香港藝術發展局 2012/13 年報　*HKADC 2012/13 Annual Report* 　/ *2013*

1 / 明日設計事務所是一所以香港為基地的平面設計事務所，專注於視覺傳意、品牌形象、包裝及書刊的設計。致力創造簡單，實用而創新的設計方案從而影響社會，建造更美好的明日。
標誌由中國古代象形文字啟發，太陽和月亮分別是日和月，組合成 " 明 " 日。我們結合傳統智慧與現代美學，運用西方手法表現中國文化，傳達出我們獨特的風格，視野與方向。
Tomorrow Design Office is a Hong Kong based graphic design studio. Their expertise lies in brand identity, visual communication, packaging, company brochure and marketing collateral. They aimed at creating simple, but practical and innovative design solutions that can influence our society and build a better tomorrow.
The logo is inspired by the Chinese ancient pictogram the sun and the moon, they combined into the meaning "Tomorrow". We try to merge traditional intelligence and modern beauty, Chinese culture and Western execution to convey our own style, vision and direction.
Minimal design element we used on the stationery, but the beauty shows in the detail like the envelop and the business card edge.

2 / 這是一份由香港設計中心出版的免費設計雜誌，會定期於地鐵站內與另一本免費雜誌 Metropop 一起派發。
鮮明有活力的顏色作背景，增加視覺動感，與白色相襯，加強個性和設計感。兩種顏色互相融合，相輔相成，有如商業與社會間的關係。
The quarterly events programme publication highlights the fascinating upcoming events held by Hong Kong Design Centre, it comes with free magazine Metropop.
Applied vivid colours on the background which contrast with the white colour to give the audience a dynamic visual experience, at the same time it echoes with the magazine title.

Hong Kong Arts Administrators Association
香港藝術行政人員協會

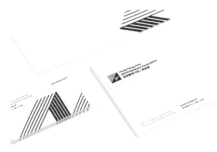

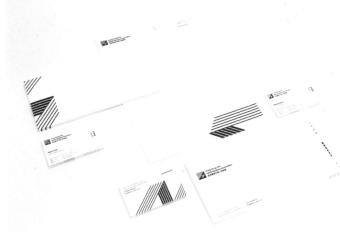

4. 香港藝術行政人員協會 *HK Arts Administrators Association* / 2013

3 / 香港藝術發展局是一個法定機構，由政府資助，擴寬香港藝術方面的發展，令香港成為一個多樣化的文化大都市。
設計概念是表達藝術在任何環境、時候都遍地開花，盛放空前。 我們以大大小小的花在不同的位置盛開，喻意不同層面，不同界別的藝術能各自精采，有美好的成長前景及發展。 花瓣是藝發局的標誌中的紅點而成，反映出每個團體或參與的公眾都是由藝發局培養而開花。豐富的層次加上流動的空間感形成充滿活力、個性的氛圍，能令人感到成長、發展的動感。而年報內容主要是講述 2012-2013 年局內事務及活動詳情，讓公眾清晰知道行業發展。
Hong Kong Arts Development Council ("ADC") is a statutory body set up by the Government to support the broad development of arts in Hong Kong. Its vision is to establish Hong Kong as a dynamic and diverse cultural metropolis.
2012-2013 annual report we designed in which detailed information about the activities and promotions that ADC conducted in the past year were reported – an initiative to keep stakeholders informed of the efforts that ADC has made in arts promotions.

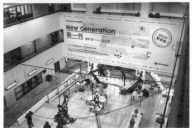

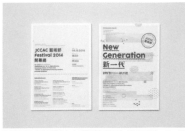

5. 賽馬會創意藝術中心藝術節 2014 *JCCAC Festival 2014* / *2014*

4 / 香港藝術行政人員協會的使命是以不同媒介去宣傳藝術管理，促進業界溝通，並作為一個發聲平台，支持本土藝術發展。
輔助圖像利用了標誌作延伸，大大增加了全套應用的一致性從而突出香港藝術行政人員協會的獨特個性。同時亦年輕化和增加動感去吸納更多的年輕人參與協會舉辦的活動。
Hong Kong Arts Administrators Association's mission is to promote good arts administration practice amongst arts managers and other stakeholders, and to serve as a platform and representative voice in order to support the advancement of a flourishing arts scene. The branding exercise aims to attract youths to attend its activities.
A set of supporting graphics consisting of interweaving threads is designed from an extension of its logo element and is in various forms under different applications. The rationales behind are to make the whole system more stylish and energetic in order to attract more youths to join its programs.

5 / 每個界別做的事不同，但大家走在一起就形成了 JCCAC 藝術節的時刻。所以用上了不同的 pattern 來代表 Festival 中的不同環節，有如組成一個小小的城市地圖一樣。而新世代不一定要給人很有活力的感覺，反而靜靜的，有點文藝感更切合來臨的大環境。
JCCAC 藝術節為期一個月，節目包括本地藝術家的作品展覽、講座、參觀和表演。
Different field of art come together as one to form the annual event - JCCAC Festival. We used different patterns to stand for different activities, events and exhibitions in the festival, it looks like a map of art city.
JCCAC Festival a month-long festival with tons of exhibitions of local artist's works, as well as talks, tours and performances each Saturday and Sunday.

Q. 請問您認為該國最棒的是什麼？(如國家的特色或文化等) 您的創作是否受其影響？

A. 激烈的競爭。每一分每一秒，任何事的競爭在這裡都異常激烈。促成人們都擁有非常勤奮和欲求進步的心，亦激發了大家(包括我)的創造力。因為你不快快地前進，馬上就要被後來的人吞噬掉，是不是聽起來很令人熱血沸騰呢？

Q. 請和我們分享您喜歡的書籍、音樂、電影或場所。

A. 岑寧兒，香港獨立唱作人。喜歡她的音樂和聲線

Q. 請問您做過最瘋狂或最酷的事情是什麼呢？

A. 一直在香港活著已經夠瘋狂，而能夠成為一個設計師就是最酷的事了。

Q. 請問您最近最想做什麼事情？是否已經著手規劃下一階段的目標或突破了呢？

A. 最近一直想嘗試做些簡單的產品設計。因為對生活上的細節有很多小不滿，總覺得自己遇到的煩惱應該不只我一個才覺得不妥吧，所以希望透過設計去幫助那些有著和我一樣想法的人們。

Q. 目前有許多行業正在被取代或是沒落，請問您對於平面設計未來的發展有什麼看法？

A. 每個年代都會有不同的行業消失，然後又有新的行業誕生，這事情是最自然不過，有如人的生老病死。平面設計其實所覆蓋的範圍比大眾所認知的要廣得多，需要設計的不只有品牌、活動或展覽，很多真正需要設計的地方還是不難發掘出來的。所以最重要的課題是如何令大眾更加明白平面設計的存在價值，繼而將平面設計應用的地方以最大的力度去擴展。

Q. 你對生活的細節上有什麼堅持嗎？(像是上廁所時一定要看詩集之類的)

A. 沒有。

Q.What is the best thing In your country? (likes features or culture) Have it ever influence your creation?

A. Hong Kong people are hard-working and aggressive for their careers due to intensive competition. You will be eliminated quickly if you can't do something better than others. I think this is one of the best inspirations for designers in Hong Kong.

Q.Share good books/music/movies/places with us.

A. Yoyo Sham, an indie musician in Hong Kong.

Q.What is the craziest or coolest thing you have ever done?

A. It is crazy enough that I'm living in Hong Kong, and the coolest thing is what I am doing – to be a designer.

Q.What are the things you want to do most these days? Have you started to set up new goals or breakthroughs for next period?

A. I wanna try to design products recently. This idea is actually triggered by my thousands of tiny problems encountered in daily life, I hope eventually I can enhance our overall living quality, not only to myself, by making some small changes.

Q.There are many industries are gradually being replaced or decline, what is your view on the future development of graphic design?

A. Some industries disappear and some emerge intermittently throughout different eras. All happen naturally. In fact, the areas involving graphic design (such as branding, exhibition) are in a much wider scope than people can imagine, it is never difficult to identify areas which require the input of a professional designer. I think the most important thing is how to promote the importance and value of design and fully integrate it into every part of our life.

Q.What is your insist on your life's details ? like toilet with your favorite poem?

A. None.

日本

Japan

Jun Oson

Ren Takaya

SPREAD

Jun Oson

www.junoson.com
info@junoson.com

JUN OSON 出生於日本愛知縣 (西元 1979 年),
目前居住在日本。大學畢業後, 最初在設計公司
工作。現在工作領域廣泛, 身為插畫師, 特別是
動畫部分, T - shirt 設計, 印刷及網頁媒體, 也
熱衷於在私人展覽展示他的作品。

JUN OSON was born in Aichi, Japan
(1979) and currently lives in Tokyo. After
graduating from university, he initially
worked for a design company.

He now works widely as an illustrator,
specialising in the areas of animation,
T-shirt design, and print and web-based
media. He is also enthusiastic about
displaying his work at private exhibitions.

1. GINZA / 2011

2. OROTI / 2010

3. ZOMBIE / 2015

1 / 在 Megane Zine 刊物中的藝術作品。
Artwork for megane zine.

2 / OROTI 的 CD 封面藝術作品。 "
Artwork for CD jacket of OROTI.

3 / 殭屍特展的藝術作品。
Artwork for ZOMBIE EXHIBITION.

4 / 這是紀念四十週年的官方認可藝術作品合作。
This is an official recognition collaboration artwork of commemoration
40th anniversary.

5 / 在米蘭的東京設計師週藝術作品。
Artwork for TOKYO DESIGNERS WEEK in MIRANO.

4. *KITTIE AND ME* / 2015

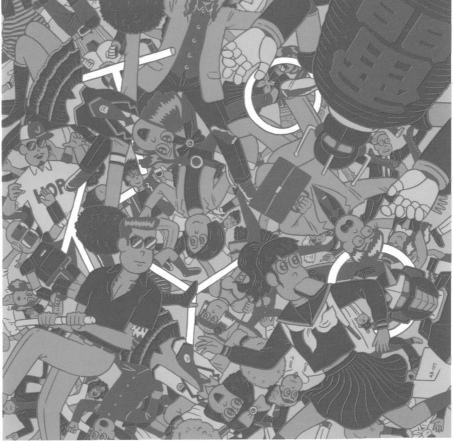

5. *TOKYO* / 2014

6. A CAR / 2015

7. SHE / 2015

6 / 新加坡區 Esquire 雜誌的藝術作品。
Artwork for esquire magazine singapore.

7 / 2015 音樂插圖獎的藝術作品。
Artwork for MUSIC ILLUSTRATION AWARD 2015.

Q. 請問您認為該國最棒的是什麼 ?(如國家的特色或文化等) 您的創作是否受其影響 ?

A. 漫畫。沒錯, 這對我的創作影響至深。

Q. 請和我們分享您喜歡的書籍、音樂、電影或場所。

A. 我喜歡看電影,"成人世界","水牛城 66","玩命法則","落日車神"等等。

Q. 請問您做過最瘋狂或最酷的事情是什麼呢 ?

A. 就是我當插畫家這件事。

Q. 請問您最近最想做什麼事情 ? 是否已經著手規劃下一階段的目標或突破了呢 ?

A. 我想在除了日本以外的國家工作。

Q. 你對生活的細節上有什麼堅持嗎 ?(像是上廁所時一定要看詩集之類的)

A. 沒有。

Q.What is the best thing In your country? (likes features or culture) Have it ever influence your creation?

A.Yes, That influences my creation.

Q.Share good books/music/movies/places with us.

A. I like the movie. "Chappie","Buffalo '66" ,"The Counselor" , "DRIVE"..etc

Q.What is the craziest or coolest thing you have ever done?

A. That's that I was an illustrator.

Q.What are the things you want to do most these days? Have you started to set up new goals or breakthroughs for next period?

A. I'd like also to work in the country besides Japan.

Q.What is your insist on your life's details ? like toilet with your favorite poem?

A. No.

日本 Japan

Ren Takaya

www.ad-and-d.jp
info@ad-and-d.jp

平面設計師及藝術總監，出生於宮城縣仙台市。
畢業於日本國立東北藝術工科大學，主修雕塑。
在設立 AD&D 之前進入好的設計公司，活躍於
許多領域，例如平面、網頁、產品設計。主要作
品為六本木新城的花卉競選活動，東急文化村
25 週年等視覺設計。

Graphic designer and art director born in
Sendai, Miyagi prefecture.

Graduated from Tohoku University of Art &
Design majoring in sculpture.

Joined good design company before
establishing AD&D.

Active in many fields such as graphics,
web, products.

Main works are Campaign of Flower Lush
in Roppongi Hills,

Visual Identity of Tokyu Bunkamura 25th
Anniversary, etc.

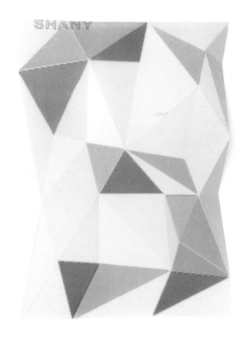

1. SHANY / 2014

2. HOPE / 2014

Ren Takaya

3. TAVERN / 2013

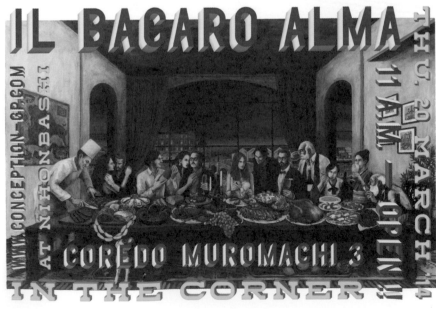

4. IL BACARO ALMA / 2014

80

美しい時代へ──東急グループ

Bunkamura,
25th Anniversary

www.
bunkamura.
co.jp

ORCHARD HALL
THEATRE COCOON
LE CINÉMA
THE MUSEUM

5. Bunkamura, 25th Anniversary / 2014

1 / 音樂家 SHANY 的宣傳海報。
Promotion of a musician, SHANY.

2 / 實驗性海報。
Experimental Posters.

3 / 餐廳的宣傳海報。
Promotion of a restaurant.

4 / 餐廳的宣傳海報。
Promotion of a restaurant.

5 / 東急文化村的海報。
Poster of a cultural facility, Bunkamura.

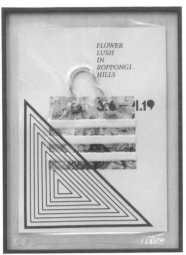

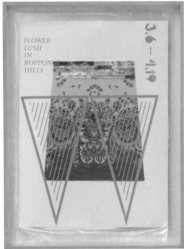

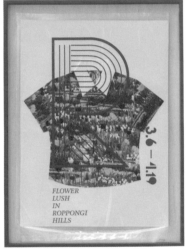

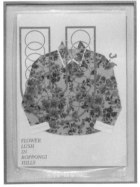
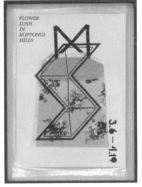

6. FLOWER LUSH IN ROPPONGI HILLS / *2015*

6 / 六本木新城的時尚活動。
Fashion campaign of Roppongi Hills.

Q. 請問您認為該國最棒的是什麼?(如國家的特色或文化等)您的創作是否受其影響?

A. 特殊的四季,也為我的創作帶來很大的生命週期。

Q. 請和我們分享您喜歡的書籍、音樂、電影或場所。

A. 書籍:"La Bombe Informatique" by Paul Virilio

音樂:古典樂、爵士、搖滾、電子樂、流行樂

電影:"戰火浮生錄","銀翼殺手"

國家:紐約,東京

Q. 請問您做過最瘋狂或最酷的事情是什麼呢?

A. 贏得國際創意節銀獎。

Q. 請問您最近最想做什麼事情?是否已經著手規劃下一階段的目標或突破了呢?

A. 提供作品是我最想要做的事。我的點子都是從日常生活的任何事跟每天例行觀察人們。

Q. 目前有許多行業正在被取代或是沒落,請問您對於平面設計未來的發展有什麼看法?

A. 一直都有個說法是平面設計領域不斷擴大,然而平面設計只是輸出的風格和設計過程中的之一,所以我覺得描述平面設計的未來發展並沒有太大的意義。設計師必須不斷提出什麼是現代和未來的答案,在這之間來回的觀察和驗證。

Q. 你對生活的細節上有什麼堅持嗎?(像是上廁所時一定要看詩集之類的)

A. 觀察並記錄我喜歡的東西,如產品,空間,顏色,佈局,平衡,音樂,氣味等。

Q. *What is the best thing In your country? (likes features or culture) Have it ever influence your creation?*

A. Specific four seasons.
That gives big biorhythm to my creation.

Q. *Share good books/music/movies/places with us.*

A. **book:** "La Bombe Informatique" by Paul Virilio
music: classical music, jazz, rock, EDM, pop music
movie: "Les Uns et les Autres" "Blade Runner"
place: NY, Tokyo

Q. *What is the craziest or coolest thing you have ever done?*

A. Winning the silver prize of ONE SHOW.

Q. *What are the things you want to do most these days? Have you started to set up new goals or breakthroughs for next period?*

A. Offered works are the best things I want to do.
My ideas are from everything in daily life and observing them is my daily routine.

Q. *There are many industries are gradually being replaced or decline, what is your view on the future development of graphic design?*

A. It has been said for long time that the field of graphic design has been expanding.
However, graphic design is just one of output styles and design processes,
so I think the description of "the future development of graphic design" does not make much sense.
Designers have to suggest the answers continuously with going back and forth between observation and verification for the present age and the next.

Q. *What is your insist on your life's details ? like toilet with your favorite poem?*

A. Observing and recording something I like such as products, spaces, colors, compositions, balances, music, smells, etc.

日本 Japan

SPREAD

www.spread-web.jp
mailto@spread-web.jp

SPREAD 是個創作型團隊由 Hirokazu Kobayashi 和 Haruna Yamada 成立於 2004。融合了景觀設計和平面設計，將記憶拆解並重建，我們傳遞跨領域的創作發明到未來。自 2004 年以來，"Life Stripe" 是一個持續著的藝術專案，用顏色記錄著生活中的模式。

Hirokazu Kobayashi: 於 1976 年出生在新潟縣，畢業於長岡設計研究所工業設計系，之後擔任廣告公司中主要海外活動的藝術總監及設計師。在 2003 年成為了自由工作者，在 2004 年成立了 "SPREAD"。為日本平面設計師協會 (JAGDA) 的成員之一。

Haruna Yamada: 於 1976 年出生於東京。畢業於長岡設計研究所環境設計系。在 Ryoko Ueyama 的景觀設計研究室開始了作為一個景觀設計師的職業生涯。在環境視覺公司、塑膠工廠、唱片公司當過設計師之後，於 2004 年創立了 "SPREAD"。

2014: 日本優良設計獎、比利時國際包裝設計獎 (銀獎)

2013: 日本優良設計獎、德國紅點設計獎 - 傳達設計獎

2012: 英國設計與藝術指導協會獎、德國 iF 包裝設計獎、比利時國際包裝設計獎 (銅獎)、日本設計師協會 (優異)、日本 JCD 設計獎

2010: 日本優良設計獎、比利時國際包裝設計獎 (銀獎)、香港亞洲最具影響力大獎 (銅獎)、德國紅點設計獎 - 傳達設計獎

SPREAD is a creative unit founded by Hirokazu Kobayashi and Haruna Yamada in 2004. By mixing the concept of landscape design and graphic design, and by dismantling and rebuilding memory, we spread multidisciplinary creations to the future. Since 2004, "Life Stripe" is an ongoing art project that records patterns of life in colors.

Hirokazu Kobayashi: Born in Niigata prefecture in 1976. Graduated from Nagaoka Institute of Design, Industrial Design department. Worked as an art Director and Designer for an advertising agency for mainly overseas promotions. In 2003 he became freelance. Established the creative unit "SPREAD" in 2004. Member of the (JAGDA) Institute of Graphic Designers in Japan.

Haruna Yamada: Born in Tokyo in 1976. Graduated from Nagaoka Institute of Design, Environmental Design department.

Started her career as a landscape designer in the Ryoko Ueyama landscape design laboratory. After working as a designer in an environmental graphic company, a plastic manufacturer and a record company, in 2004 she established the creative unit "SPREAD".

Awards Winning List

2014: Good Design Award (Japan), PENTAWARDS (Belgium) / Silver

2013: Good Design Award (Japan), red dot design award: communication design (Germany),

2012: D&AD award (UK), iF packaging design award (Germany), PENTAWARDS (Belgium) / Bronze, JAGDA Award / Merit (Japan), JCD Design Award(Japan)

2010: Good Design Award (Japan), PENTAWARDS (Belgium) / Silver, Design for Asia Award (Hong Kong) / Bronze, red dot design award: communication design (Germany)/ red dot

1. F 有機物　F organics　/ 2013, 2014

2. Spectrum / Soutaiseiriron × Jeff Mills / 2015

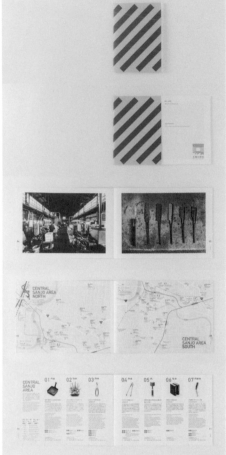

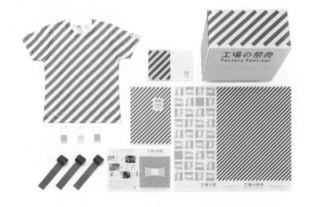

3. 工廠慶典 *Factory Festival* / 2013, 2014

1 / 這是一個新的有機護膚品牌，成分 99% 從天然原料中萃取，使用 95% 以上有機植物的成份。除了有機，它專為女性打造美容用的主題「有機即是性感」，去除皮膚上的髒汗的潔面乳外表是白色的，另一種塗抹在肌膚上的乳液是黑色。此外，隱約透出的肌膚顏色展現自然的性感，「哪裡有光，哪裡就有影子」這是稱揚日本女性之美的句子，來自古崎潤一郎的文學作品「陰翳礼讃」，該產品以白和黑，代表光與影的顏色包裝。

This is a new organic skin care brand. There are more than 99% raw organic materials derived from natural ingredients and more than 95% of the plant ingredients used is organic. Although organic, it was created as an attractive beauty brand for woman under the theme, "Organic is Sexy". The product that removes dirt from skin like cleansing foam is "white" and the other one applied on the skin is colored "black". Additionally, the vaguely transparent colors express a natural sexiness. "Where there is light, there is a shadow" that praises Japanese beauty. "Ineiraisan", using this concept, in the literature by Junichiro Tanizaki, the product is packaged in white and black, the color of light and shadow.

2 / 這是日本搖滾樂團「相対性理論」和 DJ Jeff Mills 共同錄製新曲而推出的限量 CD。包裝是由金屬裁切而成，CD 被工業用螺栓固定住，再包上一層泡泡紙、貼上有黃黑色設計的貼紙。表達對於工業產品的「警告」，在網路下載音樂的時代，我們仍可以透過包裝賦予 CD 新的意義。

This is a limited-edition CD of new songs recorded by the Japanese rock band "Soutaiseiriron" ("The Theory of Relativity") and the world's best techno DJ "Jeff Mills". The package is cut out from solid metal. The CD containing both musicians' new songs is secured to it with an industrial bolt. It is then packaged in Styrofoam wrap and sealed using tape that has a yellow and black design, which indicates "caution" on industrial products. In a download-centric era, we were able to give new meaning to the CD as an object through its packaging.

萩原精肉店

4. 萩原精肉店 *Hagiwara Butcher* / 2012

3 / " 燕三条－工場的祭典 ", 為期五天的活動, 燕三条是日本金屬加工的產地, 當地的工廠會敞開大門迎接遊客, 讓他們親身體驗日本的金屬工藝, 來振興這項行業, 因為地處偏遠缺乏接班人, 54 家金屬工廠聯合起來, 主動打開工廠大門迎接觀光客, 分享他們的金屬藝品。為何這項曾經輝煌的手藝面臨到接班的問題？因為以前工廠無法對人群敞開大門, 以及「工匠之心」逐漸封閉。這原因讓我們產生了靈感設計 Logo 的視覺, 「打開大門」, 我們想創造一個圖標, 能扛起振奮工匠心情的重大任務。
For the Tsubame-Sanjo Factory Festival, a five-day event, the Japanese metalwork production area/the factories of the Tsubame-Sanjo area, will all open their doors at once to allow visitors to witness and experience the Japanese metalwork craftsmanship.In the wake of a decline in the industry, due to a lack of successors for the craftsmen in the provincial towns, 54 factories will participate in an initiative to open their doors to the public and share their craft with visitors.Why this splendid craft is difficulty transmitted is not only because, up until now, the doors of the factories were closed to the public, but also because the "Hearts of the craftsmen" have been closed. This is what inspired the visual of our logo mark "Open Doors" ; we wanted to create an icon that would take up the big task of uplifting the craftsmen's mood.

4 / 這是替從 1947 年在古都鎌倉開業的萩原精肉店所設計的識別, 他們翻新了代表萩原精肉店的歷史的舊建築、logo、展示和包裝, 全部都被重新改造。萩原精肉店發展成兩個家族, 齊藤家 (所有者) 與萩原家 (管理者), 然而, 顧客已再也沒有機會知道萩原家的歷史, 所以我決定傳達歷史的傳承, 如同這兩個家庭共同繼承家業一樣。
These are the identity of a butcher that has been in business since 1947 in the ancient capital city of Kamakura. When the shop was refurbished due to the aging of the building, the logo, display and packaging, which symbolize the history of Hagiwara Butcher, were newly created.
This is a family butcher which has grown with two families; the Saito family, the owner and the Hagiwara family, the shop manager. However, costumers have had no opportunity to learn the history of this butcher so far. So, I have decided to make a point of passing on this history as the two families are set to continue working together.

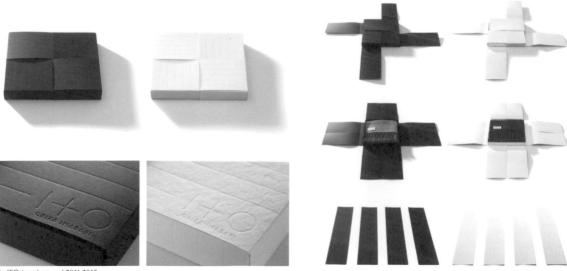

5. ITO / package / 2011-2015

6. Tadashii Soutaiseiriron / Soutaiseiriron / 2011

5 / 這個包裝是 "Kobo Oriza" 新誕生的品牌「ITO」。Kobo Oriza 是尋求創新的編織工廠。這個包裝是有四個象徵編織的寬紙條互相重疊。織線圖案是由工匠精心雕刻的，利用凸版印刷，顏色是白色和黑色。

This is a package of new stole's brand "ITO" which was born from "Kobo Oriza". Kobo Oriza is a factory seeks innovative weaving. This package is put together with four strips of papers lapped over one another, somewhat expresses weaving. Twisted thread patterns are carefully engraved by a craftsman, leveraging letterpress printing. The color is white and black.

6 / 這是日本搖滾樂團「相對性理論」的 CD 唱片。紅色和綠色的 check sheet 在日本學生之間是很流行的文具，可以幫助加強記憶，附在唱片的封套裡。大人也可以享受像是解謎一樣的快樂，尋找躲藏在紅綠之間的圖表與歌詞，而且能在這個數位下載的時代，替專輯封套創造出新的體感價值。

This is the CD album of a Japanese rock band "Theory of Relativity".

A "red and green check sheet", a popular tool for Japanese students to enhance memorization, is attached to the sleeve. Audiences can feel the joy of "imagination" by solving the studded mystery hiding in the visible or invisible analysis diagrams and lyrics. Moreover, it creates a new experience value in the sleeve in this "downloading" era.

Q. 請問您認為該國最棒的是什麼?(如國家的特色或文化等)您的創作是否受其影響?

A. 日本傳統文化, 藝術, 音樂, 日常生活。

Q. 請和我們分享您喜歡的書籍、音樂、電影、場所。

A. 書籍:地球潛水員 / 中沢新一

音樂:曾我部惠一, 相對性理論, 團團轉樂團

Q. 請問您做過最瘋狂或最酷的事情是什麼呢?

A. 我們的展覽, 日常生活

Q. 請問您最近最想做什麼事情?是否已經著手規劃下一階段的目標或突破了呢?

A. 很多的旅行。設計是由個體和社會合作而成。旅行可以為我們的工作做正確地領導。然後, 我們開始了 "Life Type", 是循著 "Life Stripe" 並籌備了四年的新作。我們將在東京國立新美術館成立工作室及舉辦展覽。

Q. 目前有許多行業正在被取代或是沒落, 請問您對於平面設計未來的發展有什麼看法?

A. 設計逐漸邁向整合, 平面、產品、空間, 不斷向外延伸的創作刺激著我們。另一方面, 細節變得更加重要, 無拘無束與注重細節看起來是矛盾的, 但這會讓設計圈的發展更臻成熟, 我想十分有趣的未來正在等著我們。

Q. 你對生活的細節上有什麼堅持嗎?(像是上廁所時一定要看詩集之類的)

A. 回首過往, 便會看見未來。

Q. *What is the best thing In your country? (likes features or culture) Have it ever influence your creation?*

A. Traditional Japanese culture, Art, Music, Daily Life.

Q. *Share good books/music/movies/places with us.*

A. **books** : "Earth diver"/ Shinichi Nakazawa
musics: Keiichi Sokabe, QURULI, Soutaiseiriron

Q. *What is the craziest or coolest thing you have ever done?*

A. Our Exhibition.
Daily Life.

Q. *What are the things you want to do most these days? Have you started to set up new goals or breakthroughs for next period?*

A. Many trips. The design is the collaboration with individually things and societies. Trip will lead directly to the our work.
Then, we started the show of new work "Life Type". This is the work that follows "Life Stripe" and had been prepared four years. We will hold the workshop and exhibition at the national art center tokyo.

Q. *There are many industries are gradually being replaced or decline, what is your view on the future development of graphic design?*

A. Design is more integrated. Graphic, product, space, the creation of on the boundary will stimulate us. the other side, the detail becomes more important. On border and high detail is contradictory. But, It leads the society to mature. Strictly fun future is waiting.

Q. *What is your insist on your life's details ? like toilet with your favorite poem?*

A. When you see the past, you will see the future.

韓
國

Korea

鄭燻東 *CHUNG, HOON-DONG*

Jin Jung

韓國 Korea

鄭燻東
CHUNG, HOON-DONG

www.dankook.ac.kr
finvox3@naver.com

1970 年，鄭燻東 (音譯) 出生於韓國。目前任檀國大學助理教授和大韓民國美術大展特邀藝術家。此外，還任韓國商品文化設計學會的副會長，及 Green+You 和 Design+You 的顧問。他的博士學位與 3D 字體 (Typography) 有著很深的關係，實驗也是主要他所關注的。他的作品還在 the Graphis Annual、紅點設計大獎、iF 設計獎、日本優良設計大獎、the Creativity Design Award、IDA 國際設計大獎和德國設計獎等國際徵集作品展上嶄露頭角。此外，他的作品還被慕尼黑國際設計博物館、蘇黎世設計博物館、法國巴黎廣告博物館、芝加哥雅典娜建築與設計博物館、丹麥海報博物館和 OGAKI 海報博物館等收藏。

Hoon-Dong Chung was born in 1970 in Korea.

He is an assistant professor at Dankook University and invited artist at the Grand Art Exhibition of Korea. In addition, he is a vice-chairman of Korean Institute of Cultural Product Art & Design and advisor to Green+You / Design+You. His Ph.D. in Design is deeply associated with 3D Typography. This is also his abiding concern with constant experimentation. The works have been showcased in numerous competitive exhibitions across the world and received a bout of awards, including the Graphics Annual, the Red Dot Design Award, the IF Design Award, the Good Design Award, the Creativity Design Award, the IDA Design Award and numerous nominations for the German Design Award with the German Design Council. Furthermore, his works are housed in the collections of International Design Museum Munich, Museum für Gestaltung, Musée de la Publicité, The Chicago Athenaeum Museum of Architecture and Design, Dansk Plakatmuseum, Ogaki Poster Museum, and the like.

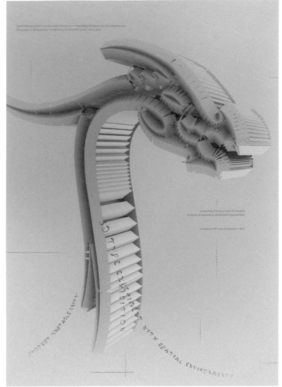

1. *3D Type Exhibition* / 2014

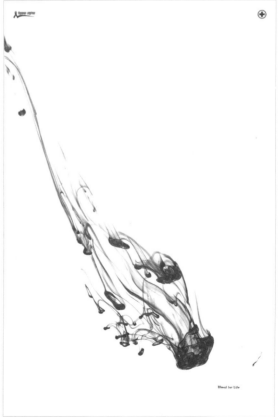

2. *Blood for Life* / 2010

3. *3D Typography Exhibition* / *2012*

DKU2011

Keep Earth's Air Safe

C Endangers O2

4. 碳正威脅著大氣, *C endangers O2 / 2011*

1 / 宣傳實驗性計畫 " 不穩定團結 (Unstable Unity)" 的海報，通過立體的字母 "T" 加以形象化。
This promotional poster is designed for an experimental project 'Unstable Unity' and used the letter 'T' in conceptual aspects. The project focuses on expanding 2D types into 3D imagery.

2 / 著眼於形成社會的倫理意識的愛滋海報。
AIDS Poster focused on forming motivation to ethical values of life.

3 / 宣傳實驗性計畫 " 不穩定團結 (Unstable Unity)" 的海報，通過立體的字母 "T" 加以形象化。
This promotional poster is designed for an experimental project 'Unstable Unity' and used the letter 'T' in conceptual aspects. The project focuses on expanding 2D types into 3D imagery.

5. 地球 *EARTH* / 2012

4 / 從大氣的視角來看時，＂碳正威脅著大氣＂。強調對氣候變化的警覺心的海報。
When it comes to the atmosphere, C(Carbon) endangers O2(Oxygen).
This 3D typography poster with the impression of space is to arouse people's attention to "Dangerous Climate Change".

5 / 蘊含有傾聽地球的聲音的寓意，強調與地球環境溝通的海報。
We are part of the earth, as much as the earth is part of us. This poster aims to convey how we all unite in communication and that we should therefore listen attentively to the earth for better communication.

CHD 2009

The Deadly Sword

6. 致命之劍 *The Deadly Sword* / *2009*

6 / 將溫度計和劍結合，象徵全球暖化嚴重性的海報。它想傳達的訊息是人為災害「全球暖化」將會成為「致命之劍」，對這項議題提出警訊。
In this campaign the thermometer which is shown rising in temperature is symbolic for "Global Warming" It wants to spread the message that with regards to man-made disasters "Global Warming" will be "The Deadly Sword" The aim is to arouse attention to this problem.

Q. 請問您認為該國最棒的是什麼？(如國家的特色或文化等) 您的創作是否受其影響？

A. 韓國的一切都在快速地發生著變化。這一點，無關我是否喜歡，我都要去接受。不管發生什麼樣的變化，我都努力找到我的 " 中心 " 所在。這一點似乎對我的創作有些影響。

Q. 請和我們分享您喜歡的書籍、音樂、電影或場所。

A. 獲得知識的方法有很多種。深而窄 (narrow and deep)、淺而寬 (broad but thin) 等等。如果選擇後者的話，推薦一本叫《100 個改變平面設計的偉大觀念》(作者：史蒂芬 • 海勒、薇若妮卡 • 魏納) 的書。

Q. 請問您做過最瘋狂或最酷的事情是什麼呢？

A. 我對國際徵集作品展產生興趣是在 2005 年前後。當時，我正在尋求一些變化。入選波蘭華沙國際海報雙年展 (the International Poster Biennale in Warsaw, Poland) 的作品是第一個成果，還獲得了被法國巴黎廣告博物館 (the Musée de la Publicité in Paris, France) 收藏的榮譽。從那之後，參與國際徵集作品展了我創作生活中的一部分，前後共參與了 80 餘次。過去的 10 年，用 " 始終如一 " 來概括可能再適合不過了。

Q. 請問您最近最想做什麼事情？是否已經著手規劃下一階段的目標或突破了呢？

A. 未來 1~2 年內不會發生大的變化。

然而，在樹立新目標之前，有一個一貫的目標，那就是 " 始終如一 "。

Q. 目前有許多行業正在被取代或是沒落，請問您對於平面設計未來的發展有什麼看法？

A. 對數位海報的需求將日益增加。不能說是傳統海報呈現了下滑趨勢，應該說是出現了新的需求更為合適。數位媒介的相互作用性 (Interaction) 與海報持續不斷地結合，將產生更多的可能性。目前，數位海報已用於商業用途，以後還有望擴大到政治 / 社會海報 (Social/Political Posters) 或藝術海報 (Art Posters) 等領域。

Q. 你對生活的細節上有什麼堅持嗎？(像是上廁所時一定要看詩集之類的)

A. 我認為，說 " 盡力了 " 這句話時應極為慎重才行。

我活到現在，還從來都沒說過這句話。

Q. *What is the best thing In your country? (likes features or culture) Have it ever influence your creation?*

A. Everything changes so rapidly in South Korea, which I should accept rather than liking. As all change drastically, I try to seek my nucleus. I think such attitude affects my creative work.

Q. *Share good books/music/movies/places with us.*

A. Knowledge can be acquired in various ways, including 'narrow and deep,' or 'broad but thin,' etc. If anyone is interested in the latter approach, '100 Ideas that Changed Graphic Design' (by Steven Heller and Veronique Vienne) is on the short list of recommendable design books.

Q. *What is the craziest or coolest thing you have ever done?*

A. I got first interested in international competitions in around 2005. I needed some change back then. My entry selected in the International Poster Biennale in Warsaw, Poland was the first fruition and I was even honored to have my work housed in the collection of the Musée de la Publicité in Paris, France. After then, entering international competitions became a part of my creative pursuits, which has afforded me over 80 significant honors to date. I would like to use the phrase, "the craziest or coolest thing," to describe my being consistent 'as ever' for the past decade.

Q. *What are the things you want to do most these days? Have you started to set up new goals or breakthroughs for next period?*

A. No significant change is likely to occur in one or two years to come. Yet, let alone new goals, I have a goal as ever, which is 'to be As Ever.'

Q. *There are many industries are gradually being replaced or decline, what is your view on the future development of graphic design?*

A. Demands for digital poster will increase. I believe such demands are of new breed rather than being associated with the decline of conventional posters. If the interactive aspects of digital media is constantly integrated with posters, more possibilities will be ushered in. Digital posters are already utilized commercially, and the path to social/political posters or art posters is also open.

Q. *What is your insist on your life's details ? like toilet with your favorite poem?*

A. I think the phrase, 'did one's best,' should be used very carefully. I have never used the phrase in my life that I did my best.

Jin Jung

www.therewhere.com
therewhere@gmail.com

Jin Jung 是個平面設計師及在韓國首爾國民大學擔任教授，曾經也是國民大學的學生，研究視覺傳達設計，之後在耶魯大學完成平面設計的創作碩士。他已經收到來自 ADC 紐約藝術指導協會及 OUTPUT 荷蘭國際學生大賞、TDC 東京字體指導俱樂部的各獎項認證。

Jin Jung is a graphic designer and professor at Kookmin University, Seoul, where as a student he pursued studies in philosophy and visual communication design. He then completed an MFA at Yale in graphic design. He has received awards from ADC (Art Directors Club), OUTPUT and TDC (Tokyo Type Director's Club).

1. 舒適的溝通系列 (實驗性字體設計) *Comfortable Communication Series (Experimental Typography) / 2013*

2. *Haegue Yang, Shooting the Elephant, Thinking the Elephant* / 2015

3. 愛馬仕工作室系列海報 Poster Series for Atelier Hermes ∕ 2012-2015

4. 韓國國家歌劇院系列海報 Poster Series for National Theater Company of Korea ∕ 2011-2015

1 ∕ 這是為韓國字體年展所設計的實驗性字體作品。在各種通訊工具及媒介發展的過程，隨之而來的是缺乏溝通。此字體試圖表示訊息的意義以及透過瓦解字母內外空間跟線的結構，將可讀性降到最低。
This is an experimental typography work made for Korean Society of Typography Annual exhibition. In the process of evolution of various communication tools and media, there ensues lack of communication on the contrary. The typographic work tries to expresses the symbolic meaning of the message and tries to achieve the minimized readability by disintegrating structures of inner and the outer spaces and lines of the letters.

2 ∕ 書是為了 Haegue Yang 在 Leeum 三星藝術館的展覽所設計。書分成兩個部分，圖和文字。
Book design for exhibition art book of Haegue Yang at Leeum Art center. The Book is physically divided by two section, image and text.

3 ∕ 我從 2012 開始在韓國愛馬仕工作室工作，展示針對多樣字體設計識別。
I have been working for Atelier Hermes Korea since 2012 and it focus about multiple typographic identity system of exhibition.

4 ∕ 自 2011 年我開始在南韓國家歌劇院工作，包括形象識別跟宣傳設計，特別是海報設計。包括伊底帕斯、安提戈涅、馬克白、暴風雨、冠軍…等等。
I have been working for National Theater Company of Korea since 2011. It cover whole area of identity and promotional design stuff, specially poster design which include 'Oedipus', 'Antigone', 'Macbeth', 'The Tempest', 'The Champion', etc

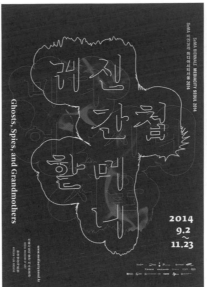

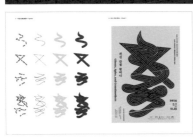

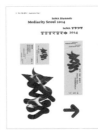

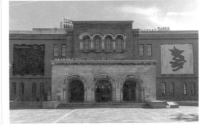

5.2014 首爾 Mediacity，鬼、間諜和祖母 *Mediacity Seoul 2014, Ghosts, Spies, and Grandmothers / 2014*

5 / 首爾 SEMA 雙年展 Mediacity 2014 年的視覺形象是創造和組合設計靈感來自各自的基本結構，關於 " 鬼 " ， " 間諜 " 和 " 奶奶 " 的主題，存在的禮儀或態度的形式。準確地說，鬼是由它的快速出現或移動表現，間諜使用尖銳的線條琢磨出背叛者的態度，而祖母象徵著時間及皺紋的累積。一旦這三種組合存在，我們可以從中探索到此次展覽主題最初的型態。此外這圖像是個現代化的護身符，一個結打開後鬆鬆的，線疊在線上。展覽期間，會以動態的形式播放識別作為圖像平台或指示符號。

The visual identity of SEMA Biennale Mediacity Seoul 2014 is about creating and combining basic structural lines inspired by respective traces, manners of existence, or forms of attitude regarding the themes of 'ghost', 'spy', and 'grandmother'. To be precise, the ghost is expressed by its swift appearance/movement; the spy, by sharp angled lines drawn as a traitor's attitude of betrayal; the grandmother symbolizes accumulation of time and wrinkles. Once these triple forms of existence are assembled, we can discover the archetypical shapes of the origin from this exhibition theme. Additionally, the assembled form looks like a modern talisman, with a knot becoming loose, thread by thread. This identity would be played in variations, as a platform embracing image, or indicative symbol mediating the artworks during the exhibition period.

6. 地板上的光影 *SUNSHINE ON THE FLOOR* / 2012

6／我曾被要求去參加一個字體的冠軍錦標賽，字體是 " Ahn sam youl"。 " Ahn sam youl" 的形狀也有點類似 Bodony，具有縱向和橫向筆畫間鮮明的對比，我想強調這一點。我將 " 光 " 的垂直及水平筆畫分離，然後把垂直比劃置於地板上，水平筆畫置於玻璃窗上。大約下午三、四點時，水瓶筆畫的陰影可以和垂直比劃對上，然而創造出一個完整的字。（作品於首爾 Thanks Books）。

I was asked to contribute a work to 'Title Match' which is a typography exhibition for 'Ahn sam youl' font. 'Ahn sam youl' font has a similar shape as Bodony which has vivid contrast between vertical and horizontal strokes. I wanted to emphasize the point. For this, I separated vertical stroke and horizontal line of single font 'sunshine', then put vertical stroke on the floor and horizontal line on the glass of a window. Around 3-4pm, shadow of the horizontal line could fit on the vertical stroke, so that created an entire letter. (Installation on the wall and floor at Thanks Books(Seoul))

Q. 請問您認為該國最棒的是什麼?(如國家的特色或文化等)您的創作是否受其影響?

A. 喧鬧聲。南韓是世界上成長最快速的國家之一,我們的生活完全沉浸著各個地方傳來的吵鬧聲。

Q. 請和我們分享您喜歡的書籍、音樂、電影或場所。

A. 岡薩雷斯。約翰·貝加《婚禮》、《看》。

Q. 請問您最近最想做什麼事情?是否已經著手規劃下一階段的目標或突破了呢?

A. 文字和圖像結構之間的關係。

Q. 目前有許多行業正在被取代或是沒落,請問您對於平面設計未來的發展有什麼看法?

A. 兩種方式,建立一個系統透過大量資訊、結構還有獨特的表達。

Q. 你對生活的細節上有什麼堅持嗎?(像是上廁所時一定要看詩集之類的)

A. 沒有。

Q.What is the best thing In your country? (likes features or culture) Have it ever influence your creation?

A. Noise. South Korea is one of fastest growing country of the world. Our life is fully immersed in noise which being in every area. Physically, and socially.

Q.Share good books/music/movies/places with us.

A. Gonzales, John Berger 'To the Wedding', 'About Looking'

Q.What are the things you want to do most these days? Have you started to set up new goals or breakthroughs for next period?

A.Relationship (or interpretation) between structure of text and image.

Q.There are many industries are gradually being replaced or decline, what is your view on the future development of graphic design?

A. Two ways. Building system through mega information and structure and unique way of expression.

Q.What is your insist on your life's details ? like toilet with your favorite poem?

A. I don't have.

澳門

Macau

●
●

洪家樂 *HONG, KA-LOK*

梁祖賢 *Joein Leong*

同點設計 *TODOT DESIGN*

黃鎮 *WONG, CHAN*

澳門 MACAU

洪家樂 HONG, KA-LOK

www.behance.net/hongkalokdaily
hongkalokdaily@gmail.com

九十後設計師，澳門出生。現於倫敦藝術大學修讀品牌設計碩士。近年作品多為當地傳統手工藝和文化創造分析型項目設計，透過檢視當今澳門本土文化的社會面貌，試圖用品牌設計的方式搜尋具有寶貴的文化傳承的設計解決方案。

其作品曾於華沙國際海報雙年展、Hiiibrand Award、the 8th Trnava Poster Triennial、GDC Graphic Design in China、 Kan Tai-Keung Design Award 等多個比賽中分別獲獎；作品亦曾輯錄於國際設計雜誌 IdN 並於中國、台灣、韓國、泰國、波蘭等多個地方展出。

A post-90s designer born in Macao. He is studying MA Graphic Branding and Identity at University Art of London.In recent, His design project often related to the analytical project for traditional handcrafts and culture. Through examines the value and significance of local culture in today's Macau on an everyday basis. He attempts to use the brand design approach to search the solutions in design that have a valuable cultural inheritance.

His design work had been awarded in the 24th International Poster Biennale in Warsaw, Hiiibrand Awards 2014, The 8th Trnava Poster Triennial, GDC Graphic Design in China, Kan Tai-Keung Design Award, also compiled in international magazine IdN v21n4, and also displayed in different exhibitions including China, Taiwan, South Korea, Thailand, Poland, and other places.

1. *DAY-TO-DAY DESIGN (Branding)* / 2013

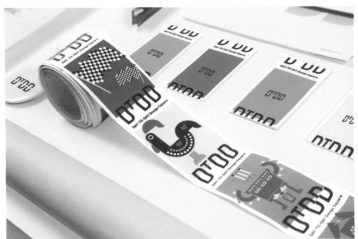

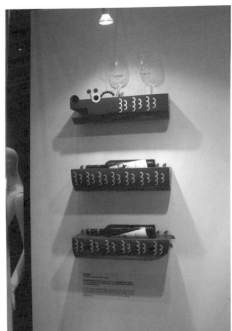

DAY-TO-DAY DESIGN throught strong local taste of life to let people note special macau culture. Use daily things with creativity mix together, to attract people to understand the story behind the design of products.

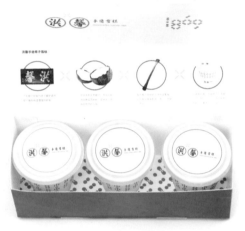

2. 洪馨椰子 1869　*Hong Heng coco 1869 (Brand Identity)　/ 2014*

TOUCHWOOD
We are blessed to catch a wood that tell us who and where you are. Touch Wood, you have the force that is say own knowledge.

MACAO
SEOUL

Touchwood
Macau design
design exhibition
in wood

2014

designed by
Hong Kai Lok

3. Touch Wood / 2014

1 /Day-To-Day 的目的是通過品牌設計，有效地改造澳門的歷史古蹟，以便使其能適應現代社會的需求。之所以創造這麼有趣的產品，就是為了提醒觀眾享受生活在這個美麗的城市的每一天，也幫他們瞭解古蹟的來歷。
Through branding design, the aim of "Day-To-Day" project is to transform Macau's historic heritage effectively so that it can fit in with modern society. Fun products have also been created to remind viewers of the enjoyment of life in this beautiful city and also to help them understand the stories behind it.

2 /洪馨椰子 1869 是一間過百年的澳門傳統老店，四代人的信念與傳承，充滿本土人情風貌的手造椰子雪糕店。透過品牌再造的方式，重新喚起傳統中小企在現今市場的價值，用視覺語言向大眾帶出品牌背後的故事與歷史價值。
Hong Heng coco 1869 is a traditional brand in Macau over hundred years. Four generations of belief and heritage, Local style and hand made coconut gelato shop. Through the rebranding project, we try to evoke her traditional value in current market, use visual language to bring out the story and historical value behind the brand.

3 / Touch Wood/2014

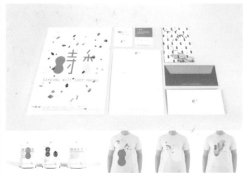

4. 時香花生瓜子 *Si Heung* / 2012

5. *B to D (Installation)* / 2014

4 / 時香花生瓜子是一所擁有五十年歷史的傳統店鋪。老闆堅持手造傳統的花生和瓜子，同時又不斷創新尋求味蕾上的突破，生產更多特色口味，便是這間小店的品牌價值。透過品牌再造的方式；歡樂、活躍的造字手法，重新帶出品牌的價值。

Si Heung is a 50 years traditional nut shop in Macau. Si Heung insisted handmade peanuts and seeds, but also to seek a breakthrough innovation on the taste buds, producing more characteristic taste. We try to bring out the brand value through rebranding way, joy coinage and active approach.

5 /B to D 是跟澳門新中央圖書館—『閱讀．好設計』展覽所合作的一個裝置設計。作品透過 Book to Design 這個簡單的出發點，思考閱讀是怎樣一回事，並把這種自身對閱讀的理解轉化成句子再延伸到設計上。

" 每個人的閱讀都是獨一無二。於我來說，閱讀輕鬆而愉快；就像每個晚上，選好舞伴，點起燭光跳舞。待空氣中瀰漫著恰到的色彩，沙沙的落下鋼針，築起了蹦蹦之處；在內心奏起旋律，哼著哼著起舞。書本是你夜裡的舞伴，互相凝視，摟著身軀，轉換舞姿；直至音樂停止，竟不知疲倦。"

B to D is a installation design with New Central Library of Macau. Cooperation with the exhibition "Reading x Good Design". Through the simple concept from Book to Design, redefine the own idea of reading then convert it into sentences and develop to design artwork.

Q. 請問您認為該國最棒的是什麼？(如國家的特色或文化等) 您的創作是否受其影響？

A、中國五千年歷史所孕育的文化、故事、民族特色、哲學思想, 是我認為最棒的事。對一直受西方設計教育影響卻身為亞洲設計師的我, 這些資源就如豐富的靈感燃料, 不斷使我在創作路上走得更遠。

Q. 請和我們分享您喜歡的書籍、音樂、電影或場所。

A. 雜誌：Design 360°、IDEA、IdN、Monocle、It's nice that、Eye magazine
音樂：電台司令、酷玩樂團、魔力紅、Portishead、Jamie XX、Russian Red、恭碩良、岑寧兒、盧凱彤、擁抱人群樂團
電影：楚門的世界、全面進化、蘿拉快跑

Q. 請問您做過最瘋狂或最酷的事情是什麼呢？

A. 最近做過最酷的事便是駕小型飛機在天空中漫遊, 那種自由的感覺無法言語。

Q. 請問您最近最想做什麼事情？是否已經著手規劃下一階段的目標或突破了呢？

A. 沒有太認真想過甚麼階段性目標, 但現階段還處於每天都有所獲有所想, 鬥志滿滿的狀態。

Q. 目前有許多行業正在被取代或是沒落, 請問您對於平面設計未來的發展有什麼看法？

A. 現今媒體越來越多, 單單用平面設計師這個詞已經很難清楚地描述工作範圍了。大概未來 " 平面設計 " 會發展成更全面的 " 傳播設計 " 吧。

Q. 你對生活的細節上有什麼堅持嗎？(像是上廁所時一定要看詩集之類的)

A. 1. 多晚睡也早起 2. 不自覺把東西排好 3. 新項目進行前一定要收拾好工作間。

Q. What is the best thing In your country? (likes features or culture) Have it ever influence your creation?

A. Five thousand years Chinese history gave birth to the culture, stories, national features and philosophy. Those are definitely the most greatest thing for me as a designer who have been influencing by the western design education but being an Asian. All the resources, language and knowledge such as fuel, inspired me and continuously rich my design go further and depth in the way.

Q. Share good books/music/movies/places with us.

A. Reading: Design 360° Magazine、IDEA magazine、IdN, Monocle、 It's nice that、 Eye magazine

Listening: Radiohead、Coldplay、Maroon5、Portishead、Jamie XX、Russian Red、Jun Kung、Yoyo Sham、Ellen Loo、Foster the People
Watching: The Truman Show、Transcendence、Run Lola Run

Q. What is the craziest or coolest thing you have ever done?

A. Recently did the coolest thing is driving small plane roaming in the sky, the feeling of freedom words can not express.

Q. What are the things you want to do most these days? Have you started to set up new goals or breakthroughs for next period?

A. Most want to graduate and then to continue my career. I do not thinking about what goals seriously, but still be in harvested and thought and fighting everyday.

Q. There are many industries are gradually being replaced or decline, what is your view on the future development of graphic design?

A. Nowadays more and more media, using the word of graphic designers alone has been difficult to clearly describe the scope of work. Near future, maybe "Graphic Design" will develop into a more comprehensive "communication design".

Q. What is your insist on your life's details ? like toilet with your favorite poem?

A. 1. No matter how late get to sleep, still get up early. 2. Things lined up unconsciously. 3. Before the new project ,studio must be cleaned.

澳門 Macau

梁祖賢　Joein Leong

www.facebook.com/joeinleong

畢業於澳門理工學院綜合設計，以錄像及攝影為
主要創作媒介，自 2008 年起參加多個設計、錄
像及藝術展覽。現於澳門特別行政區文化局文化
創意產業促進廳擔任設計師。

曾獲 " 第七屆澳門設計雙年展 " 學生組書籍設計
金獎及優秀新人獎；畢業作品《我》參展 " 第五
屆華語青年影像論壇 " 並於北京公開放映。

Graduated in Macao Polytechnic
Institute (Arts & Design), with video and
photography as her main creative media.
She has taken part in different video
and photography exhibitions since 2008,
and now she works at the Cultural Affairs
Bureau of Macao SAR with her specialty in
art and design.

She won the Gold Award of Book Design
(Student Category) and the Best New
Comer in the 7th Macao Design Biennial.
Her graduation work "I AM" was screened
in Beijing during the 5th Chinese Young
Generation Film Forum.

1. 玩黏土 CLAY / 2013

電影長片
製作
支援計劃

//Support Programme for the Production of Feature Films

program de subsídios à criação

2013

澳門文化創意產業系列補助計劃
Série de Programas de Subsídios para as Indústrias Culturais e Criativas de Macau
Subsidy Programme Series for Macao's Cultural and Creative Industries

www.icm.gov.mo 澳門特別行政區政府文化局
INSTITUTO CULTURAL do Governo da R.A.E. de Macau

cau

2. 花紙 WRAPPING - NEWS PAPER / 2014

1 / 此海報是為澳門特別行政區文化局宣傳文化創意產業系列補助計劃而製作的，計劃目的是扶持及培養澳門文化創意產業人才，藉此鼓勵創意，2013 系列產補助的項目有時裝及電影。
以創意為核心構想，訂定海報以符合大眾對時裝及電影的印象作基本要求。故此，我想起了兒時的玩具 - 黏土。它柔軟且可塑性高，玩的時候很自由，有種能不斷重塑的特性。以黏土為載體，寓意創意的天馬行空及變化萬千。
In 2013, Cultural Affairs Bureau of the Macao S.A.R. Government introduced the "Subsidy Program Series for Macao's Cultural and Creative Industries", with the objective to foster potential local talents in the cultural and creative industries.
Creativity as the cord direction, yet the visual could not go too far from the target audiences. In order to balance such constricts while to catch the eye-balls, I recalled one toy in my childhood, "clay" pops up in my head and became the themed elements on my creation, for its unique features: soft, playful, flexibly reshaped and plasticity.

3. 分解常規 NORM FREE / 2014

2 / 每天經過書報攤，報紙頭版上的大標題往往印在腦海裡：2014 年 5 月 20 日 " 星期二 超市豬肉平過街市 "、2014 年 6 月 3 日 " 星期二街市活雞半日沽清 "、2014 年 7 月 21 日 " 星期一衛生局籲滅蚊防登革熱 "。這些可笑的報導編排在報紙上最重要的位置，那份報紙就像花紙一樣，花紋並不重要，它的存在只是為了修飾，花紙包裹禮物是約定俗成的事，而那份報紙便是成就和諧社會，修飾城市日常美麗奪目的花紙。

20 May 2014 (Tuesday) "Fresh & Cheap pork give-away", 3 June 2014 (Tuesday) "Live chickens sold out in 4 hours", 21 July 2014 (Monday) "Board of Health called the Mosquito Control Campaign to prevent Dengue Fever"...... These funny wacky headlines on newspaper bothered me while I found them quite inspiring! I wondered the value of newspaper has no difference to wrapping paper, which role is to modify truth by the pattern it is carrying. In the end, newspaper becomes the wrapping tool to achieve social harmony.

3 / 在社會制度下，所有事情都有著既定的道德規範，生活形式形式、方方正正，我們如何能跳出框框而不失優雅？活得自在？

The underlying social norms contribute in our code of ethics, these unwritten rules implies the right form or models of living. Under the constraints scenario, how could we possibly live at ease and free?

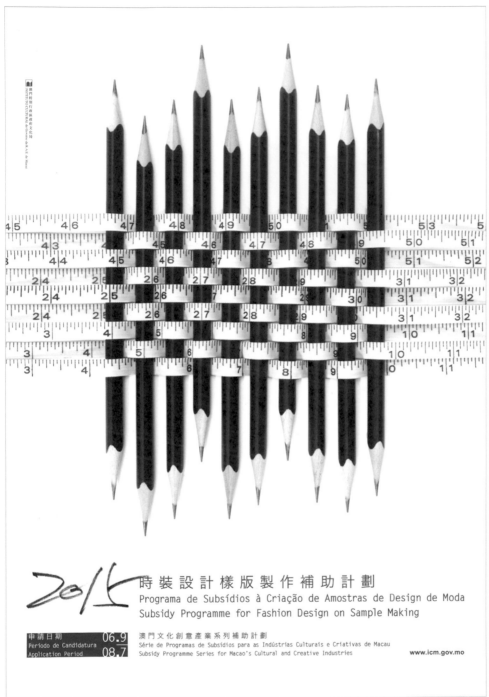

4. 織織復織織 *Knitting* / 2015

4 / 藝術家揮動鉛筆記下靈感時，感覺粗糙狂野，想像遠無邊際；配合裁縫師的身份標誌 "軟尺"，清晰及具象地模仿編織紋路，讓大眾明快地捉緊海報主題。同樣是文化創意產業系列補助計劃的海報，目的為扶持及培養澳門文化創意產業人才。
Wielding pencils to note down the inspirations creates a sense of coarse and wild, imagination across infinity. "Soft ruler", a symbolic tool from tailors was also applied, which merged the "pencil" cleverly in the visual. The knitting fusion deepened people's impression of fashion.
The Subsidy campaign was launched by Cultural Affairs Bureau of the Macao S.A.R. Government, with the objective to sustain potential local talents in the cultural and creative units in a long run.

Q. 請問您認為該國最棒的是什麼?(如國家的特色或文化等)您的創作是否受其影響?

A. 我覺得影響最深就是兒時校園的觀感,園內有兩個建築最為獨特。其一是在中、小學操場的分隔處聳立著一座三角形的白色建築,三角形的三個立面中,一面為以落地玻璃設計,作為底層圖書館的採光處及入口;另一面是數十級樓梯登上角樓小教堂,感覺像要走上天堂跟天主接觸一樣(本人並無任何宗教信仰)。

另外一個建築是個架空的八角亭,作用是教職員室,教職員室出入口連接著教學大樓,為何設計師要特別把教職員室置外?我到今天還搞不懂,但那個灰黃高高的八角亭令人印象深刻,那個黃磚灰水泥跟格子厚玻璃磚是多麼的恰襯!最後就是堪稱全澳門最漂亮的校服,夏天是清爽的藍色格子水手裝,冬天是沉穩深綠格子西裝空姐裝。這些生活上的事物時時刻刻都在發揮作用。

Q. 請和我們分享您喜歡的書籍、音樂、電影或場所。

A. 生活每個片刻都需要不同的養份,值得分享的電影太多所以不說了。對於設計相關書籍我買的很多反而看的極少,最常閱讀的是喬治·歐威爾《1984》和《動物農莊》,閱讀此書讓我覺得今天的世界也不算太可怕,我們還是有自由能夠呼吸和生活的。音樂方面推薦 Pink Floyd 的《The Dark Side of the Moon》聽著聽著就會呼口氣有釋懷感,而需要溫暖的時候我會聽張懸。

Q. 請問您做過最瘋狂或最酷的事情是什麼呢?

A. 決定養貓。很開心也很殺時間,我本來已經很宅,現在更加不想外出啦。

Q. 請問您最近最想做什麼事情?是否已經著手規劃下一階段的目標或突破了呢?

A. 我天天都想增肥 XD。創作方面想要做一些和感覺相關的實驗錄像或海報,是去年參加香港亞洲實驗錄像節的延伸,現在首要的是每天打開感覺細胞踏實過活。

Q. 目前有許多行業正在被取代或是沒落,請問您對於平面設計未來的發展有什麼看法?

A. 印刷業漸漸息微,沒人再需要買書買唱片的說法已經好幾年了,可是商品過度包裝、宣傳品、請柬、場刊等印刷物還是愈做愈多,多得令人髮指,有時候我會期待印刷業不那麼發達昌盛,大家能夠以很珍惜資源和印刷機會的心態去做設計。再者即使印刷業真的要息微,人們轉向電子媒介觀看,也都是需要平面設計的,然而好像每個時代都會有某種風格的趨向,設計師如何從上班下班中不斷創新以及尋找新的美學平衡,就要大家一起努力了。

Q. 你對生活的細節上有什麼堅持嗎?(像是上廁所時一定要看詩集之類的)

A. 喝檸檬茶的時候要把檸檬一同吃掉。

Q. What is the best thing In your country? (likes features or culture) Have it ever influence your creation?

A. It has to trace back to my childhood, I was so inspired by the architectural features of my school, especially its triangular white building with transparent glass on one side, while another side is the staircases to the mini church, felt like it is the tunnel to god and heaven. (Btw, I do not have any religious preferences).

Another part in my school amazed me the most should be the octagonal pavilion - built above the ground, iron racks as its foundation and support, printed in yellow and grey, checkered patterns. All these things concreted and meant a lot in my memory. Last but not the least, how could I possibly miss the best school uniform in Macau! Blue plaid sailor in summer, dark green plaid in winter. See, every tiny thing in my everyday life meant a lot to me.

Q. Share good books/music/movies/places with us.

A. Reaching each different moment in a life, nutrient in inspiration varies. There are too many movie on my sharing list, so let's skip this. Literally, I rarely read design reference book, but two novels written by George Orwell "1984" and "The Animal Farm". I am thankful after reading them, at least we are free to breathe and live, the world is not that horrible. For music, I recommend Pink Floyd "The Dark Side of the Moon", cause I feel so much relieved after listening to this album, a kind of meditation, and whenever I need warmth, Deserts Xuan will be on my playlist.

Q. What is the craziest or coolest thing you have ever done?

A. To adapt a cat is the happiest thing to me, well of course it is very much time consuming! Basically I am a homely kind, and now I am even more homely than I was since having it.

Q. What are the things you want to do most these days? Have you started to set up new goals or breakthroughs for next period?

A. I participated in Hong Kong Asia Experimental Movie Festival last year, I want to further extent my sensory related creativity into experimental video filming or visual design. So, first of all, I have to let myself feel and experience what live gives me.

Q. There are many industries are gradually being replaced or decline, what is your view on the future development of graphic design?

A. Printing industry gradually declines, there's been several years people saying that, "no one will buy any books or CDs". However, commodities, promotion material, invitation cards or booklet brochures are mass and over produced, which is infuriating and horrendous. Somehow, I would pray that the printing industry is less prosperous, so that people could work hard on their design / art works, cherish resources and the chance for being published. And yet, even it the industry declines, the pattern will change to the digital channel or another channel that fits the trend. Back to the point, how could the designers reach the harmony of "innovating idea" and "aesthetics", well, let's work hard together!

Q. What is your insist on your life's details ? like toilet with your favorite poem?

A. I will insist to eat all lemon slices when I am having the lemon tea.

TODOT DESIGN

澳門 Macau

同點設計 TODOT DESIGN

www.todotdesign.com
www.behance.net/todotdesign

bob@todotdesign.com

本公司理念由點出發：聚點成線，聚線成面，面
移動形成空間，加上動向則成形態。萬象皆由點
生成；本公司理念是將萬象回歸基本，把握好原
始點，透過不同的嘗試建構出不一樣的線與面，
呈現不一樣的設計。

Todot Design Co., Ltd. was founded on
the belief that everything starts with a dot:
dots form a line, lines form the surface,
movements of the surface form a space,
with different trends and elements, we
have different things in different shapes.
Our philosophy is to have everything back
to its origin, to design which in a better
way from the start of the original dot.

1. 市民專場 / 2014

2. 奴 SLAVE / 2013

3. 格子爬格子 *PUZZLE THE PUZZLE* / 2014

4. 第一稿 *The first draft* / 2013

5. 水是生命 *Water is life* / 2009

1／以（2015）為主題，用豐富的顏色和不同的幾何圖案互相組合，形成規則的格局，藉以吸引觀眾的眼球。
In (2015) as the theme, with rich colors and different geometric patterns are combined together to form a regular pattern, in order to attract the audience's attention.

2／人類成為金錢的奴隸。
Human become a slave to money.

6. 心亂疑城 CITY MAZE / 2014

3 / 微小而強大——獻給在各領域努力創造的每個人。一位詩人的創作過程，從書本出發，找到與自己性靈相契合的文哲大師。這是一個以書店或圖書館作為演出場所的微型環境劇場演出，由旅居澳門的台灣劇場導演蔣禎耘於 2005 年創作，於澳門「邊度有書」首次發表，及後於香港、波蘭、台灣、韓國春川、英國愛丁堡、北京、廣州及韓國首爾的書店及另類空間中演出了 48 場。2007 年更獲提名台灣「台新藝術獎」的年度十大優秀作品。戲中的真人演員搭配書、芭比鞋、小木偶等微小物件偶的聯合演出，加上西班牙音樂家 Victor Garnier 的原創的劇場音樂，意想不到的多媒體影像等豐富的元素。作品是獻給在各領域努力創造的每個人。

Small but Powerful - Dedicate to creators from all areas The story describes the mind map of a poet when he creates his poem in the corner of his room… a great work would burst soon in this night… This is a miniature object and movement site-specific theatre, featuring in bookshops or library. It was created by Macao-based Taiwanese theatre director Hope Chiang and firstly launched at "Pinto-livros"in Macau. After that, it has been performed in bookshops or alternative space of Macau, Hong Kong, Poland, Taipei, Chunchon, Edinburgh, Beijing, Guangzhou, Seoul for 48 sessions and was nominated to the 6th Annual Taishin Arts Awards of Taiwan in 2007. This stunning work describes the mind map of a poet in the midst of his work and on a journey through discovery and creation. The two performers, poet and his soul, to play with books, barbie shoes, little puppet … along with the background music which was composed by the Spanish musician Victor Garnier and the exciting multi-media elements, to bring the audience into the world of imagination. This play is dedicated to creators from all areas.

7. 国 *COUNTRY* / *2013*

4 / 這活動是一個以本地詩人的自身感覺來朗讀其他詩人的作品，讓觀眾能感受不同的情感。
This activity is a local poet's own feelings to read other poets, so the audience can feel the different emotions.

5/ 水龍頭流出的，不只是水，更是生命。當滴盡了大自然的最後一滴水，世界也就走到了盡頭。
What runs out from the tap is not just water, but substance of life. When it comes to the last drop of water, it comes to the end.

6/澳門堂口故事3是澳門本地的電影，項目要求是要為電影設計主畫面海報及宣傳物。電影當中的所有情節都發生在澳門的大街小巷裡，更結合了人性背後的種種社會問題。
This is a combination of suspense and thriller that promote a more intriguing film of Macau.

7 / 男人的臉被 " 国 " 所覆蓋到，說不到，嗅不到，但他不害怕，因他深信他所信的。男人可以被蒙眼睛，被掩耳朵，被封嘴巴，但從不畏懼，只因心中信念從不動搖。

The face of the man is covered by the Chinese character " 国 ", which means "Country" in Chinese. Although the man's eyes, ears, and mouth are covered all. Never our hearts as we Chinese have faith and truth in ourselves to believe.

Q. 請問您認為該國最棒的是什麼 ?(如國家的特色或文化等) 您的創作是否受其影響 ?

A. 美食和顏色。

Q. 請和我們分享您喜歡的書籍、音樂、電影或場所。

A. 我愛我的工作室。

Q. 請問您做過最瘋狂或最酷的事情是什麼呢 ?

A. 跑了 20 公里。

Q. 請問您最近最想做什麼事情 ? 是否已經著手規劃下一階段的目標或突破了呢 ?

A. 救回公司的植物。

Q. 目前有許多行業正在被取代或是沒落，請問您對於平面設計未來的發展有什麼看法 ?

A. 時常改變, 改變是好的。

Q. 你對生活的細節上有什麼堅持嗎 ?(像是上廁所時一定要看詩集之類的)

A. 當我吃薯條時, 不可以加蕃茄醬。

Q.What is the best thing In your country? (likes features or culture) Have it ever influence your creation?

A. Food and color.

Q.Share good books/music/movies/places with us.

A. I love my studio.

Q.What is the craziest or coolest thing you have ever done?

A. I had run 20 kilometers.

Q.What are the things you want to do most these days? Have you started to set up new goals or breakthroughs for next period?

A. Save my studio's plants.

Q.There are many industries are gradually being replaced or decline, what is your view on the future development of graphic design?

A. Often to change, change is good

Q.What is your insist on your life's details ? like toilet with your favorite poem?

A. When I eat french fries, can not add ketchup.

黃鎮 WONG, CHAN

dim4design@gmail.com

澳門平面設計師；
喜歡遊走於藝術與設計之間，並非在不斷變化中
尋找突破，而是希望在變化中尋找快樂。
作品先後於德黑蘭、莫斯科、保加利亞、日本、
烏克蘭、墨西哥、捷克、玻利維亞及義大利等地
區的國際設計比賽中獲得專業認可。

Macau graphic designer;

Roaming through art and design, felling the continue change is not for seeking a breakthrough, but the change is for finding happiness .

Work has received professional recognition in Tehran, Moscow, Bulgaria, Japan, Ukraine, Mexico, the Czech Republic, Bolivia, Italy and other places of international design competitions.

1. 澳門默劇節 *Macau Mime Festival* / 2013

2. 音樂封面 *Music Cover* / 2013-2015

CTA

3. 二十九屆國際音樂節 *29th International Music Festival* / *2014*

125

4. 實驗書籍：水中智慧 *Experiment books : Water Wisdom* / 2013

1 / （自由主題創作） 在痛苦中尋找美，美與痛苦的相擁。
(Free theme creation) Find beauty in pain,Beauty and painful embrace.

2 / 在播放不同音樂類型的情況下進行創作
Creation in the case of playing different types of music.

3 / 音樂盛宴
Music Feast

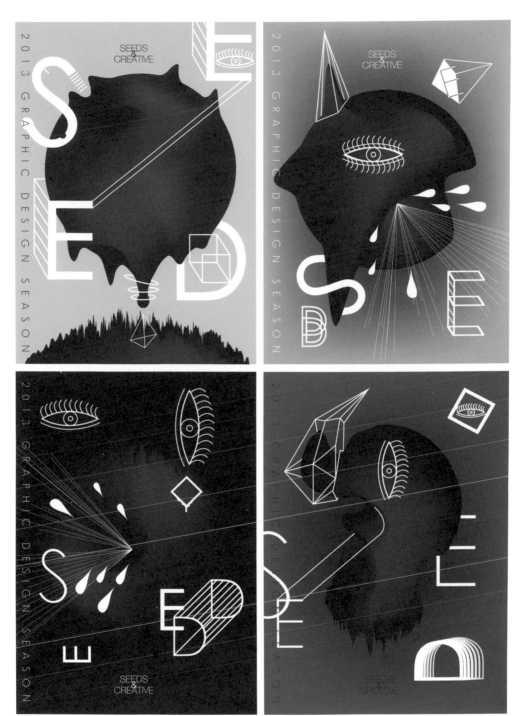

5. 2013 Graphic Design Season (A series of 4 works)　/ 2012

4 / 孔子曰：智者樂水
老子曰：上善若水
禪語曰：善心如水
Water Wisdom.

5 / 種子與創意
Seeds and creative

6. 實驗字體 *Experimental Typography* / 2015

6 / 畫面創造了文字，文字又創造了畫面
Meaning behind the words.

Q. 請問您認為該國最棒的是什麼？(如國家的特色或文化等) 您的創作是否受其影響？

A. 澳門最吸引的當然是中葡歷史文化, 然而這也衍生了一些設計師在藝術設計方面有著出色的表現。

Q. 請和我們分享您喜歡的書籍、音樂、電影或場所。

A.《北島詩歌》

Q. 請問您做過最瘋狂或最酷的事情是什麼呢？

A. 最瘋狂的事:還未死,還在做設計...

Q. 請問您最近最想做什麼事情？是否已經著手規劃下一階段的目標或突破了呢？

A. 最近想泡好一壺茶, 茶文化與設計有著密切的關係, 所以想深入探討中國茶道文化。

Q. 目前有許多行業正在被取代或是沒落, 請問您對於平面設計未來的發展有什麼看法？

A. 持續性是一切問題的答案

Q. 你對生活的細節上有什麼堅持嗎？(像是上廁所時一定要看詩集之類的)

A. 一天最少放空半小時 .

Q.What is the best thing In your country? (likes features or culture) Have it ever influence your creation?

A. The most attractive thing in Macau is mix-culture between Chinese and Portuguese.

This special culture inspires many Macau designers to create the outstanding artwork full of unique style.

Q.Share good books/music/movies/places with us.

A. Beidao's poem

Q.What is the craziest or coolest thing you have ever done?

A. The craziest thing: not dead yet, still playing design.

Q.What are the things you want to do most these days? Have you started to set up new goals or breakthroughs for next period?

A. Recently I want to make a pot of good tea. Since tea culture is related to design, I want to explore the Chinese culture deeply.

Q.There are many industries are gradually being replaced or decline, what is your view on the future development of graphic design?

A. keep going is the answer to all problems

Q.What is your insist on your life's details ? like toilet with your favorite poem?

A. One day at least half an hour of meditation.

馬
來
西
亞

Malaysia

●
●

Jay Lim (椿之工作室 *TSUBAKI)*

葉永楠 *YAP, WENG-NAM*

Jay Lim　TSUBAKI　椿之工作室

www.tsubakistudio.net
info@tsubakistudio.net

Jay 在 2004 踏入這個創意設計行業之前，他曾經在娛樂行業，設計公司和廣告公司裡上班。因為他的天賦和精湛的技巧，常有知名品牌公司誠聘 Jay 為其設計商品。

2008 年，他與他一生的伙伴兼太太 - Vivian Toh，一起設置了他們第一個設計公司－TSUBAKI。在這些年裡，Jay 率領著一眾成員努力下，成功獲得超過 50 個國內外與本地媒體的採訪以及作品刊登在著名的雜誌。

在設計公司的鼓舞下，Jay 在 2010 年創辦了馬來西亞首屈一指的設計雜誌－卡奧設計雜誌 (CUTOUT Magazine)。該雜誌目前仍持續出版以及深深影響了現今的創意行業與風氣。

在 2010 年同年內 Jay 被齊藤學院聘請為聘任客座講師，他也曾兩次受邀到台北 LOWPOSE 角色設計大會以及高雄設計節 2011 擔任國際講師。隨後，Jay 二度赴台灣高雄文藻外語學院大學擔任主講嘉賓。

2013 年，Jay 加盟到 KBU 國際學院大學擔任英國諾丁漢特倫特大學的客座講師。同年六月，一名來自馬來西亞的知名設計大師提名他為下 ANTALIS 102030 的年輕創意設計師之一。

2014 年 3 月，他被台南崑山科技大學所邀請擔任客座教授進行為期兩個星期的設計指導課程，在同年的五月裡他也被邀請到高雄青春設計節擔任國際評審以及講師，十二月也被馬玉山邀請擔任國際藝術家為策展製作以及到達高雄樹德科技大學演講以及卡奧設計雜誌代表馬來西亞勇奪 2014 台灣金點設計年度最佳獎。

在新的一年 2015，台灣設計中心選為 Jay 為 2015 亞洲創意設計類新銳設計師。第二次的也被高雄文化局特邀擔任青春設計節的評審，同星期裡也被樹德科技大學邀請擔任國際論壇的講師。最近，他摘下視覺傳達：德國紅點設計獎 2015。

Jay's early foundation in the design industry saw a repertoire of experiences in the entertainment industry, design houses and advertising agencies. His talents and craftsmanship were developed handling campaigns for Mercedes Benz, U Mobile, Abbott, Wyeth, GSK, Sony Malaysia, TV3, Unilever and SP Setia. In 2008, his entrepreneurial instincts drove him into setting up TSUBAKI with his lifetime partner Vivian Toh – garnering numerous recognitions both abroad and locally; received interviews and had works featured in Choi Gallery Shanghai, Hitone GuangZhou, DESIGN Taiwan, Sendpoint Publication, Sandu GuangZhou, The Pepin Press, Babyboss Indonesia, TOUCH Shanghai, Ish Singapore, Idea Design Taiwan and BBC Noise Australia.

That led Jay to the creation and publication of CUTOUT in 2010, Malaysia's premier design magazine. CUTOUT continues its publication and influence in the industry today. 2010 also marks the year Jay forayed into lecturing at Saito College and was invited twice to the International LOWPOSE Character Design Conference in Taipei (2011, 2012). Kaohsiung Design Festival 2011 saw him representing Malaysia as speaker. Subsequently, Jay went to Taiwan again as a guest speaker twice, to the Wenzao Ursuline University in the Kaohsiung district.

In 2012, Jay joined KBU international College as guest lecturer taking on the challenge in lecturing to Bachelor Degree students from Nottingham Trent University, UK. In June that same year, he was nominated as one of the creative young guns under the ANTALIS 102030 programme.

2014, He was hired as associate professor in Kun Shan University, Taiwan for 2 weeks workshop lecturing, also invited as international judge and speaker in Youth Innovation Design Festival 2014 in Kaohsiung. End of the year 2014, he won his first international award - Best Design Award in Golden Pin Design Award 2014.

In the new year of 2015, he nominated by Taiwan Design Center as young Asian Rising Star in 7 countries of Asia under age 35, he had a week long of exhibition in Taiwan Creative Expo 2015. Just recently he invited twice again as design judge and speaker at Youth Innovative Festival 2015. At the same period of time, he also invited as international speaker in New Media Design Forum in SHUTE University in Kaohsiung. Just recently, he won Red Dot Award 2015: Communication Design, Germany.

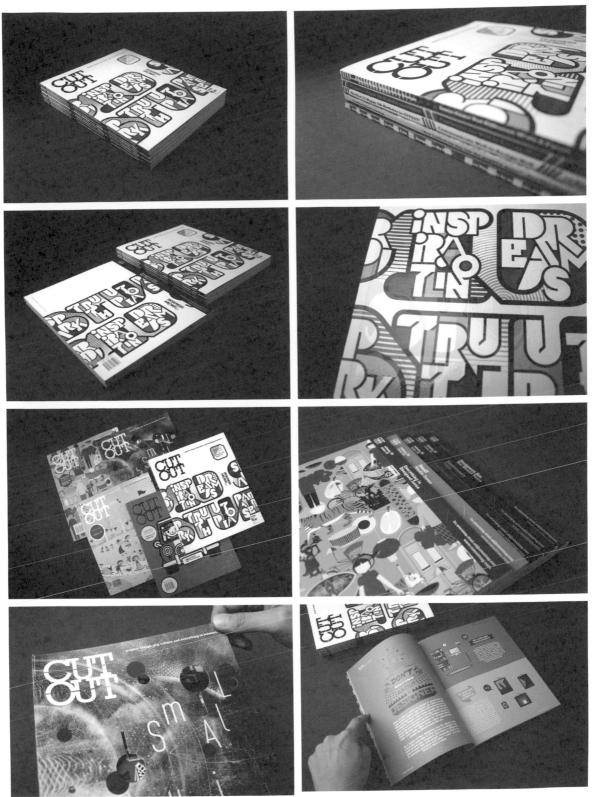

1. 卡奧設計雜誌：民權運動 CUTOUT Magazine / 2015

2. 年曆書 ANTALIS Planner *ANTALIS / 2014*

1 /CUTOUT 設計雜誌除了針對其內容的設計，也詳細地考慮到雜誌包裝設計的重要性與可行性。雜誌的封面是一本書直接的賣點，CUTOUT 執著於高水平的封面設計並讓一些聞名於藝術或設計界的藝術家參與設計新奇與別具一格的雜誌封面，除了雜誌封面，每一期的雜誌內容也依照讀者的需求量身打造。現今社會的讀者對閱讀的習慣也漸漸地淡忘，要追求著視覺上的方便，但也希望有知識的洗禮，因此 CUTOUT 更運用了這一點，創作不同系列的信息圖表 (infographic) 以方便讀者閱讀。除此之外，在考慮到雜誌包裝的可行性，CUTOUT 也考量了馬來西亞信箱的特點，那就是「小」。因此，CUTOUT 經過不斷的實驗，終於成功地把雜誌的大小改良成既實用又方便的一本設計雜誌。在與大家一同努力之下，CUTOUT 不知不覺中在馬來西亞已成為首屈一指的設計雜誌。

CUTOUT is a leading graphic design magazine in Malaysia with a dominant position in print media, online–24,000 Facebook followers to date, and most recently on the airwaves. Poised to be a thought leader in the field of design, CUTOUT is known for recognizing the influence of designers in the economy and society more broadly. Since January 2010, the magazine has been building a presence in the local and regional market through event tie-ups, road shows, and talks at universities and colleges. CUTOUT is targeted at students, academics, designers, art lovers, and creative people. The magazine aims to educate, inform, and inspire designers to be creative thinkers through designers' showcases, tips, features, and interviews. These articles sit comfortably alongside contributions mostly from the people that make up the design industry in Malaysia and beyond.

3. PAGENUMBER / 2013

2 / 身為擁有共同喜好的創意團隊，Antalis Malaysia 與 Tsubaki 合作推出四款別具創意的 2014 年的手帳來打動你的心，並且讓每個人知道只要使用一點創意與創新，人生會變得截然不同。最重要的是，它使用各種特殊的紙料與精美的塗裝印刷成冊。
In our shared interest as a creative entity, the collaboration between Antalis Malaysia & Tsubaki have introduced four great ideas in this 2014 weekly planner - to start getting you inspired and letting everyone know that it just take a little bit of creativity & innovative to see life in a whole new different way. Above all, it is printed on various special paper with a great finishing.

3 / Pagenumber 想成為現今視覺傳達發展的中心，同時，它對於設計產業的培育這一塊占有一席之地，有點像是大師級視覺傳達設計師們的盛典，還有期待著於新銳設計師滿懷雄心壯志在這場競賽中力爭上游。某種意義上，我們想重溫那些舊時的好設計帶來的感動，精彩又令人難以忘記。
Pagenumber 的設計強調大量的圖像與少量的文字，因為我們想要讓讀者驚嘆那些存在於每一頁作品中，設計師們的精神。我們也可以將 Pagenumber 本身視為藝術作品，替世界各地設計師搭起橋樑。
Pagenumber wants to be the portrait for visual communications taking place at the heart of now. At the same time, it stands for something significant in the upbringing of the design industry. It is some kind of celebration of the great and almighty visual communicators. It is also a much-anticipated scenario where the upcoming and ambitious visual communicators set their foot forward in the league.
In every sense, we want to relive those moments where good design is so inspiring, so fascinating and so hard to forget.
In Pagenumber, the source of design is depicted in pictures and takes up very minimal space for words because we want to leave our readers awe-inspired by the soul that lives in the works of each artist featured on every page. We also see PageNumber as a work of art, produced and built through a supportive network of designers from around the world.

4. 染紅媒體坊 *Red Velvet Media Lab* / 2015

4 / 染紅媒體坊是建立在一個簡單的信念，激情孕育創造力以及新穎性。為了不被誤認是因為它的名字是來自染紅蛋糕，它其實本身是象徵著一個甜點的標誌性，在顏色如紅色象徵著熱情與經驗。染紅的價值觀就像蛋糕上的奶油—意味著公司會盡力在製造高標準的服務讓客戶滿意。染紅媒體坊殊榮地擔任著獨立設計雜誌出版商—CUTOUT。相對於說"熟悉的內容與品種"，在出版業 5 年裡染紅媒體坊大膽地踏出行內的一大步，讓 CUTOUT 再重新定位馬來西亞設計行業的野心。RED VELVET RV Media Lab 建立在一個簡單的信念之上，用熱情孕育出創造力，創新則是副產品。不要因為它的名字就誤以為這是那個指標性的甜點——紅色天鵝絨蛋糕，這款甜點的特色就是熱情的紅色以及鮮奶油。而 Red Velvet 的價值就像是蛋糕上的裝飾，一間好的公司成功的地方不是遵守達成客戶的要求，而是達到正確的結果。RED VELVET 以前的名字是 The Kraft Store，它是得獎無數的獨立設計雜誌 CUTOUT 的出版商，五年的印刷經驗使 Red Velvet 因為透過 CUTOUT 重新定義了平面設計行業而廣為人知。

RED VELVET RV Media Lab is founded on a simple belief that passion breeds creativity, and novelty is the by-product. Not to be mistaken for a cake because of its name, Red Velvet holds an iconic resemblance to the dessert, represented in colours such as red for zeal and cream for experience. Red Velvet's values are like toppings on the cake - the company does its best not in conforming to standard client requests, but in complementing the duty with the right deliverables. Formerly known as The Kraft Store, Red Velvet is the publisher of the award-winning independent design magazine, CUTOUT. As opposed to the saying "content breeds familiarity", five years in the publishing business and counting makes Red Velvet an enterprise known for taking a bold step to redefine the graphic design industry through CUTOUT.

Q. 請問您認為該國最棒的是什麼？(如國家的特色或文化等) 您的創作是否受其影響？

A. 三大種族—華人、馬來人以及印度人。

這國家充滿了不同的文化與色彩。

是的, 在加入多元的文化與生活習慣後, 設計也變得更精采。

Q. 請和我們分享您喜歡的書籍、音樂、電影或場所。

A.GQ Magazine / 陳百強精選集 / 復仇者聯盟 1&2 / Goh Peng (Perak)

Q. 請問您做過最瘋狂或最酷的事情是什麼呢？

A. 告白。我在網路認識了 Vivian, 她現在是我的老婆。

Q. 請問您最近最想做什麼事情？是否已經著手規劃下一階段的目標或突破了呢？

A. 家具設計, 我想製造一張椅子。

是的, 我正在與幾個單位談著如何利用基本設計來製造一張椅子。希望不失眾望, 3 年後可看的到。

Q. 目前有許多行業正在被取代或是沒落 , 請問您對於平面設計未來的發展有什麼看法？

A. 往解決方案出路的平面設計是不會死的。被取代可能是科技、技術以及想法。

Q. 你對生活的細節上有什麼堅持嗎？(像是上廁所時一定要看詩集之類的)

A. 玩具。因為它是我的知識與靈感的發源。

Q.What is the best thing In your country? (likes features or culture) Have it ever influence your creation?

A. 3 major races - Chinese, Malay & Indian. The country with cultural and colors.
Yes, the design will be more interesting after added the various cultural studies and habits.

Q.Share good books/music/movies/places with us.

A.GQ Magazine, The Collection of Danny Chan, Marvel's The Avengers 1&2, Goh Peng (Perak)

Q.What is the craziest or coolest thing you have ever done?

A. Confession in love. I met Vivian via online and she's my wife now.

Q.What are the things you want to do most these days? Have you started to set up new goals or breakthroughs for next period?

A. Furniture Design, i want to build a chair.
Yes, now i am talking with few parties to present my idea on how to build a chair with the basic design terms. Hopefully it can be released on next 3 years.

Q.There are many industries are gradually being replaced or decline, what is your view on the future development of graphic design?

A. Graphic design with design solution will be always evergreen, the changes might be replaced would be the technology, technique and thinking.

Q.What is your insist on your life's details ? like toilet with your favorite poem?

A. Toy, i am obsessed because it's always my inspiration.

馬來西亞
Malaysia

葉永楠 YAP, WENG-NAM

www.wengnamyap.com
wengnam@gmail.com

擁有多元文化與多語言背景的葉永楠，來自於馬
來西亞吉隆坡，從事平面設計與藝術創作。他於
2012 年畢業於荷蘭海牙皇家藝術學院平面設計
系（Graphic Design at Royal Academy of Art,
The Hague），陸續於巴塞隆納、葡萄牙實習，
並於海牙從事平面設計相關工作。葉永楠的作品
曾獲得荷蘭 2012 年 Fontanel Finals 與 Gogbot
Festival 的年輕設計師獎，在 2014 年獲得歐洲
設計獎，曾受邀於威尼斯、日內瓦、布里斯托、
台中以及北海道展出，也曾在各歐洲與亞洲的設
計雜誌刊登，現居於馬來西亞。

Weng Nam is a graphic designer and
artist with multicultural and lingual
background from Kuala Lumpur,
Malaysia. He holds a B.A. degree in
Graphic Design at Royal Academy of Art,
The Hague in 2012. Weng Nam's strength
lies in his ability to produce solutions
that push creative limits yet answer the
client's brief. His working experience in
The Hague, Barcelona and Prague has
armed him with a unique approach to
designing – one that challenges the
norm and celebrates the random beauty
of experimentation. His talent and works
have won international recognition
including the Young Talent Award at
Fontanel Finals 2012, the Youngblood
Award at Gogbot Festival 2012, and the
European Design Awards 2014. His works
have been featured in publications
and exhibited in Japan, China, Taiwan,
Switzerland, the UK, and Italy.

1. 面相醒世歌 *Physiognomy Awaken Song* / 2012

2. 本土濃郁大雜匯 *Exotic Tempatan Mix* / 2013

3. 七天破事兒 *Seven Day Trivial Matters* / 2011

4.《圖形話語》過程紀錄本 *Graphics Speak Process Book* / 2012

5. 馬來西亞，能！ Bolehland / 2011

1 / 面相醒世歌 ' 裡的內容原是表達各種面相的性格與禁忌，這是一張依據此內容對迷信作出嘲諷而創作的海報。
This is a self-expressed poster according to ' 面相醒世歌 ' (Physiognomy Awaken Song), which is an assessment of a person's character or personality from his outer appearance. The poster is presented in a kitschy manner and questioning the unprovable fetish with sense of sarcasm – would life be easier according to the song?

2 / 海報中的圖像是似甜醬水果沙拉的馬來西亞著名食品 ' 囉喏 '，描述了自身對多元種族複雜的社會結構及對民族身份何去何從的感受與看法。' 囉喏 ' 的食材來自各類蔬菜水果與其它食品配搭，各種族就像 ' 囉喏 ' 的各類蔬菜水果一樣，各自擁有自己特色與味道，但一旦被切開湊在一起後就已無法回到各自的原貌，然而有必要將濃郁的甜黑醬給淋上，方能與其它蔬菜水果的味道調和共存。
A poster questioned the identity of Malaysian, hereby the Malaysian's prestigious local food – 'Rojak' is selected as the nearest interpretation. As a Malaysian born Chinese, unquestionably I am rooted and raised in a multiracial atmosphere, just like 'Rojak' as a metaphor, various pieces of local fruits(races) in the 'Rojak' are all well blended into a certain form with other materials, and importantly the exotic sauce, which harmonize the 'Rojak' and meanwhile it can never be deconstructed. This is the taste of Malaysia to me.

3 / 這是一本敘述了本人在海牙其中 7 天生活的視覺日記本，內容涵括許多的芝麻綠豆小事與對話。內頁應用非常小的字體排版，以表達內容純屬個人及無關要緊的性格。
A visual diary documented things and conversations that seem as if not important in seven days of my daily life in The Hague, Netherlands. The small texts and images in the layout represent the meaning of trivial matters.

6. Smart Master 服裝品牌 *Smart Master Brand Refinement* / 2014

4 / 這是一本紀錄了《圖形話語》聲音映像藝術裝置的發展思路與製作過程的紀錄本。
A publication documented all the attempts, experiments and the process of the sound installation project 'Graphics Speak'.

5 / 在馬來西亞，'Malaysia Boleh' 一詞是每當值得自豪或發生無可理喻的事情的時候都能用上的一句口號與口頭禪，帶有雙重意義。'Bolehland' 是一張針對馬來西亞滑稽可笑的事物及本土特色所創作的海報。設計裡的每個字體都敘述著不同的故事，如 (B)Bribery 貪污；(O)Oil 油價；(L)Language 語言 (多元種族語言同化)；(E)Election 選舉 (幽靈選票)；(H)Holidays 假期 (很多，而且有時會因贏了球賽而全國放假)；(L)Liberty of speech 言論自由；(A)Alcohol 酒精；(N)National Anthem 國歌 (模擬夏威夷歌謠 'Mamula Moon' 或印尼歌謠 'Terang Boelan')；(D)Datuk 拿督 (有地位和崇高名望者的一種尊稱，在馬來語也有爺爺的含義)。
This poster was created for a competition on the subject of organ donation. It is especially pertinent to me because I have a close friend who is on the waiting list for a heart transplant." A poster dedicated to my home country, Malaysia. It reflects some of the cultural and bizarre issues in a humour perspective by using letters. The word 'Bolehland' (Can Land) was derived from a cheesy national slogan 'Malaysia Boleh' (Malaysia Can), which is a word contains double meaning, Malaysians used to say it whenever proud or bad thing happened. Every letters come with a story: (B)Bribery; (O)Oil/Petrol; (L)Language (Assimilated language); (E)Election (Ghost voters); (H)Holidays (A lot, sometimes with bizarre reason); (L)Liberty of speech; (A)Alcohol (Prohibited for Muslim); (N)National Anthem 'Negaraku' (Imitation of a Hawaiian song 'Mamula Moon' or Indonesian song 'Terang Boelan'); (D)Datuk (A federal title, which means grandfather in Malay language).

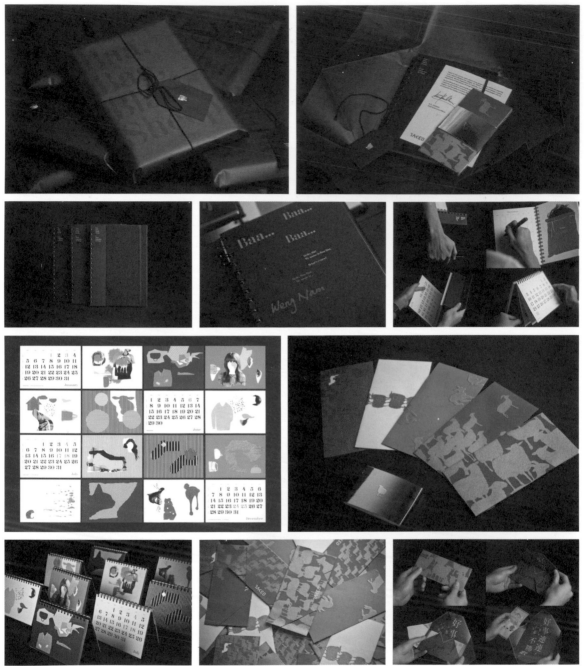

7. 竹尾造紙公司 2015 年日曆與日記本設計《咩，咩，黑羊兒》 *Takeo Calendar & Diary 2015 – 'Baa Baa Black Sheep'* / 2014

6 / Smart Master 是一家從事男士服裝的公司，在裁縫行業裡經過約 30 年的歲月後決定讓該品牌找尋一個明確的方向。品牌進行設計改革後，決定將品牌的焦點放在他們的強項，定位 Smart Master 為一個優雅高貴，自信成熟與內斂，以及擁有專業裁縫經驗的男士西裝服飾品牌。該品牌由專賣店至公司內部都逐步經歷結構性的改變與調整，將品牌帶領到一個新視角。

Smart Master is a clothing company that specializes in men's wear. Its founder, having over 30 years of experience immersed in the tailoring industry, was looking for a clear direction to take the brand to the next level. The brand was redesigned to bring back focus onto men's wear, where the project starts with the idea that a man's suit is a weapon that expresses his character and confidence. Using distinguishing elements from a gentleman's wardrobe to reflect a classy elegance, the new image brought about a series of restructuring exercises to elevate the brand to a new benchmark of quality. Store by store, each outlet underwent structural changes both internally and aesthetically to match its course, inspiring a fresh perspective on the brand that emanates sophistication.

7 / 每年，竹尾造紙公司都會藉由紙為主要媒介與不同的設計師合作推出他們的年度創意紙品設計，讓各設計師展現他們的創意。在 2015 的羊年也不例外，這是一份以著名童謠《Baa Baa Black Sheep》（咩，咩，黑羊兒）為故事藍本的創意紙品設計，裡面含有設計師混合中西角度重新對童謠詮釋的一本插畫日曆與日記本，和一份華人農曆新年紅包套。

Takeo is a paper company that believes that all works of artistic creativity begin with the blank slate we call paper. Every year Takeo gives away a gift set to their clients, and for the year of the sheep 2015, it came in the form of a diary calendar. The design introduces the aspect of the sheep year using the age-old "Baa Baa Black Sheep" nursery rhyme as a basis. The lyrics are brought to life through abstract designs according to an artist's interpretation, creating a compilation that includes a set of Chinese New Year Red Packets with good wishes and a diary calendar. A fusion of Western elements and Asian influences to usher in a new year.

Q. 請問您認為該國最棒的是什麼?(如國家的特色或文化等)您的創作是否受其影響?

A. 最棒的是由於地理位置使然,這裡沒有太多的天然災害,也造就了世界聞名的潛水海域與最古老之一的熱帶雨林,一年四季裡都可以吃到各式各樣的熱帶水果,還有那引以為傲的多元種族飲食文化。在創作上也自然會受其社會複雜多元層面的影響。

Q. 請和我們分享您喜歡的書籍、音樂、電影或場所。

A. 音樂:YMO, Steve Reich, 陳昇

電影:《經典老爺車》,《百萬寶貝》,《菊次郎的夏天》,《那年夏天,寧靜的海》,《3-4x10 月》,《七武士》

場所:山,海,瀑布

Q. 請問您做過最瘋狂或最酷的事情是什麼呢?

A. 有一年的六月去了西班牙北部的一個小地方貝爾加(Berga)的煙火節(La Patum),在約五千人擁擠地無處動彈的人海中似乎只有我一個亞洲人,連續兩晚與眾把酒遊行,然後煙火才是節日最後的重頭戲。此煙火非彼普通煙火,參加者必須近距離在接近頭部的位置點燃煙火,然後隨著音樂結群起舞形成一大片火海,所以當時長袖衣和鐵鞋是必備之物。在此有點難以筆墨形容,若網上搜尋 Els Plens de la Patum de Berga 能比較容易了解現場情況。

Q. 請問您最近最想做什麼事情?是否已經著手規劃下一階段的目標或突破了呢?

A. 探討更多其它表達事物與傳達感受的可能性。進行中。

Q. 目前有許多行業正在被取代或是沒落,請問您對於平面設計未來的發展有什麼看法?

A. 科技不斷迅速地改變遊戲規則,潮流來去匆匆,審美也隨時間改變,平面設計的定義與職責同時也變得多元,甚至讓我懷疑"平面"在現在的含義。我認為若相較較早前,平面設計多了許多的選擇與可能性,彷彿像寄生蟲一樣,只要有生存的可能條件,就有隨意滋長的機會。

Q. 你對生活的細節上有什麼堅持嗎?(像是上廁所時一定要看詩集之類的)

A. 盡量做好一點。

Q. *What is the best thing In your country? (likes features or culture) Have it ever influence your creation?*

A. There's not much natural disaster in Malaysia, that's one of the best thing I think. Other than that, Malaysia has also one of the best diving spot and the oldest rainforest in the world, meanwhile we can get various tropical fruits easily. Malaysian food is also one of our prestige. I think my creation sometime influenced the multiplex culture unconsciously.

Q. *Share good books/music/movies/places with us.*

A. **Music:** YMO, Steve Reich, Bobby Chen

Movies: <Gran Torino>, <Million Dollar Baby>, <Kikujiro>, <Boiling Point>, <Seven Samurai>

Places: Mountain, sea and waterfall

Q. *What is the craziest or coolest thing you have ever done?*

A. Participated La Patum at Berga, a traditional festival that is celebrated each year in the Catalan city of Berga, a small city at North Spain during Corpus Christi. It seems I was the only Asian tourist among the five thousand people. Fire and fireworks are the main features of this festival. During Els Plens, protective clothing and tough footwear are necessary, the lights went out and the square was festooned with crazy fireworks and smoke. You may get a better idea if you check out 'Els Plens de la Patum de Berga'.

Q. *What are the things you want to do most these days? Have you started to set up new goals or breakthroughs for next period?*

A. Exploring innovative possibilities in the form of expressing.

Q. *There are many industries are gradually being replaced or decline, what is your view on the future development of graphic design?*

A. It is an exciting moment, technology rapidly changing the rules of game, the trend come and go, and aesthetic may vary over time, the definition and role of graphic designer has become multitasking and challenging. I think graphic design now has more choices and possibilities than before.

Q. *What is your insist on your life's details ? like toilet with your favorite poem?*

A. Try my best to make things slightly better.

菲
律
賓

Philippines

Raxenne Maniquiz

菲律賓
Philippines

Raxenne Maniquiz

raxenne.com
raxenats@yahoo.com

Raxenne Maniquiz 是位來自馬尼拉的平面設計師及插畫家。對於可愛的、複雜的視覺效果有興趣，也經常搜集色彩鮮豔、華麗的小物來應用在她的工作上。將自己的風格融入到數個創意專案，同時繼續利用媒體和技術發展她個人的手工藝品。一些與她合作過的品牌包括 JanSport、Digital Walker 和 Bratpack。

Raxenne Maniquiz is a graphic designer and illustrator from Manila. With an interest in lovely and intricate visuals, she often collects colorful, ornate objects to use in her work. She infuses her style into a variety of creative projects while continuing to evolve her craft using other media and techniques. Some of the brands she has worked with include JanSport, Digital Walker, and Bratpack.

1. *Tropical Skull* / 2015

2. Bratpack Peg 2013 春夏型錄 *Bratpack Peg Catalog Spring/Summer 2013 / 2013*　3.JanSport x Bratpack 聯名限量版背包 *JanSport x Bratpack Limited Edition Backpack / 2013*

4. Bratpack Peg 2012 假期 型錄 封面 *Bratpack Peg Catalog Holiday 2012 (cover) / 2012*

5. Bratpack Peg 2013 假期 型錄 封面 *Bratpack Peg Catalog Holiday 2013 (cover)* / 2013

1 / Chaser Action Sports 曾委託我為他們新滑板路線設計。他們想將頭顱和一些熱帶元素合併在一起。這就是我將兩個想法結合在一起的成果。
I was commissioned by Chaser Action Sports to illustrate an artwork for their new line of skateboards. They wanted to incorporated skulls and something tropical. This is how I married the two ideas.

2 / Bratpack 是菲律賓當地概念店，有數個超酷品牌而市場族群趨向青少年及年輕人。Peg 是他們每年發行兩次的產品型錄，為了符合夏天主題所做，所有商品皆以顏色做區分。
Bratpack is a home-grown concept store in the Philippines that houses a variety of cool brands marketed towards teenagers and young adults. Peg is their product catalog which they publish twice a year. These are the artworks I did for the summer issue wherein all the products are categorized by color.

3 / 我曾是內部設計團隊受命於設計 Bratpack 與 JanSport 合作的一員。我的設計被選為繡在背包口袋上。可在菲律賓、香港、印尼、馬來西亞及日本的 Bratpack 商店裡購買。
I was part of the in-house design team that was tasked to create a design for Bratpack's collaboration with JanSport. My illustration was chosen and embroidered into the pocket of the backpack. It was made available in Bratpack stores in the Philippines, Hong Kong, Indonesia, Malaysia, and Japan.

6. 畫畫遊戲 *Paintings Play* / 2015

7. Mabuhay 雜誌 2015/ 3 月份封面 *Mabuhay Magazine's March 2015 Cover* / 2015

4 / Bratpack 是菲律賓當地概念店，有數個超酷品牌而市場族群趨向青少年及年輕人。Peg 是他們每年發行兩次的產品型錄，這是為了他們的假期主題而做的封面，我使用素描和廣告顏料描繪人物，再將其掃描起來用電繪加點其他元素。
Bratpack is a home-grown concept store in the Philippines that houses a variety of cool brands marketed towards teenagers and young adults. Peg is their product catalog which they publish twice a year. These are the covers I illustrated for their holiday issue. I used pencil and poster color for the portraits, and then scanned it to add the other elements digitally.

5 / Bratpack 是菲律賓當地概念店，有數個超酷品牌而市場族群趨向青少年及年輕人。Peg 是他們每年發行兩次的產品型錄，這是為了他們的假期主題而做的封面，是個精緻的花圈。
Bratpack is a home-grown concept store in the Philippines that houses a variety of cool brands marketed towards teenagers and young adults. Peg is their product catalog which they publish twice a year. This is the cover I illustrated for their holiday issue. It's an elaborate wreath.

6 / 把人們從畫像中帶離因偉大的大師所既定的印象，用幾何和花卉元素做出對比。
People in paintings by great masters were taken out of their original sets and were juxtaposed with geometric and floral elements.

8. 紅色 *Aka* / 2015

7 / 受菲律賓航空公司的飛行雜誌 Mabuhay 的委託，為他們設計三月份的封面。這是他們紐約直飛及 74 週年紀念特刊。三月開始，從馬尼拉經溫哥華直飛到紐約將被許可。全部用電繪的寫意風格，因為他們想要讓人聯想到旅行手記。顏色和陰影選擇菲航的 Logo 為基底。
I was commissioned by Mabuhay, Philippine Airline's in-flight magazine, to illustrate the cover of their March issue. It's their New York inaugural and 74th anniversary issue. Starting March, direct flights to New York from Manila via Vancouver will be available. Everything was drawn digitally in a sketchy freehand style because they wanted something reminiscent of travel journals. The colors and shades I used are based on PAL's logo.

8 / 這是代表日本的各種不同的圖示，Aka 在日語中表示紅色。
This is an illustration of different icons that represent Japan. Aka means red in Japanese.

Q. 請問您認為該國最棒的是什麼?(如國家的特色或文化等)您的創作是否受其影響?

A. 這裡最棒的事情是食物(笑)。我也喜歡它的多樣性以及各式各樣你可以做跟看的事情。我想這已經影響我的創作,我猜它促使我在案子中使用鮮豔的顏色。

Q. 請和我們分享您喜歡的書籍、音樂、電影或場所。

A. 書籍:冰與火之歌(喬治·R·R·馬丁),盲柳以及睡女(村上春樹),易碎物(尼爾·蓋曼)

音樂:孟買單車俱樂部,肯伊·威斯特,蘿兒,雙門電影俱樂部,鳳凰樂團

電影:機械姬(2015),雲端情人(2013),偷情(2004),北非諜影(1942),蝙蝠:血色情慾(2009),狼的孩子雨和雪(2012),

國家:馬尼拉、東京、曼谷

Q. 請問您做過最瘋狂或最酷的事情是什麼呢?

A. 我不完全認為這很瘋狂,但是目前為止我做過最酷的事情,就是我獨自到一個國家旅行七天。是個可怕又可愛的經驗,是去年一月,去東京、大阪、京都。我很樂意再度自己去旅行。

Q. 請問您最近最想做什麼事情?是否已經著手規劃下一階段的目標或突破了呢?

A. 我一直很想執行跟朋友醞釀很久的設計計畫,其包括使用傳統技術再次繪畫,我希望在今年結束前達到我的目標。

Q. 目前有許多行業正在被取代或是沒落,請問您對於平面設計未來的發展有什麼看法?

A. 我希望在未來幾年裡平面設計依然是相關聯的。我覺得它不斷地發展,特別是現在資訊和數據傳播很有效率。我想數位時代已經影響了我們如何製造、使用和看待平面設計了。

Q. 你對生活的細節上有什麼堅持嗎?(像是上廁所時一定要看詩集之類的)

A. 我喜歡在我的筆記型電腦上邊看電影和電視劇邊吃薯片跟喝冰美祿(笑)。

Q. What is the best thing In your country? (likes features or culture) Have it ever influence your creation?

A. One of the best things here is the food. :) I also like its diversity and the variety of things you can do and see. I think that has influenced my artworks. I guess that led me to using vibrant colors in my projects.

Q. Share good books/music/movies/places with us.

A. **Books:** A Song of Ice and Fire series (George RR Martin), Blind Willow, Sleeping Woman (Haruki Murakami), Fragile Things (Neil Gaiman)

Music: Bombay Bicycle Club, Kanye West, Lorde, Two Door Cinema Club, Phoenix

Movies: Ex Machina (2015), Her (2013), Closer (2004), Casablanca (1942), Thirst (2009), Wolf Children (2012), Eternal Sunshine of the Spotless Mind (2004),

Places: Manila, Tokyo, Bangkok

Q. What is the craziest or coolest thing you have ever done?

A. I don't think that this is totally crazy, but so far the coolest thing I've done is to travel alone for seven days in another country. It's a scary and lovely experience. I did this last January. I went to Tokyo, Osaka, and Kyoto. I'd love to travel alone again.

Q. What are the things you want to do most these days? Have you started to set up new goals or breakthroughs for next period?

A. I want to start on design projects I've been brewing with friends, and projects that involve painting again using traditional media. I hope I reach my goals before the year ends.

Q. There are many industries are gradually being replaced or decline, what is your view on the future development of graphic design?

A. I hope that graphic design is still relevant in the years to come. I think it continuously evolves especially now that information and data travel way more efficiently. I think the digital age has influenced us on how to make, use, and see graphic design.

Q. What is your insist on your life's details ? like toilet with your favorite poem?

A. I like watching movies and tv series on my laptop while eating chips and drinking iced Milo. :)

新
加
坡

Singapore

Bravo

Bravo

www.bravo.rocks
info@bravo.rocks

我們是一個創意工作室製作和塑造的重要品牌。
我們開發的概念比 Arial 粗體大膽，藝術方向具
有比權力遊戲更多的藝術性，設計比安娜溫圖爾
的頭髮有更多的技巧。我們熱愛我們的工作。

We are a creative studio making and
shaping brands that matter. We develop
concepts bolder than Arial Bold. Art
direction with more artistry than Game
of Thrones. And design with more finesse
than Anna Wintour's hair. We love what
we do.

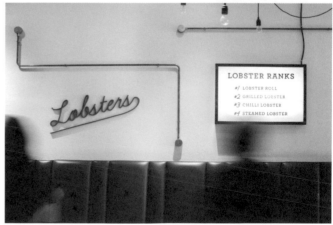

1. *Pince & Pints* / 2014

155

2. K.BLU / 2014

1 / 我們的任務是要為當地專做龍蝦菜餚的餐廳及酒吧設計識別系統，我們以店內最突出的兩個元素替餐廳命名— Pince & Pints，龍蝦鉗子與一品脫啤酒，並以龍蝦做為主要的識別。Pince & Pints 外表看起來時尚卻同時很俗氣，我們希望它跳脫精緻的、優雅的環境，這樣子根本讓客人倒盡胃口。這裡不是適合大啖龍蝦的好場所，顧客只想不顧一切享用龍蝦大餐，我們對 Pince & Pints 的理想是：一個舒適的地方，人們結束一添辛苦的工作之後，在這裡他們不會在乎弄髒自己雙手或是製造髒亂。

We were tasked to create an identity for a local restaurant and bar that specialises in lobster dishes. With that in mind, we named it after the two prominent elements in the restaurant – the lobster's pincer and the pints of beer. We created a lobster centric identity for Pince & Pints, one that looks modern yet rustic at the same time. We wanted Pince & Pints to step out of the fine dining environment where everything is prim and proper. At Pince & Pints, there is no dining etiquette. There is no proper way to eat a lobster, consumers would eat their lobsters whatever way they want. Our idea of Pince & Pints is a comfortable place people head to after a hard day's work where they wouldn't mind dirtying their pincers and making a mess.

2 / K.BLU 是具有精緻美學同時兼顧亞洲女生嬌小身形的泳裝品牌。他們替孕婦設計泳裝款式，特色是能完整包覆支稱孕婦新生的身材，並提供自信心。為了慶祝 K.BLU 的理想，我們使用風格化的海龜代表海洋與生育女神維納斯，因為海龜這種生物通常也被稱為海洋的母親。

K.BLU is a swimwear line of sophisticated aesthetics and quality that is catered to petite Asian frames. Designed for women after pregnancy, the swimwear line features pieces with fuller coverage and increased support to provide confidence to their new bodies. In celebration of K.BLU's ideals, a stylized turtle was used in representation of Venus, The Goddess of Sea and Fertility, a creature that is commonly termed as the Mother of the Sea.

3. Rhinoshield / 2014

3 /Rhinoshield 是個螢幕保護貼且獨一無二，是嚴謹的研究和開發材料、科學及工程的結果，Rhinoshield 設計提供最好的衝擊防護來保護您的電子設備。為了加強產品的主要特性，標誌是由抽象化的、在負空間中的犀牛盾牌所構成，而自定義所繪製的模板為未來的排版提供一個很好的參考。根據觸碰及由科技驅動的同樣設計情感所創造的功能性輔助圖形。

Rhinoshield is a screen protector that is in a class of its own. A result of rigorous research and development in materials, science and engineering. Rhinoshield is formulated to provide the best impact protection for your electronic devices. To reinforce the key attributes of the product, the logo mark forms an abstract forward profile of a rhinoceros in the negative space of the stylized shield, while the custom-drawn stencil logotype makes a reference to a futuristic typography. Secondary graphics of the product's features were also created under the same design sentiments of being touch and technologically-driven.

4. Beauty Candy / 2014

4 / The Beauty Candy Apothecary 是個生活方式的概念店，選擇並結集了世界各地最好的、最新的美容產品及生活用品。受到在紐約的蘇荷區、倫敦的諾丁山、東京的表參道的小精品店的啟發，商店販售各式各樣的手工採摘的產品，其中許多都是新加坡首次許可販賣。考慮到這一點，我們為 Beauty Candy 設計了一個純粹的且乾淨的外觀，靈感來自傳統藥劑師註冊商標的字體來表現產品所帶來的質感。

The Beauty Candy Apothecary is a lifestyle concept store that brings together a curated selection of the best and up-and-coming beauty products and lifestyle accessories from around the world.

Inspired by the small boutiques in New York's Soho, London's Notting Hill, and Tokyo's Omotesando, the store sells a wide variety of hand picked products, many of which are available in Singapore for the first time.

With that in mind, we created a pure, clean look for Beauty Candy, drawing inspiration from typography of traditional apothecary trademarks to reflect the quality of products they carry.

Q. 請問您認為該國最棒的是什麼?(如國家的特色或文化等)您的創作是否受其影響?

A. 新加坡是東西方文化的交點,意味著是對我們最好的。我們從小長大的兩個影響,有英語作為我們的第一語言及我們的母語作為第二語言。因此,這給了我們一個對世界整體來說是局外人的角度,就像是我們可以同時看見硬幣的兩側。Bravo 的作品不容易被劃分成是被東方還西方影響,所以,我們能夠以國際觀眾的方式做設計。

Q. 請和我們分享您喜歡的書籍、音樂、電影或場所。

A. 新加坡必訪:Basheer 書店(百勝樓)、中峇魯市場(30 成保路)、F&B projects 網站中的任何一個。

Q. 請問您做過最瘋狂或最酷的事情是什麼呢?

A. 我們認為,我們在中峇魯市場最新的個人計畫很酷 - www.tiongbahru.market。你不覺得嗎?

Q. 請問您最近最想做什麼事情?是否已經著手規劃下一階段的目標或突破了呢?

A. 與不同行業的客戶合作,還有跟數不盡的品牌計劃合作之後,證明我們是能夠做設計的,我們的下一步可能是去推向創意的盡頭,這代表我們會有更多實驗性作品,更加前衛,迫使品牌能突破固有的框架。我們想要更大膽去創作,拒絕安全的做法——基本上就是去做沒有人做過的事。

Q. 目前有許多行業正在被取代或是沒落,請問您對於平面設計未來的發展有什麼看法?

A. 被代替及自動化的工作大多是費力的工作。在設計及品牌中,我們的工作是傳達無法用語言表達的想法。作品有來自一定的情感方面,為了實行這情感方面,我們需要人情味。所以,這是不可能將創造性行業成為自動化及被替代。

在這行業中多年,已經注意到些有趣的東西,設計及品牌與經濟走相反的方向,意思是,當經濟下滑時,我們發現有更多品牌崛起。無論未來這趨勢是否會跟上,我們不能肯定。然而在現今的社會中,很難確定設計的重要性,因為他是重要的但同時也不重要,不重要的是他不是必須存活的工具,但重要的是它會清楚傳達,使其更加有用並有令人愉快的感覺。

Q. 你對生活的細節上有什麼堅持嗎?(像是上廁所時一定要看詩集之類的)

A. 幸福感。無論你是富是貧,快樂是金錢買不來的,這是生命中最重要的本質,且是我們的座右銘。

Q.What is the best thing In your country? (likes features or culture) Have it ever influence your creation?

A. Singapore is in the intersections of the eastern and western culture – which means the best of both worlds for us. We grew up with both influences, having English as our first language and our mother tongue as our second language, as such, this gives us an outsider's perspective on the world as whole, as we are able to look at it from both sides of the coin. Bravo's works aren't easily classified under eastern or western influenced so, in that way, we are able to do works for an international audience.

Q.Share good books/music/movies/places with us.

A. Places to visit in Singapore:

- Basheer Books (Bras Basah Complex)

- Tiong Bahru Market (30 Seng Poh Road)

- One of our F&B projects (Any!)

Q.What is the craziest or coolest thing you have ever done?

A. We think our latest personal project on the Tiong Bahru Market is pretty cool - www.tiongbahru.market. Don't you?

Q.What are the things you want to do most these days? Have you started to set up new goals or breakthroughs for next period?

A. Having worked with clients from different industries and countless of branding projects, we have proven the fact that we are able to do design. The next step for us then would be to push the boundaries of creativity. This means being more experimental with work and doing work that is more edgy and pushing the boundaries of what a brand can be. We want to be more bold in our approaches and resist safe approaches – basically, to do things that no one has done before.

Q.There are many industries are gradually being replaced or decline, what is your view on the future development of graphic design?

A. The jobs that are replaced with automated systems are mostly laborious jobs. In design and branding, our job is to communicate ideas that cannot be expressed in words. There is a certain emotional aspect that comes from doing such works and in order to fulfil that emotional aspect, we need a human touch. So, in that way, it is impossible for this creative industry to be automated and in this case, replaced.

Over the years we've been in the industry, we've noticed a few interesting things, one of it is that design and branding goes the opposite way of the economy – which means, when the economy is down, we find ourselves with more brands wanting to pick up branding. Whether or not that trend would keep up in the future, we are not sure. However, in today's society, it's hard to determine the importance of design as it is important, yet not important at the same time. Unimportant in the sense that it is not an essential survival tool but important as it clears communication channels and makes things more useful and pleasant.

Q.What is your insist on your life's details ? like toilet with your favorite poem?

A. Happiness. No matter if you're rich or poor, being happy is something that money can't buy, it's the most important essence in life and it's our motto.

台灣

Taiwan

●
●

林致命 *Ainorwei Lin*

鍾謹安 *CHUNG, JIN-AN*

陳青琳 *KIM (深度設計 DEPTH DESIGN)*

瑜悅設計 *Transform Design*

台灣 Taiwan

林致命 Ainorwei Lin

www.behance.net/Ainorwei_Lin
ainorwei.l@gmail.com

林致命，平面設計師。1990 年出生於臺南。專長於平面設計、視覺設計、文字設計等。大學夜校就讀期間，發現對設計產生極大興趣，並常常上日間部修課，自此開始與平面設計談戀愛。近期致力於文字設計、品牌設計、平面設計為興趣。目前就讀於南臺科技大學數位內容與應用設計研究所。

Ainorwei Lin, born in 1990. A graphic designer based in Taiwan. Graduated from Southern Taiwan University of Science & Technology with a Bachelor Degree of Visual Communication Design. and studying master degree of Digital Content and Applied Design. Focus on Graphic design, Typography, Branding & Print Design.

1. *STUST Recruitment Poster (Graduate School)* / *2015*

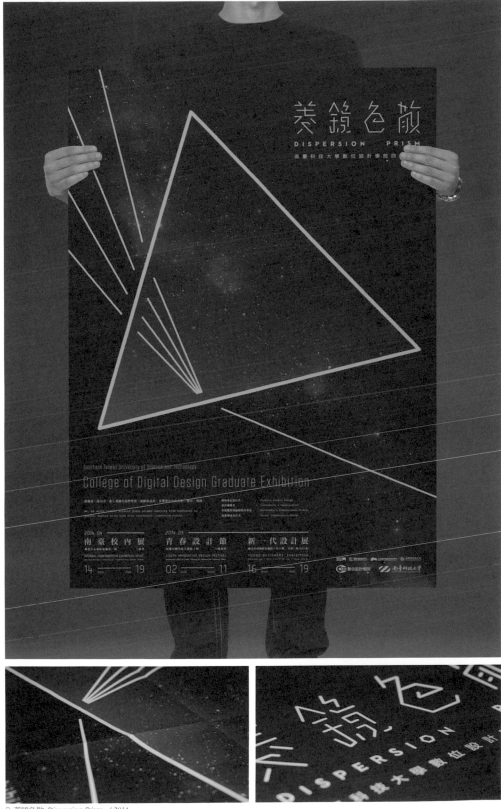

2. 菱鏡色散 *Dispersion Prism* / 2014

3. *Natural (2014 Calendar)* / 2013

1 / 透過螢光色彩與數位頻譜資訊以及相呼應的字體設計，來傳達數位內容與應用設計感。
Through neon audio frequency symbol and Chinese character logotype to communicate the digital content and design sense.

2 / 就像是一道白光，進入菱鏡內我們學習、迷惘與成長，並帶著各自的色彩，發光、飛翔。
We, as white lights, entered glass prisms learning from confusion to growth, hoping to fly high with individual lightening colors.

3 / 傳說，吉普賽人之間流傳著，人與生俱來擁有「色彩天性」說法。人依照出生的季節、自然界的變化，帶有不同的色彩天性，本月曆根據每月所代表的含義，以符號轉化，搭配顏色作為主要傳達的手法。以筆記本書寫方式，試著改良桌曆的使用價值與美感。
A Gipsy legend that says the humans are born with "color natures" means everyone who has different "color natures" according to the season and the change of the Mother Nature when a person was born. It is utilized symbolic figures and colors to represent the meaning of every month on this calendar as well as the way of writing in order to enhance aesthetics and values for this calendar.

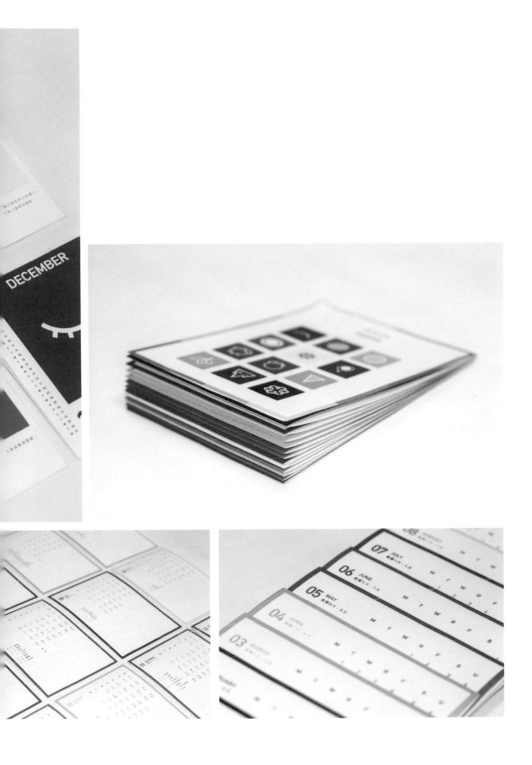

4. 時間抓緊 *Time is Money* / 2015

4 / 每當年底時，我們都會回顧一年發生的事，常聽到「Oh my god！（或一些髒話）時間過好快喔！」，當我們回想時，是否想過自己掌握好人生規劃，而不浪費時間呢？
One could often hear, "Oh my god！(Or some bad words) How time flies!" When we recall, have I ever make good use of my life and do not waste it?

Q. 請問您認為該國最棒的是什麼?(如國家的特色或文化等)您的創作是否受其影響?

A. 臺灣最棒的是經過近四百年不同文化的殖民與統治,在臺灣從建築到生活行為,可以看到許多不一樣的文化。

Q. 請和我們分享您喜歡的書籍、音樂、電影或場所。

A. 喜歡有深遠寓意或思考程度深層的電影,書籍絕對離不開藝術與設計類,音樂則是按照當下的行為去曲風的取捨。

Q. 請問您做過最瘋狂或最酷的事情是什麼呢?

A. 目前還沒有歷經過最瘋狂或最酷的事情。

Q. 請問您最近最想做什麼事情?是否已經著手規劃下一階段的目標或突破了呢?

A. 現階段正著手碩士畢業創作論文的展覽,是有關於城市視覺識別系統的展覽,在未來目標希望可以跟市府接洽,能夠將概念真正的落實。

Q. 目前有許多行業正在被取代或是沒落,請問您對於平面設計未來的發展有什麼看法?

A. 自己秉持著「為社會而設計」的精神,不只是平面設計,整個設計產業可以作為推動人類發展的一種方式,若以平面設計的角度來看,我想在臺灣目前是以提升全民美學做落實會比較實際。

Q. 你對生活的細節上有什麼堅持嗎?(像是上廁所時一定要看詩集之類的)

A. 對於購買的商品追求極簡、或是無標誌(Logo)等,例如衣著總是黑灰白,「實踐把色彩留給世界」的概念。

Q. What is the best thing In your country? (likes features or culture) Have it ever influence your creation?

A. During the recent 400 years, Taiwan's been governed by many different countries. And due to the impact from these countries, we can see a variety of cultures in our architectures, lives, and even behaviors. That's one of the most valuable assets in Taiwan, I think.

Q. Share good books/music/movies/places with us.

A. I love profound movies, and books of art and design. As for music genre, it depends on what i'm doing.

Q. What is the craziest or coolest thing you have ever done?

A. So far, I've never experienced anything craziest or coolest.

Q. What are the things you want to do most these days? Have you started to set up new goals or breakthroughs for next period?

A. Currently I'm focusing on my graduating exhibition for master's degree, which is about city visual identity. Next, I'm looking forward to contacting to our government and make the concept real if possible.

Q. There are many industries are gradually being replaced or decline, what is your view on the future development of graphic design?

A. I always persist in the spirit of "design for the society." Not only the graphic design, the whole designing industry can be a boost of human beings' development.

And I think it's more practice to enhance our national's perception of beauty if we're viewing from the aspect of graphic design.

Q. What is your insist on your life's details? like toilet with your favorite poem?

A. To practice the concept of "leaving the color to the entire world," I'm a minimalist when it comes to shopping. For example, my wearing's always in pure gray, black, or white, just monotonous.

台灣 Taiwan

鍾謹安 CHUNG, JIN-AN

www.behance.net/jin-an
michelle82318@gmail.com

No art, no life.

1. 帶我飛！ *Fly me to the moon* / 2013

2. Work Life / 2014

如果明天再見

國立雲林科技大學104級畢業典禮

畢業典禮
時間__2015.6.6
地點__國立雲林科技大學大禮堂
上午場次__管理學院‧設計學院
下午場次__工程學院‧人文學院

如果明天____校園留言板
邀請通過成是未來的 自己，寫給待了好久開始有感情的學校，
寫給身邊一起努力的同學，一篇美好的祝福和起許吧！

時間__2015.6.6
地點__國立雲林科技大學校門口

3. 如果明天再見 – 畢業典禮視覺設計 *Graduation visual design* / 2015

Everything
Means
Nothing

Everything
Means
Nothing

4. *Everything Means Nothing* / 2015

1／請帶我離開這個喧囂的世界。
Please take me away from the hustle and bustle world.

2／你要像這樣工作一輩子，還是擺脫一切去追求夢想？
You have to work for a lifetime, or get rid of everything to pursue their dreams?

3／圓到方，離開保護進入社會，我們從圓滑柔順的個性，被社會磨的不得不築起自我保護的牆，以抽象的幾何形表現進入社會前的恐懼與期待，地板上佈滿了彩色的線，捲捲線絲、收拾回憶，我們準備朝夢想邁進。
Circle to square, leaving the protection into the community, from the sleek submissive personality, socially mill had to build a wall to protect themselves to abstract geometric performance into the community before the fear and anticipation, the floor covered with color line, curly wire, packed memories, we are ready to move towards a dream.

Everything
Means
Nothing

4 / 三張系列稿以抽象的方式表現人在遇到低潮時，從崩潰、情緒緩和到走出框架的過程。作品裡的紅色是紅包袋的材質。紅色有警告的意象，卻也是喜氣的代表色，換個角度思考，其實衰事也是一種喜事，只是看你如何看待。
Three series of draft in an abstract way to show people in the face of low tide, from crashes, to ease the mood to go out the framework of the process.The red in this work is bag material. Red represents Warning, but also on behalf of festive color, from another perspective, in fact, a bad thing is a happy event,just depending on how you look.

Lapse of Dialogue

5. *Lapse of Dialogue* / 2015

5 / 學生的腦袋，被標準答案制約著。點滴本是治療用，而老師正在用正確答案 " 治療 " 學生不及格的腦袋。
The student's head, is the standard answer restricting.This was treated with intravenous drip, and teachers are using the correct answer "treatment" students do not pass the head.

Q. 請問您認為該國最棒的是什麼?(如國家的特色或文化等)您的創作是否受其影響?

A. 人。台灣人的人情味對我的設計影響很深,讓我更有感情、更感性。

Q. 請和我們分享您喜歡的書籍、音樂、電影或場所。

A. Picasso and Amedeo Modigliani. 這是一部我很喜歡的電影,我是學純藝術十幾年才轉而做設計,因此對我來說藝術是我所有情感的來源。這部電影讓我看見一個不得志的藝術家,如何在困境中堅持自我,而最諷刺的地方是,可以讓你同時看見兩個藝術家:畢卡索和莫迪利亞尼之間亦敵亦友的關係,和他們幾乎完全相反的命運。就像現實生活中,不管是哪個年代,都會有像他們這樣的對比,但也因為生命中充滿了不確定,才讓我們更有動力去闖蕩。

Q. 請問您做過最瘋狂或最酷的事情是什麼呢?

A. 和合作三年的夥伴拆夥。

Q. 請問您最近最想做什麼事情?是否已經著手規劃下一階段的目標或突破了呢?

A. 最近給自己一個挑戰,一年之內完成新的一系列作品,預計於明年(2016)在台北公開展覽。

Q. 目前有許多行業正在被取代或是沒落,請問您對於平面設計未來的發展有什麼看法?

A. 未來平面設計不是發展出新的形式,就是被動態取代,也許未來世界沒有靜態的平面設計了,就像哈利波特裡的報紙一樣,所有東西都是動態的。

Q. 你對生活的細節上有什麼堅持嗎?(像是上廁所時一定要看詩集之類的)

A. 無法在沒有音樂的環境下生活。

Q.What is the best thing In your country? (likes features or culture) Have it ever influence your creation?

A. People. Taiwanese warm hospitality deeply influenced my design, it make me more emotional.

Q.Share good books/music/movies/places with us.

A. Picasso and Amedeo Modigliani. This is a movie I liked, I was learning the fine art ten years before then turn to do the design, for me, art is the source of all my emotions. I saw the movie makes a frustrated artist, how to adhere to self in trouble, and most ironic point lets you simultaneously see two artists: Picasso and Modigliani between hares relationships, and they are almost the exact opposite fate. Like real life, no matter what age, will have such a contrast like them, but also because life is full of uncertainty, it makes us more motivated to go out.

Q.What is the craziest or coolest thing you have ever done?

A. Separated with who I have cooperated with for three years.

Q.What are the things you want to do most these days? Have you started to set up new goals or breakthroughs for next period?

A. Give myself a challenge recently to complete a series of new works within a year, is expected to be next year (2016) public exhibition in Taipei.

Q.There are many industries are gradually being replaced or decline, what is your view on the future development of graphic design?

A. In the future, graphic design either develop a new form or replace by dynamic. Maybe there are not static state graphic design in the future. Just like newspaper in Harry Potter, everything is dynamic.

Q.What is your insist on your life's details ? like toilet with your favorite poem?

A. I can't live without music.

台灣 Taiwan

深度設計 - 陳青琳
DEPTH DESIGN-KIM

www.behance.net/depthdesign
service@depthds.com

深度設計成立於 2012 年，由三人組成的多面向設計工作室。

服務的客戶有華研國際音樂、華納音樂唱片 (國內盤)、國立故宮博物院、安麗日用品股份有限公司、台北市捷運局、新北市政府文化局、國際綠色和平組織、天下文化 ... 等。

曾獲選 2011 年與 2013 年 apportfolio asia、2014 年第十四屆網路金手指，並於 2015 年受邀 AISA NEST 亞洲海報前衛設計展、The Ensouler Design Festival、高雄紅頂穀食間旅行邀請展、2014 年好玩漢字節展覽、亞洲插畫祭與展場主視覺、2013 年高雄設計節創意逛大街展覽、廣州太古匯流動藝術環保行展覽、以及香港 K11 ART MALL 聯展。

Depth Design is a versatile design studio found in 2012 by three people. Clients includes HIM International Music Inc., Warner Music Taiwan, National Palace Museum, Amway, Taipei Metro, Cultural Affairs Department of New Taipei City Government, Greenpeace, Bookzone... etc. Depth Design was honored to be selected in Apportfolio Asia in 2011 and 2013 and got invited in many festivals, such as AISA Next 2015 Poster Experimental Design Invitation Exhibition, The Ensouler Design Festival, Red Barn—Journey of Flavor Exhibition, The Delight of Chinese Character Festival, Asia Illustrators Collections of Taiwan, Kaohsiung Design Festival—Street Gallery, Mobile APPorfolio in TaiKooHui, Canto, K11 ART MALL Group Exhibition.

1. 共生共榮 *co-existence and co-prosperity. / 2015*

2. 思想飛翔 *Knowledge makes fly / 2015*

3. 心如鋼鐵也成繞指柔　　*Heart as steel has also become a pliant* / 2015

ANGER
COURAGE

4. 起身而戰 *Fight up* / 2015

1 / 自然環境孕育萬物生命，供予活動和生存的場所，離開自然環境則生命無法久續。然而萬物生命本身也是自然界的一部份，與其成為一個整體，密不可分。
構築成人類形貌的大自然元素，與以鳥類輪廓結合人體心臟的圖像，比擬自然環境與萬物生命之間的關聯與重要性。將大自然以人型表現，期盼在自然環境中不斷給予劇烈改變的我們，能以自然環境孕育生命的胸懷為範，尊重所有生命。
Natural environment nurtured all life, for activity and places to live, leaving the natural environment, the life can not long continue. However, life itself is a part of all things in nature, rather than as a whole, are inseparable. Human's shape are composed of in element nature, and birds profile combined with the human heart image, compared the relation and importance of the natural environment and all things. Show the natural with human's shape, look forward to when we giving severe change to the natural , using the natural environment nurtured all life for example, respect for all life.
2 / 知識推動了人類文明的演進，其奠基於人類以各種學習積累為經驗，加以思想與實踐而成。
在學習轉化為知識與智慧的過程中，鼓舞使之不斷前進的是逐漸開闊與宏大的思想境界。
以書頁填為人類形貌表達因渴求知識進而學習積累為深厚的底蘊。而展翅欲飛的鳥比擬知識引領生命飛翔，高飛的視野開展了原本認知的世界。
同時展現著當代社會中知識的自由與開放性，讓人類在名為未來的無窮天際中，飛躍極限。
Knowledge driven the evolution of human civilization, which is founded on the accumulation of human experience in a variety of learning, thinking and practice. Learning into knowledge and wisdom in the process, so as to continuously advance inspiration is gradually open and grand ideological level. To fill the pages of human shape due to thirst for knowledge and then learn to express the accumulation of strong background. Bird spread wings compared to lead life's flying, the vision widen the world what we thought. At the same time demonstrating the freedom and openness of contemporary society of knowledge, so that the future of human in the name of the infinite horizon, leap limit.

5.《偷偷跟你說 whisper》電影海報設計 / 2014

6. 中央太空遙測中心的監測系統成果報告書 CI 設計　Land monitoring plan / 2013

3／「心如鋼鐵也成繞指柔」此句因《月亮惹的禍》一曲廣為人知。其原句為：「百煉鋼化為繞指柔」，意指百煉過後的鋼可以變成繞指的柔軟之物。經過時空的轉化用來比喻剛硬的性情變得柔順。此次選擇以書法來進行書寫，是想藉此體現人們從剛強無畏的年少，逐漸邁入深思謹慎的壯年，此份心路歷程的轉變。字體設計過程中，以書法書寫過百字。過程中躁動急切的心緒，也因感受與領悟到書寫所給予的真意，從而漸漸使心境轉為平穩的態狀。在生命這場旅途中總有各式樣的累積，在奠基起能量後，如何將強烈的力道轉化為不同樣貌無限延展的能量，使生命面向更加的完整，這是我們必經的過程、與努力的目標。

"Heart as steel has also become a pliant" sentence for " Blame the moon "a widely known. Its original sentence to read: "Steel smelted into a pliant," meaning one hundred practiced after steel can become something soft around things. Through conversion of time parables rigid temperament become compliant. Choose to write calligraphy, is reflected in the people want to take from the strong without worry of young, gradually entered the thoughtful care of prime, this part of the mentality change. When design the font, calligraphy writing over a hundred words. At once eager mood, but also because of feelings and comprehend the true meaning given to writing, and thus gradually making steady state. In this journey of life cumulative total of each style, after the foundation from the energy, how strong the force into different faces of unlimited extension of energy to complete more face of life, this is the process we go goal and through.

4／為不平而生的努力，讓起身而戰的汗水在見證者的心中化為淚水、所生的傷口在心中留下烈血。理想讓苦難輝煌、輝煌絢爛生命質地。過去會成為歷史，但歷史不會只落在身後，而是在所即之處映入交會者的腦海中。放棄永遠無法成為選項，終點止在證明對美好生活 (人性) 的嚮往。

Fight for the unfair effort, let sweat turn to tears in the hearts of witnesses, the wounds will leave blood in the mood. Dream makes suffering brilliant, and brilliant the texture of life. The past will become history, but history will not only fall behind, but where ever you are.
Let it deeply imprinted in the minds of those rendezvous. Giving up is never an option, the destination is to accomplish the yearning of good life .

7. 田馥甄渺小演唱會動態視覺插畫設計　/ 2014

5／《偷偷跟你說》訴說校園霸凌及社會現象，故事以不愛說話的 17 歲高中生 " 阿宏 " 身上所發生的霸凌事件，家庭狀況及苦澀的戀愛串起整個故事，透過阿宏對世界的觀察讓觀眾看到生命真實的一面。

不同於以往商業型電影的故事都屬於歡樂愉快的節奏，此片偏陰暗、憂鬱、痛苦，卻充滿寫實，觀者很容易藉著男主角的視角、經歷等各種細節轉換成自身的經歷因此感同身受而產生同理心，卻又因為過於不堪醜陋而產生排拒，此部電影就是充滿矛盾又沉重的人生寫實電影。由於電影其實是人的人生縮影而非單純的校園霸凌，因此設計概念從針對校園轉為關注人類本質。

設計上選擇繪畫男主角正面的臉龐滿版直視觀者，做著無聲的抗議與無奈地反擊，因為臉部過於龐大、直接又陰鬱使觀者略顯壓力，同時將半邊臉龐交融伸出援手的少女側臉，刻意模糊不清男主角雙眼，使其產生錯覺。

背景選擇天空藍色意指青春的天空，然而實則色彩並不澄澈，於其中增添陰鬱、濃重的灰藍色，象徵人生的的苦痛。

"Whisper" telling school bullying and social phenomena, the story what happened of 17 years old high school student who is very quiet and bullied, "Aron", family status and bitter of love strung the whole story, by Aron observation of the world let the audience see the real of life. Unlike previous story commercial-type movies are all happy rhythm, this piece biased dark, depression, pain, but full of realism, the viewer can easily through the various details of the actor's perspective, experience thus converted into their empathy generating empathy, But because it is too unbearable ugliness arising excluded, this movie is full of contradictions and heavy life realism. Since the film is actually a microcosm of human life rather than simply campus bullying, so the design concept for the school turned attention from human nature. Designed to select the front face painting actor full version look viewer, doing a silent protest and helpless to fight back, because the face is too large, so that the viewer somewhat gloomy direct and pressure, while half of the face blend a helping hand girl side faces deliberately obscure actor eyes to illusions.

Choose a sky blue background sky means youth, but in reality is not the color clarity, which adds to the gloomy, thick gray-blue, a symbol of life's pain.

6／中央太空遙測中心的監測系統 2013 主視覺設計。以台灣的外觀去做簡化設計成幾何形，並將針對國土監測計畫成果當中的：都市／農業／魚塭／工業，四大項分類內容，設計出個別代表性的符號元素，並將該符號視覺元素，與構成監測國土的各個多邊造型，融合成為有代表特色的視覺形象。 太空監測國土的衛星圖像中，可見多種分布於各處的線狀與塊狀圖形，我們以當中的將衛星影像轉為 " 矩形向量資料 "，作為製作概念，以單位提供之成果集資料取概要作為設計的主軸：以農地完整度分析的最小單位 (Mapping Unit) 為 0.25 公頃，也就是以邊長 50m × 50m(0.25 公頃) 的矩形為分析單位。

Central Space Center telemetry monitoring system 2013 main visual design, Taiwan the appearance of to do to simplify the design into a geometric shape, and plans for monitoring outcomes among land: Urban / Agriculture / Fish farm / Industrial, the four items classified content, design a representative symbol of individual elements, and the symbol visual elements constituting the observation of various multilateral modeling land, integrated into representatives of the characteristics of visual image. Satellite images of space monitoring homeland, we see a variety of distributed linear and blocky graphics around, we will be among the satellite images to "rectangular vector data", as the concept of the production, to provide the results of the information unit set to take summary as part of the design themes: the smallest unit (Mapping Unit) with a complete analysis of agricultural land is 0.25 hectares, it is the side length of 50m × 50m (0.25 ha) of the rectangular unit of analysis.

7／參與田馥甄演唱會《矛盾》一曲的平面視覺部分。

《矛盾》的歌詞裡面有段：「同樣一個懷抱水火都沸騰 快樂凝望不快樂 妥協共生，同樣一個腦袋對立的靈魂 勇敢挑釁不勇敢 激烈辯論」「想改造自己想粉碎孤寂卻搞亂自己卻打破愛情」，設計發想始於此。

顏色上我們採用歌詞提及的水火，使用紅白 (紅血與白焰)，動態交錯時，在交融的過程波紋符號、色彩變化、物質交換印象皆象兩個靈魂正在辯論過程然後妥協默契，色彩會逐漸變得絢麗，最後交錯彼此的色彩，象徵不同的兩個靈魂正在辯證試著融合，即使無法並進，卻也給彼此生命更多激盪，這就是愛。

Participate in Hebe concert "contradiction" plane visual part.

"Contradiction" in the lyrics there are sections: "The same embrace, water boils and fire burns. Those who are happy stare at those who are not, living together through compromise. The same head opposite the soul. Those who are brave challenge those who are not, debating passionately." "I want to change myself, want to break the loneliness. But I confused myself, and my love is in pieces." design thoughts started this. The colors we use water and fire lyrics mentioned, using red and white (red blood and white flame), dynamic cross, in the process of blending ripple symbol, color changes, material exchange are a symbol of two souls being debated process of understanding and compromise, the color will gradually become colorful, and finally cross each other's color, a symbol of two different souls are trying dialectical fusion, if not keep up with, but also to each other's lives more agitation, which is love.

Q. 請問您認為該國最棒的是什麼 ?(如國家的特色或文化等) 您的創作是否受其影響？

A. 台灣是個自由度高、社會安全秩序、物產豐饒、也是文化多元、包容度廣大的國家，而最好的是台灣同時也有所不足，值得大家繼續為塊土地努力。

或許因為如此，作品上較多元，很少有單一模式和風格定型的問題。

Q. 請和我們分享您喜歡的書籍、音樂、電影或場所。

A. 我們喜好的模式蠻統一，皆屬於階段性的喜好。

在書的方面我們特別喜歡小說，但誠如上方所述，我們都沒有長久鍾愛特定書籍，而是階段性的喜愛。近期最喜歡的是《垂暮戰爭》、和《萊緹的遺忘之海》。電影與音樂皆是相同概念，近期印象深刻的電影為：《囚徒》、《隱牆》、《汙垢》。音樂為 :Keaton Henson - 《Charon》、the american dollar-《anything you synthesize》。我們最喜歡的場所應該是工作室與家了。

Q. 請問您做過最瘋狂或最酷的事情是什麼呢？

A. 為了喜歡的案子連續工作超過一星期，幾乎未眠。可以說是瘋狂但應該不酷。

Q. 請問您最近最想做什麼事情？是否已經著手規劃下一階段的目標或突破了呢？

A. 一直很希望工作室能以專業長處和社會團體合作完成有意義的案子。目前已經開始著手這個目標規劃，理想期望今年年底可以達成。

Q. 目前有許多行業正在被取代或是沒落，請問您對於平面設計未來的發展有什麼看法？

A. 世界上並沒有無法取代的事物，但每個被取代的事物同時都會有被取代的原因、以及不可取代的重要性，端看思考的面向。

雖然乍看平面設計的應用物正逐步被電子設備取代，但截至目前，電子設備與平面實體之間的差別就像電腦與人腦的差異 - 即為溫度的差別，因此應該強化此差異性，提高平面實體的獨特性。

Q. 你對生活的細節上有什麼堅持嗎 ?(像是上廁所時一定要看詩集之類的)

A. 僅對工作與創作上有所堅持，並因為工作時間長，所以處在謹慎狀態的時間也長，於是剩下為數不多的生活時間，便顯得漫不經心無法有甚麼非不可的堅持。

Q.What is the best thing In your country? (likes features or culture) Have it ever influence your creation?

A. Taiwan is a high degree of freedom, social security and order, rich, but also cultural diversity, inclusion of the majority of the country, and the best is Taiwan also inadequate, it is worth continuing to efforts this land. Perhaps, works are multivariate, rarely has a single mode and style stereotypes problem.

Q.Share good books/music/movies/places with us.

A. Our favorite mode unified, all belonging to phased preferences. Books we prefer to novels , but like what we just said, no books specific love longer, is phased. Recent favorite is "OLD MAN'S WAR" and "The Ocean at the End of the Lane". Movie and music are both the same concept. Recent impressive movie is "Prisoners"、"The Wall"、"Filth". Our favorite place is the studio and home.

Q.What is the craziest or coolest thing you have ever done?

A. For cases which I like continuous work more than a week, almost did not sleep. It can say is crazy, but should not be cool.

Q.What are the things you want to do most these days? Have you started to set up new goals or breakthroughs for next period?

A. Has been very much hope that the studio can use professional cooperate with social organizations to accomplish meaningful case. Has already started planning this objective, it is desirable to achieve the desired end of this year.

Q.There are many industries are gradually being replaced or decline, what is your view on the future development of graphic design?

A. Nothing in the world can not be replaced, but each has been replaced at the same time it will be replaced by some kind of reason, and the importance of irreplaceable, which opinion you thought. While graphic design for applications is gradually being replaced by electronic equipment, but so far, the difference between the electronic device and the graphic design just like computers and the human brain , is the temperature , so this difference should be strengthened to improve the plane unique entity.

Q.What is your insist on your life's details ? like toilet with your favorite poem?

A. Insist on only working and creative, because of long working hours so in a cautious state time is long, so the few daily time, they seems to casual and nothing to insist on.

瑜悅設計
Transform Design

www.transform.tw
leo@transform.tw

某年夏天的一趟旅程裡，創辦人感受到了來自四面八方的衝擊與影響，激起潛藏在內心的熱情與渴望改變的精神。於是開始進行籌備。在 11 年正式營運，沒有絢爛與遙不可及的理想，只有堅持不停改革、改變。工作室成立的名字：transform 就是由這個理念所誕生的，設計是我們的專業與熱情，希望透過與客戶不斷的溝通與合作，激發出最佳的視覺方案。

During a summer trip a few years ago, Leo, the founder of Transform, faced the tides of influences around him, and found himself driven by the thirst and ambition to make a difference, longing for transformation. Thus, in the year 2011, Transform Design took its first step into the world with no far-fetched dreams or impractical ideals but only the stubborn insistence on change. Design is our profession and passion. Through communication and collaboration, we deliver the best visual solutions to our clients.

1. 瑜悅設計品牌識別設計 *Transform Design Brand Identity* / 2012

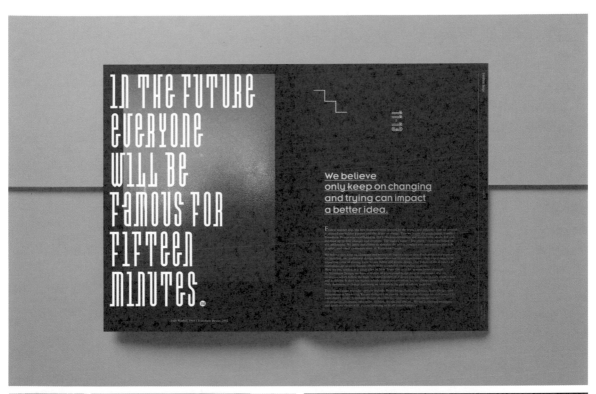

2. Transform Design Issue No.1 / 2013

3. 青春大衛專輯包裝設計 Young David Album Design
Special credits - calligrapher：陳麗文 / 2014

1／某年夏天的一趟旅程裡，創辦人感受到了來自四面八方的衝擊與影響，激起潛藏在內心的熱情與渴望改變的精神。於是開始進行籌備。在 11 年正式營運，沒有絢爛與遙不可及的理想，只有堅持不停改革、改變。工作室成立的名字：transform 就是由這個理念所誕生的，設計是我們的專業與熱情，希望透過與客戶不斷的溝通與合作，激發出最佳的視覺方案。
During a summer trip a few years ago, Leo, the founder of Transform, faced the tides of influences around him ,and found himself driven by the thirst and ambition to make a difference, longing for transformation. Thus, in the year 2011, Transform Design took its first step into the world with no far-fetched dreams or impractical ideals but only the stubborn insistence on change. Design is our profession and passion. Through communication and collaboration, we deliver the best visual solutions to our clients.

2／Transform 企圖以顛覆的思維來建立屬於自己的作品。不同於以往的編輯方式，在設計的過程中透過嘗試、找尋探索建構出獨有的作品呈現方式，這本刊物以大量的視覺符號為基礎，拆解作品的元素，再重新組合。最終以一個再生作品的概念完成了這本極具實驗精神的作品集，整本黑白的調性是希望強化閱讀的專注。期望能帶給觀者視覺的獨特經驗。
At Transform Design, we create our own work with a free-spirited mindset focused on breaking ground. By replacing conventional editorial habits with experimentation and exploration, we were able to find our unique voice with which w e present our work. Transform Design Issue No. 1 is a composition of the various visual elements extracted from our original work. Through the process of deconstruction and reconstruction, the final outcome is an experimental portfolio piece built upon the theme of rebirth. The black and white monotone palette of the volume was used intentionally to help readers understand our work through a unique visual experience.

4. 幸運火花品牌識別設計 *LUCKY SPARKS Brand Identity* / 2014

3 / 青春大衛台灣獨立樂團，擁有獨特力量的嗓音征服每個喜愛的聽眾！純樸、人情味、力量是唱片設計的核心，青春無疑是一種恣意地揮灑毫無保留的將歌曲的意念感染每個人。書法是最佳首選的創造工具，它的筆韻、氣勢、顏色、濃度都可代表歌曲的精神。文字的線條長短代表了情緒，或短或長伸縮點綴其中。
Young David is a Taiwanese indie band that conquers their audience with a voice that releases special powers. Sincerity , humanity and energy are the key ingredients for designing their album, and unreserved and reckless youth is unquestionably the core spirit in their music that we must visualize. Calligraphy became the best solution for the design—the attitude, strength, color and richness of every brush stroke communicate the spirit of their music. The linear quality of the typography expresses emotions that embellish the calligraphy art.

4 / LUCKYSPARKS 專注於多元影片形式的製作，將各品牌的核心價值呈現至作品中，使想像力與故事性的運作完整的傳遞給人群，築構更深層的關係。 提供獨特的觀點與創意，觸動觀眾的內心，作品的標準是直接呈現最真擊與細緻的情感。LUCKYSPARKS 團隊擁有多樣的技術，從導演的人才至製作團隊的各要角，都是來自不同專長及領域的專業人士。 多元團隊的配合與默契使 LUCKYSPARKS 備妥接納各形式的案子。融合了東方與西方兩界的工作理念與獨特視覺呈現，團隊只忠於最高標準與最真誠的作品。
LUCKYSPARKS is an integrated production company with a love for human stories and imagination. We craft video content by our core principles and ideas, one that allows our viewers to build a deeper and personal connection with the world around them.
Our talented pool of directors and experienced producers make for a well-balanced team, taking on ideas with efficiency and flair always looking to bring on a new perspective. Our understanding of eastern and western values makes for a unique blend, while our diverse team offer a novel experience that we hope is truly one-of-a-kind.

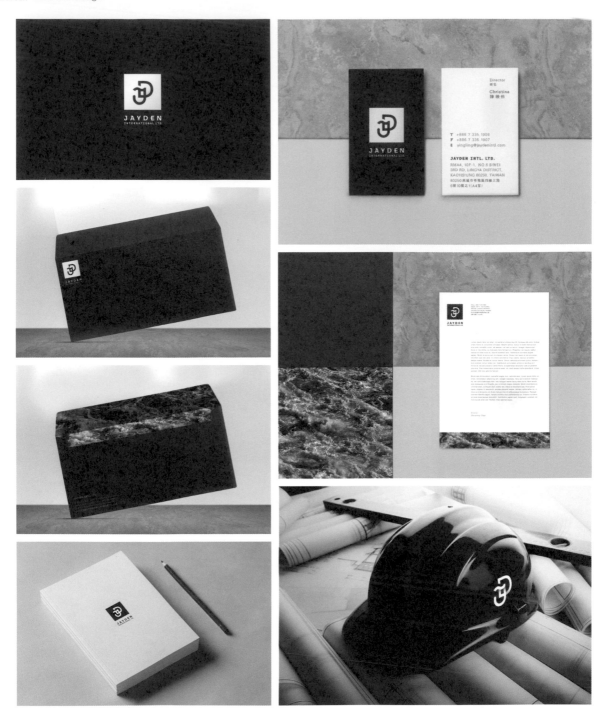

5. 捷登國際有限公司品牌識別設計 *Jayden International Ltd. Brand Identity* / 2014

5 / 捷登是提供專業咨詢、設計級生產製造的捕魚業船隻品牌。在捕魚船業中，衡量船隻的好壞，莫過於速度、動力與方向的掌控。捷登在設計製造上，強調其抗風浪的能力，是最能在驚濤駭浪中穩定航行，並以最快的速度抵達目標，準確下錨、快、狠、準且安全地完成任務。標誌與品牌識別中，我們以船錨的造型表達品牌的穩定性，並且帶入海浪的造型，與海洋意向連結，表現造船業本身的形象。除了敏捷、快速抵達的含義之外，我們更強調與客戶建立的良好關係，以互信、互助、環環相扣，培養穩定的經營模式。

Jayden is to provide professional consulting, design-level manufacturing fishing vessels brand. In the fishing boat industry, a measure of the quality of vessels, than control the speed, power and direction. On the design and manufacturing, to emphasize its ability to resist wind and waves, is the most stable sailing in rough sea, and the fastest goal arrived, drop anchor accurately, fast, aggressive, accurate and complete the task safely. Logo and brand recognition, we use anchor to express the stability of brand's styling, and add waves to connect the ocean intention, showing the image of the shipbuilding industry itself. In addition to the agile, quick access to the meaning, we emphasize the establishment of good relations with customers, based on mutual trust, mutual, interlocking, train the business model stable.

Q. 請問您認為該國最棒的是什麼 ?(如國家的特色或文化等) 您的創作是否受其影響？

A. 多半來台灣的外國朋友對於台灣的共同記憶都是對於台灣的方便以及人民的友善。

我想，這就是台灣最棒的地方，近期頻繁的旅行工作，我更深深的感受到這一點。

所有的創作靈感跟來源，我想都是源自於自己的生活經驗。而我也從我的生活體驗中累積了很多的資料。

在台灣，生活很方便代表的就是我們對於生活中有很多的環節都很在意，在意 24 小時的閱讀感受，在意 24 小時的零售服務，在意晚間的生活、飲食等等 ... 所以我們有不打烊的書店、便利商店、夜市等。這些都在我的生活中出現，交織而成一個豐富有趣的經驗網絡，這些都富足了我的作品。

Q. 請和我們分享您喜歡的書籍、音樂、電影或場所。

A. 我喜歡的電影比較多，例如：

1. 阿甘正傳 Forrest Gump
2. 辛德勒名單 Schindler's List
3. 魔戒 三部曲 The Lord of the Rings
4. 星際效應 Interstellar
5. 艾蜜麗的異想世界 Amélie

會發覺我看的種類很不一樣，我喜歡電影的原因主要是因為在一兩個小時裡我們就可以穿越時空，體驗一個全新的感受或觀念，也開啟了我們對於未知的思考與想像！

同時電影也是一個複合體，我所愛的元素都結合在此之中 (大量的音樂、影像、人) 我想，這是我最喜歡電影的原因。

Q. 請問您做過最瘋狂或最酷的事情是什麼呢？

A. 我覺得最酷與最瘋狂的事情往往一體兩面，能符合這個答案的對我來說只有一個，那就是 " 創業 " 創業是因為夢想要做一件對自己有意義的事情，所以不夠瘋狂，沒有勇氣是不可能做的。同時也因為夠瘋狂 (創業) 你才有機會做一些更酷的事情。所以對我來說，創業是這一件既美妙也夠瘋狂的事情了！

Q. 目前有許多行業正在被取代或是沒落，請問您對於平面設計未來的發展有什麼看法？

A. 現在的世界轉動的速度很快，有很多的產業因為需求的關係而有所改變。這些改變震盪的幅度很大，有很多改變的速度跟方向我們始終無法預測。

平面設計在未來的需求並不會減少，減少的只是媒介或平台的改變而已，但相反的也增加了很多的產業可能。我想平面設計只是整體設計面向的一個環節而已，如果放大到整個設計來談，其實機會還是非常大的。透過不同平台的合作，設計的本身會更加強大，平面設計也會在這整體的需求環節中站的更穩。

Q. 你對生活的細節上有什麼堅持嗎 ?(像是上廁所時一定要看詩集之類的)

A. 相較於工作，生活上我顯得比較輕鬆。但如果真的要說有什麼堅持，那就是我覺得在生活中一定要懂得放鬆並懂得欣賞更多人事物。這很重要，週末即使我仍需要工作，我也會選擇一個不是在家或者公司的地方好好的靜下心來想思考一些事情。一方面你需要抽離你所習慣的環境，試著多讓自己處在一個全新的地方，透過這些新的感受，來重新撞擊、刺激你原本的生活。這樣你會覺得有所吸收，有所前進與思考。

Q. What is the best thing In your country? (likes features or culture) Have it ever influence your creation?

A. Most of visitors from other countries might have the same views about Taiwan, such as the convenient living hood, and the friendly people. Actually this is also what I think the best part of Taiwan, especially after the frequent visits to other countries these days, I am more convinced to it.

All my ideas and inspirations are mainly come from my daily life. In which I have accumulated quite a lot my personal views. In Taiwan, convenience means we care about the various parts of life, we care about the reading experiences at the late night, we care about the needs of buying stuffs at any time of a day, also we care about the food and fun in the night and etc. All of these encourage the emerging of services such as 24-hrs bookstores, a lot of convenient shops and night markets. These experiences in my daily life build up a rich network in my mind, and further contribute to my works.

Q. Share good books/music/movies/places with us.

I am more into films, such as:
1. Forrest Gump
2. Schindler's List
3. The Lord of the Rings
4. Interstellar
5. Amélie

You might think those films are all different style. The reason why I like films is that we can travel trough the time within one or two hours to experience a new feeling or perception as well as stimulate our unknown thinking and imagination!

Meanwhile, film is a complexity, it contains all my favorite elements (Lots of musics, images, people). I think this is why I love films.

Q. What is the craziest or coolest thing you have ever done?

A. To me "crazy" and "cool" is quite the same, and for this question my answer will go for "starting up my own business". It was simply because I dreamed to do something meaningful for myself, and it is impossible without sufficient craziness and courage. Also, to get chance to do something cool, you really have to be crazy. So, starting my business is the craziest and the most beautiful thing in my whole life!

Q. There are many industries are gradually being replaced or decline, what is your view on the future development of graphic design?

A. Everything is changing faster and faster, a lot of industries have changed due to the different requirements these days. Some of the changes were huge, it's really hard to predict how different will it be.

The needs of graphic design would not decline, but the media or platform might change, which could increase more possibilities in certain ways. In my opinion, graphic design is only part of the whole design industries, if we think from the whole design industries, there are still a lot of opportunities. With the collaboration through different platform, design would be more and more powerful and the following needs of graphic design would strengthen our roles.

Q. What is your insist on your life's details ? like toilet with your favorite poem?

A. Comparing to work, my life seems slower.

If I have to say any about insistence, I would say people must know how to relax themselves and appreciate things and people.

This is very essential, even I have to work on the weekend, I would find a place which is neither home nor studio but could calm me down to think and reflect.

Also you need to pull away from the place that you're familiar with, and try to put yourself in a completely new environment. These fresh changes, could re-strike and stimulate your original life. As a result, you would get more insights and thus gain more improvements and thoughts.

美
國

USA

Bizhan Khodabandeh

Erin Wright

Pouya Jahanshahi

Bizhan Khodabandeh

www.mendedarrow.com
bizhan@mendedarrow.com

Bizhan Khodabandeh 目前任教於弗尼吉亞聯邦大學媒體與文化學院, 並經營自己的設計公司 -Mended Arrow, 網站上還有自己畫的漫畫。Khodabandeh 曾獲得全國性以及國際性的獎項, 包括插畫協會的銀獎、美國圖形藝術協會 (簡稱 AIGA) 最佳形象海報, 並入圍了 AIGA 國際競賽 - 跨文化。

他的作品已被收錄且出刊, 像是 Print,Creativity International and Adbusters— 書籍上有 The Design Activist's Handbook and The Green Patriot Poster Project.

Bizhan Khodabandeh currently teaches as an Instructor at Virginia Commonwealth University's Robertson's School of Media and Culture, runs his own design firm, Mended Arrow, and makes comics on the side. Khodabandeh has received numerous national and international awards such as: a Society of Illustrators Silver Medal, Best in Show Poster through the American Institute for Graphic Arts (AIGA), and a finalist for the AIGA's International XCD Competition.

His work has been featured in publications such as: Print, Creativity International and Adbusters — as well as books including: The Design Activist's Handbook and The Green Patriot Poster Project.

1. *Entropy Ensemble* / 2012

PLAYING CLASSICAL
ARRANGEMENTS
OF RADIOHEAD SONGS

ENTROPY
ENSEMBLE

W/NICK CRIDER

$8 IN ADVAN
$10 AT DOC

7PM AUGUST 8TH
AT GALLERY5
200 W MARSHALL
STREET RICHMOND, VA 23222

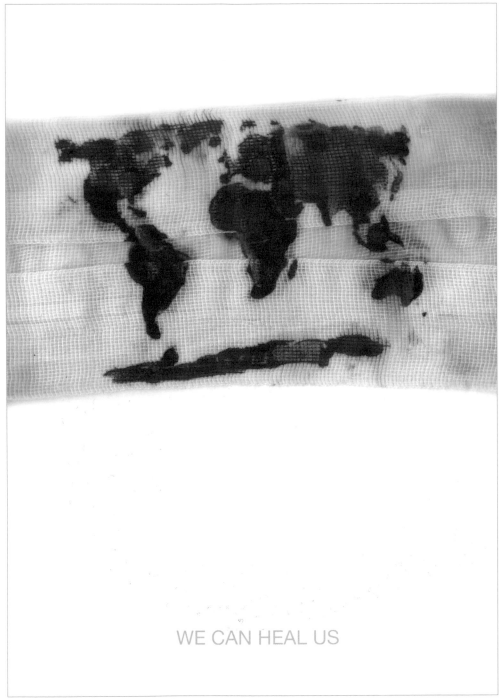

WE CAN HEAL US

2. 全民醫療健保 *Universal Health Care* / 2009

1 / 這張海報是為了一另類搖滾樂團融合交響樂 - Radiohead (電台司令) 而設計。我拍了我弟的電吉他和我自己的小提琴來兩者作結合，說明了將一個音樂風格轉換成外一個。
A poster for a band that was doing symphony style arrangements of th rock band, Radiohead. I took photos of my little brother's guitar and my own violin to combine them, illustrating the idea of translating one style of music to the other.

2 / 這件作品是以地球陸地形狀的模板再漆上紅色的壓克力顏料。模板 " 流血 " 後經過紗布透出了形狀。創作理念是，我們作為一個全球性的社會，擁有能力去補救缺乏醫療的能力和措施。
This piece was designed using a stencil of continents that I laid on top of red acrylic paint. The stencil allowed the paint to "bleed" through the gauze in the shape of the continents. The idea is that we, as a global community, have the capacity to remedy lack of access the health care.

Because we all need a heart.

Celebrating 10yrs of the
Vegan Certified Logo

3. 素食廣告 *Vegan Ad* / 2010

3 / 這項廣告是以素食認證標誌的心型來設計。經過一些搜尋我發現，所有生物都需要一種循環系統，這是我們普遍都擁有的。自從認證標誌使用心型後，我決定用蔬菜組成來為組織作一個充分的表現。
在創作的過程中，我不斷地問自己：哪顆紅洋蔥最像心臟？或是哪個芹菜的分支最像動脈？而 Photoshop 只用來修掉支撐蔬菜的牙籤。
This advertisement was designed with the Vegan Certified heart logo in mind. After some research, I learned that all living creatures need some sort of circulatory system. It's something that we all have in common. Since the logo already used a heart, I decided to sculpt one using vegetables to best exemplify the organization. This piece was actually sculpted out of real vegetables.
During the process, I had to ask myself questions like "Which one of these red onions looks the most like heart?" or "Which one of these celery branches looks most like an artery?" Photoshop was only used to airbrush out the toothpicks used to hold the vegetables in place.

4. *Circle Takes the Square*　/ 2014

4 / 這張海報使用拼貼的方式去刻畫復古樣式的動物圖像，來充分表現出這次活動中領銜樂團的音樂。
This poster was an exploration using collaged vintage engraved images of animals to best exemplify the music of the headlining band at this event.

Q. 請問您認為該國最棒的是什麼?(如國家的特色或文化等)您的創作是否受其影響?

A. 我熱愛我國家裡的人們。他們持續促進和幫助我了解我自己,我知道這是個非常普通的答案,但這是事實。

Q. 請和我們分享您喜歡的書籍、音樂、電影或場所。

A. 我喜歡 Gabriel Garcia Marquez 所寫的 "100 years of Solitude"。電影有兩部是我的最愛 "Bladerunner" 和 "The Secret of Kells"。音樂部分很難準確地去點出哪個風格,我熱愛大部分的音樂,所以我沒有辦法去定義這個。但當我在回答這些問題時,我正在聽 "Zorba the Greek"。

Q. 請問您做過最瘋狂或最酷的事情是什麼呢?

A. 我曾經參與設計及安裝一個有著輪子的人造建築物。輪子可以讓人們在這長廊中去移動那建築物。當時的想法是要讓人們去塑造自己的城市。還有其他幾個組件,像是有麥克風的講台或投票箱,這也可以當成是建築物的形體。還有個假廣告版給人們來用粉筆作畫。這是一個很大的樂趣。

Q. 請問您最近最想做什麼事情?是否已經著手規劃下一階段的目標或突破了呢?

A. 說實話,比起平面設計,我最近畫了更多漫畫,我熱愛畫畫,我享受將畫畫結合在我的設計裡,但這不總是適合於每個客戶或案件。

我並不會訂定設計的目標,尤其是我工作的方式就是客戶所依賴的。我試圖使用或學習那適合給大部份客戶的技巧,很幸運地,懂得幾種方式去製造設計圖,所以我總是在每個計畫中學習。我想這信念會讓我不斷學習和不斷向前邁進。

Q. 目前有許多行業正在被取代或是沒落,請問您對於平面設計未來的發展有什麼看法?
A. 誰知道未來會是怎麼樣?我們身在任何事看起來都是可能的且發展快速的時代。很難去推測未來的設計會變成怎麼樣,除了這些,是有趣又刺激的。

Q. 你對於生活的細節上有什麼堅持嗎?(像是上廁所時一定要看詩集之類的)

A. 我熱愛 Hafiz 大部份的詩作。

Q.What is the best thing In your country? (likes features or culture) Have it ever influence your creation?

A. I love the people in my country. They continue to help push me and aid my understanding of myself. I know that is a pretty generic answer, but it is the truth.

Q.Share good books/music/movies/places with us.

A. I love "100 years of Solitude" by Gabriel Garcia Marquez. Probably two of my favorite films are "Bladerunner" and "The Secret of Kells." Music is hard to pin-point. I love a lot of music. There isn't really anything I can say defines me, but as I respond to these questions, I am listening to the soundtrack to Zorba the Greek.

Q.What is the craziest or coolest thing you have ever done?

A. I once co-designed and built an installation of faux buildings with wheels underneath them. The wheels allowed the audience to move the buildings around the gallery. The idea was to allow people to shape their own city. There were several other components such as a podium with a microphone and ballot box - that was also built in the shape of a building - and fake billboards that audience members could draw on with chalk. It was a lot of fun.

Q.What are the things you want to do most these days? Have you started to set up new goals or breakthroughs for next period?

A. To be honest, I have been doing more work with comics than graphic design lately. I love to draw. I enjoy incorporating it into my design work, but it isn't always appropriate for the client or event.
I haven't set up goals for design specifically because the way I work is dependent on the client. I try to use or learn skills that are the most appropriate for the client. I'm fortunate enough to understand several ways to produce imagery, so I'm always learning with each project. I guess the hope would be to keep learning and keep progressing.

Q.There are many industries are gradually being replaced or decline, what is your view on the future development of graphic design?

A. Who knows what the future will hold? We are in a place where anything seems possible and happens so fast! It's hard to speculate what the future of design will be - other than it will be fun and exciting.

Q.What is your insist on your life's details ? like toilet with your favorite poem?

A. I love most of the poems by Hafiz.

Erin Wright

erinwright.org, asylumdesign.org
asylum@uab.edu

生於 1959 年 7 月 24 日

丹佛市，科羅拉多州，美國

Erin 畢業於亞利桑那州立大學並取得其創作碩士 (簡稱 MFA) 及在科羅拉多州立大學與 Phil Risbeck 一起就讀的創作學士 (簡稱 BFA)。目前在阿拉巴馬大學伯明翰分校任教，為藝術指導教授。

Erin 設計的海報曾參加超過 50 個比賽及邀請展，並在超過 17 個國家裡展示，包括：波蘭首都華沙、捷克中的布爾諾、南韓、墨西哥國際海報邀請展、中國 the Mark X 國際海報邀請展、俄羅斯莫斯科的金蜂國際海報雙年展、科羅拉多國際海報雙年展、玻利維亞國際海報雙年展、斯伐洛克特爾諾瓦三年展、土耳其國際海報邀請節、比利時蒙斯國際政治海報三年展，以及第五十六屆華盛頓藝術指導俱樂部在華盛頓當地展覽的圖文提倡：國際數位時代海報。

"Erin Wright (Asylum)

Born – 24 July 1959

Denver, Colorado, USA

Erin graduated with a Master of Fine Arts from the University of Arizona and a Bachelor of Fine Arts from Colorado State University where he studied with Phil Risbeck. He is currently a Professor of Art at the University of Alabama at Birmingham.

Erin has designed posters shown in more than 50 competitions and invitational exhibitions in over 17 countries around the world including: Warsaw, Poland; Brno, the Czech Republic; South Korea; the Bienal Internacional del Cartel en México; the Mark X International Poster Invitational in the Republic of China; the Golden Bee in Moscow, Russia; the Colorado International Invitational Poster Exhibition (CIIPE); the Bienal del Cartel Bolivia BICeBé; the Trnava Poster Triennial in Slovakia; the International Invitational Poster Festival in Turkey; the International Triennial of the Poster in Mons, Belgium; and the 56th Annual Art Directors Club of Metropolitan Washington Show in Washington, D.C. as well as Graphic Advocacy: International Posters for the Digital Age.

With Antonio Castro and Eric Boelts he is a co-founder of Posters Without Borders a biennial invitational poster exhibition that focuses on political and social issues."

1. 自由 / 暴政 Liberty / Tyranny / 2013

2.五十週年：民權運動 *50 Years : Civil Rights Movement* / 2013

3. 我的選票在哪？ *Where is My Vote?* / 2015

1 / 這張海報是設計來舉例證明，自由是沒有了暴政，而暴政是民主的死亡。藉由旋轉海報 180 度，圖會從飄在花瓶上的花轉變成骷髏頭，文字 " 自由 " 變成 " 暴政 "。
This poster was designed to exemplify that Liberty is freedom from Tyranny and that Tyranny is the death of Liberty. By rotating the poster 180 degrees the image changes from flowers floating free from a vase with the text "'liberty'" to the image of a skull and crossbones and the text "'tyranny'."

2 / 1963 年被認為是美國民權運動的開端。"華盛頓的三月"、馬丁·路德·金著名的演講，阿拉巴馬州的喬治·華萊士"擋校門事件"等運動催化了種族之間的平等。在 2013 年，是個開創性的 50 週年，而阿拉巴馬電力公司舉辦了一個反映人權的展覽。這張海報是設計給展覽的，引用自金博士演講中的一句名言"這是呼籲大家對待他人時依據對方的個性，並非種族、宗教或階級。"
The year 1963 is considered the start of the Civil Rights Movement in America. The "'March on Washington'" and Dr. Martin Luther King's famous speech, Alabama Governor George Wallace's "'Stand in the Schoolhouse Door'" and other events catalyzed the movement for equality among the races. In 2013, on the 50th Anniversary of that seminal year, the Alabama Power Company held an exhibition reflecting on civil rights. This poster for the exhibition, paraphrases a famous quote from Dr. King's speech. It is a call for everyone to treat each other according to their character, not their race, religion, or class."

4. 死亡不是正義 *Death Is Not Justice* / 2011

5. 愛是給予 ... *Love is Giving...* / 2015

6. 停止殺害我們的環境！ *Stop Killing Our Environment!* / 2009

7. 世界平面設計日 *World Graphics Day* / 2014

3 / 這張海報是為為名為 " 海報無邊際 " 的團體所舉辦的一國際邀請賽海報展所設計，主題是對投票權的自由與公正的選舉，而我是創人之一。在現在這個自由的社會，人們必須要有領導人選舉的投票權及法律來管理。但顯然投票權是不夠的，除非選舉是公平的投票。這張海報是給予最近新聞上選舉舞弊的國家的回應，例如伊朗和俄羅斯。
This poster was designed for an international invitational poster exhibition on the subject of voting rights as well as free and fair elections organized by the group '"Posters Without Borders"' of which I am one of the founders. For a society to be free the people must have the right to vote on their leaders and laws that govern them. The right to vote is not enough though unless the elections are fair and those votes count. This poster is a response to recent news reports of election fraud in countries such as Iran and Russia."

4 / 這張海報本來是設計給一個關於死刑的展覽，將正義女神 (Justitia) 捆綁在電椅上，意思是死刑不會帶來正義，只會帶來死亡。
This poster was originally created for an exhibition about capital punishment. By strapping Lady Justice to an electric chair the implication is that capital punishment is not justice but the death of it."

5 / 這張海報是設計給一個主題為器官捐贈的比賽。這對我來說意義非凡，因為我有個非常親密的朋友正在等待心臟移植。
This poster was created for a competition on the subject of organ donation. It is especially pertinent to me because I have a close friend who is on the waiting list for a heart transplant."

8. 和平，正義，真相 *Peace, Justice, Truth* / 2015

6 / 設計這張海報以讓大眾注意到管理不善的工廠所製造的汙染，這汙染同時也會造成全球暖化。
Designed to create awareness of pollution produced by poorly regulated factories. Pollution that also contributes to global warming.

7 / 我被邀請參加德黑蘭一個紀念" 世界平面設計日 " 的展覽。我是唯一一位被邀請的美國籍人士。當美國和伊朗經常因為不同立場所引起的爭議，我想利用我的海報去表達設計及藝術可以幫助我們去了解彼此，並利用和平、非暴力的方式去解決我們的爭執。
I was invited to take part in an exhibition in Tehran commemorating "World Graphics Day". I was the only American invited to exhibit. While the USA and Iran are often on different sides of disputes I wanted to use my poster as a way of expressing that design and art can help us to understand each other and use peaceful non-violent ways to settle our disagreements.

8 / 我這張海報是在經過一連串非洲裔美國人在無武裝狀態下被警察射殺的事件後所設計的。調查往往都偏向警察，沒有任何警方被起訴或罰鍰，這在槍擊案發生的這些社區裡，導致了更多的騷亂、傷害及破壞財產。最著名的是在密蘇里州裡的佛格森市，麥克布朗的被槍擊案件。主要是呼籲希望在調查這些案件中有真相跟公開。
This poster was designed after a series of events where unarmed African-American men were shot by police. The investigations into the shootings were often biased in favor of the police and none of the officers faced any indictment or charges. This lead to rioting in those communities where the shootings occurred which resulted in many more injuries and destruction of property. The most notable of these incidents is that of the shooting of Michael Brown in Ferguson, Missouri. This poster was designed to call for truth and openness in those investigations.

Q. 請問您認為該國最棒的是什麼？(如國家的特色或文化等)您的創作是否受其影響？

A. 我最喜歡的是在美國有我們生活上的自由，照我們的想法去走，開放地表現自己。在我的創作上有顯著的差別，因為我可以藉由我的海報去陳述我的想法而不必擔心那些限制。這並不是無論我說什麼都要讓人們接受。通常我的設計會讓一些反對層面的人有點回應，但我覺得那對話對一個健全的社會是很重要的。

Q. 請和我們分享您喜歡的書籍、音樂、電影或場所。

A. 我喜歡老舊的電影，尤其是亞佛烈德·希區考克所執導的"後窗"、"北西北"等等。我也喜歡"霹靂高手"及"臥虎藏龍"。雖然我也喜歡現代動作片，但更偏愛舊式電影，因為它們靠的是更多的情節而不是動作。

Q. 請問您做過最瘋狂或最酷的事情是什麼呢？

A. 我曾經做過最瘋狂或最酷的事？這會是一條非常長的清單。不過我覺得是當我大學時，獨自搭車穿越美國西南部。這對我的人生產生很大的衝擊，因為它讓我明白我的獨立與依賴。我自由選擇我要去哪，有很長一段時間非常適應自己一個人，但當我想去哪裡時也依賴搭別人的便車。這讓我走出我自己的舒適圈，讓我自在地接觸陌生人。

Q. 請問您最近最想做什麼事情？是否已經著手規劃下一階段的目標或突破了呢？

A. 我一直都很對社會及政治議題的海報設計很有興趣，但最近開始經營部落格。小時候想過長大後要當個作家和政治漫畫家，在某個程度上這個渴望已經在我的社會及政治海報上得到一個延續。有了部落格後，我可以用更直接的方式，去嘗試寫作及畫政治性漫畫，或設計其他社會及政治相關議題。

Q. 目前有許多行業正在被取代或是沒落，請問您對於平面設計未來的發展有什麼看法？

A. 我寫了一封介紹信給我在墨西哥海報雙年展的同事，安東尼奧·卡斯特羅 H. 和 Eric Boelts。之後我們進行了採訪，有人問我關於平面設計的重要性。我幽默地說：有什麼可以比這個更重要的？但你想想，平面設計師有很大的力量去影響公眾輿論，我相信即使科技變化，真理依然存在。

一個好的設計師總是好奇，不僅找到如何在這個不斷變化的世界繼續設計的應變方法，更會用設計去影響這個變化。

Q. 你對生活的細節上有什麼堅持嗎？(像是上廁所時一定要看詩集之類的)

A. 我不需要太多的物質享受，我唯一需要的是花時間與我愛的人相處。我注重的是經驗多過於物質。目前的經驗下來，旅行對我來說很重要。作家馬克·吐溫就曾經說過：旅遊是偏見，偏執和狹隘的殺手。

Q.What is the best thing In your country? (likes features or culture) Have it ever influence your creation?

A. The thing I like the best about the USA is our freedom to live our lives the way we want to and to express ourselves openly. It obviously makes a difference in my creative work because I can state my opinions through my posters without fear of restriction. That is not to say that people will always accept what I have to say. Often my posters will instigate a response from those with opposing views but I feel that dialog is important to a healthy society.

Q.Share good books/music/movies/places with us.

A. I love old movies, especially those of Alfred Hitchcock such as "Rear Window", "North by Northwest", etc. I also like "Oh Brother, Where Art Thou" and "Crouching Tiger, Hidden Dragon". While I also like contemporary action movies I prefer older movies because they relied much more on plot than on action.

Q.What is the craziest or coolest thing you have ever done?

A. The craziest or coolest thing I ever done? That is a long list but I would probably say hitchhiking alone across the southwestern United States when I was in college. It had an impact on my life because it helped me to realize my independence as well as my dependence. I was free to go where I chose and was okay with spending long periods of time alone yet I was also dependent on other people to give me rides to get where I wanted to go. It got me out of my comfort zone and made me comfortable relating to total strangers.

Q.What are the things you want to do most these days? Have you started to set up new goals or breakthroughs for next period?

A. I continue to be very interested in social and political poster design but have recently thought about starting a blog. When I was young I wanted to grow up to be a writer and an editorial cartoonist—in a way my social/political poster design is an extension of that desire. With a blog I feel I could experiment with writing and drawing editorial cartoons or other designs with social and political content in a more immediate way.

Q.There are many industries are gradually being replaced or decline, what is your view on the future development of graphic design?

A. "I gave a presentation at the Bienal del Cartel en México with my colleagues Antonio Castro H., and Eric Boelts. Afterwards, we were interviewed and someone asked me about the importance of graphic design. My response then was ""What could be more important?"". I was being humorous but if you think about it, graphic designers have tremendous power to influence public opinion. I think as technology changes that truth will still remain

A good designer is one who is always curious and will not only find how design applies in an ever-changing world but use design to affect that change."

Q.What is your insist on your life's details ? like toilet with your favorite poem?

A. I don't need much as far as material comforts. The thing I require in life is spending time with people I love. I value experiences more than things. As far as experiences go, travel is important to me. As the writer Mark Twain once said, " Travel is fatal to prejudice, bigotry, and narrow-mindedness".

美國 USA

Pouya Jahanshahi

www.xpatstudio.com
pjahans@okstate.edu

Pouya Jahanshahi 是伊朗裔美國籍平面設計師,
策展人和教育家,目前在俄克拉荷馬州立大學任
平面設計助理教授。Jahanshahi 在加州藝術學
院取得平面設計和綜合媒體的創作碩士學位。
除此之外,他已在富勒頓加利福尼亞州立大學
（CSUF）完成文學碩士學位,攻讀符號學與動
態影像。他的研究和計畫側重於「混合的視覺文
化」的全球化發展,以及在全球化的環境中獨特
行為的符號學。「文化混種」這樣的觀點引導著
他的視野,在他各地展出的作品當中也可看見,
他的創作本身也跨越了許多媒材。

在國際間提出相關議題的同時,他目前的計畫包
含即將推出的紀錄片:《伊朗平面設計的視覺語
言》。此外,他也是藝術設計團體 Local / Not
Local 的共同創辦人,在知名的國家與國際場合
中展示與波斯阿拉伯文字相關的平面設計。在閒
暇之餘,Pouya 投身當地組織擔任志工,而他也
是個充滿熱情的捐印海報設計師,同時涉獵具體
藝術與書法。

Pouya Jahanshahi is an Iranian-American
Graphic Designer, Curator and Educator,
currently Assistant Professor of Graphic
Design at Oklahoma State University.

Mr. Jahanshahi received his MFA in
Graphic Design and Integrated Media,
from California Institute of the Arts
(CalArts). In addition, his MA studies
were completed at California State
University of Fullerton (CSUF) in Graphic
Design, with emphasis on Semiotics and
Motion Graphics.

His research and projects focus on
the global development of what he
terms "Hybrid Visual Cultures" and the
unique behavior of semiotics in such
environments. This perspective of "Cultural
Hybrid" is what guides his vision, visible in
his works across various mediums being
exhibited in various arenas.

While presenting on such related issues
internationally, his current projects include
the upcoming documentary film: The
Visual Language of Iranian Graphic
Design". Furthermore he is co-founder of
the Art and Design collective "Local / Not
Local", presenting in prestigious National
and International venues in regards to the
rise of Perso-Arabic Typographic Graphic
Designs. In his spare time Pouya volunteers
for local organizations, and is a passionate
silk-screen poster designer, while dabbling
in concrete and calligraphy.

1. 兒童詩人 *Childrens Poet* / 2015

2. 革命的詞彙 *Vocabulary of a Revolution* / 2008

3. 波斯之美 *Persian Beauty* / 2011

4. 亞歷山大大帝 *Darius Alexander* / 2011

1 / 在這部紀錄片（傳記片）中傳奇性的伊朗兒童歌曲創作者 Abbas Yammini Sharif 被塑造成永恆的存在。他的作品被以各種材質與形式呈現，進一步考量到約旦中心的觀眾，設計上同時使用波斯語和英語呈現相關資訊。

In this documentary / biography film the legendary Iranian children's songwriter Abbas Yammini Sharif is made eternal. The multimedia aspects of his work is presented through various textures and forms. The Bi-Lingual audience for Jordan Center if Persian Studies further considered - hence both Persian as well as in English information design is implemented.

2 / 系列版畫中的第一張，以我童年時期在伊朗革命期間間學到的詞彙為基礎。詞是 伊斯蘭革命民兵 - 殉難 - 貴族 - 自由。主要內容是由數位印刷聚合物版所創造成的波斯排版形式，這封信的內容形式帶有協調的混亂，反映孩童時代的我對於他們的想法。英文翻譯部分採用活字金屬印刷──參考精神上的痛苦與回憶──沒有間距，挑戰讓觀看者介入翻譯與解碼每一個字的過程。手的印刷部分為了呈現手的結構，使用粉狀的紅墨水捕捉住細節，同時讓每張印刷品產生細微的個體差異。

First of a series of prints, based the vocabulary I learned in my childhood during the Iranian revolution.
The Words are: Islamic Revolution-Militia-Martyrdom-Aristocracy-Freedom. Main content is comprised of Persian typographic forms create by implementation of polymer plates from digital prints. The letter forms are in a coherent-chaos, reflecting how I thought of them as a child.
English translations were printed using metal type – referring to the mental anguish and memories – with no word spacing, challenging viewer's involvement in the translation process and decoding each word. Hand-print was printed using powdered red ink, to capture the details present in the structure of the hand, as well adding nuances an individuality to each print.

5. 波斯裔伊朗人 *Tehrangeles* / 2011

3 / 也許在所有手工藝品當中，波斯地毯就是波斯文化裡最貼切的象徵。從它精緻的絲綢和羊毛線，到雋永的圖騰與華麗的工藝，這樣的工藝品持續鋪蓋著波斯的所有空間、街道，以及多數 Tehrangeles/ 西洛杉磯的巷弄裡。背景中的地圖顯示這些資源的存在。海報設計成「織布機」和線，與主題互相連接。
Perhaps amongst all artifacts , the Persian carpet best signifies the Persian culture, from its delicate silk and woolen threads, to its timeless patterns and magnificent craft. This artifact continues to weave a Persian presence through any space it occupies, as well the streets and alleys of Tehrangeles / West LA. A map in the background shows where these resources exist. The poster is designed as a "Carpet Loom" with threads connecting to main content.

4 / 認同自己的混合身分難戶是每一個移民的命題，對我來說，身為移民到美國的伊朗人，這雙重身分涉及到公元前331年的史詩級戰爭，亞歷山大大帝造成波斯帝國的潰敗。西洛杉磯的書店內容反映了對這個關鍵的事件的觀點。我的雙重護照構成了雙重的畫面結構：伊朗護照 / 美國護照。以幾何與合成的構成呆板的框架，強調移民的身分。
The adoption of a hybrid identity is amongst the tasks of any immigrant. For me as an Iranian immigrant in the United States, the dual identity is referenced in the epic battle of 331 BC, and the defeat of the Persian Empire, by Alexander the great. The contents of bookstores in West L.A. are a reflection on this perspective at this pivotal event. My dual Passports comprise the main duality-structure : Iranian Passport / US Passport. Emphasized by the Geometric and Synthetic structure as inflexible frame : the identity of an immigrant .

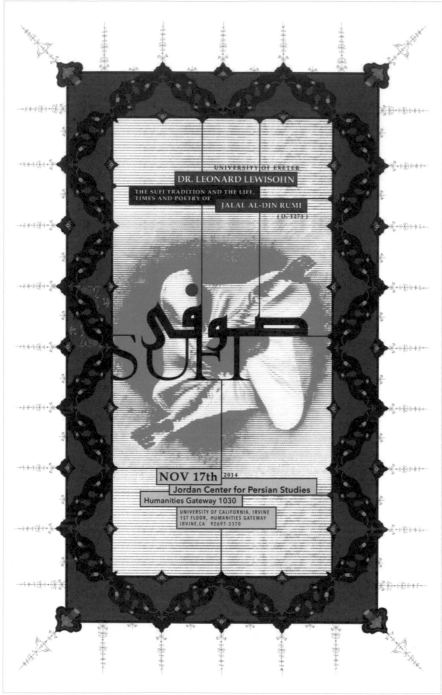

6. The Sufi / 2015

5 / 由於不同代波斯人在 Teherangeles 肩並肩一起成長，波斯語和英語的雙語創建一個新的 " 混合語 "，有時簡稱為 P- 英語。因此同時使用兩種語言的句子，創造了鮮明的發聲的轉變，其本身就是一個美女，聽說一直在 Tehrangeles 附近。這張海報的結構從拉丁 / 波斯字母形式的術語 "TehranGeles" 的製作。相片圍在周邊創建波斯地毯的樣子 - 包括同一地區的房地產。
As different generations of Persians grow side by side in Teherangeles, the dual language of Farsi and English create a new "hybrid language", at times referred to as P-English. Hence both languages are used in a sentence, creating distinct audible transitions between the vocals; a beauty in itself, heard all along Tehrangeles vicinity. The structures of this poster are made from Latin / Persian letter forms of the term "TehranGeles". The surrounding photos create a Persian carpet form - comprising of real-estate shots of the same vicinity .

6 / 講授著名詩人和哲學家 Jalaldin Rumi 的特點，本次活動的海報著重於 "Sufi" 的主體。要產生出兩個東方西方的廣告視角，波斯字和拉丁文譯本合併 - 創建一個混合詞表（中心）。視覺從上方往下拍攝 Sufi 舞者，進一步強調了這個方面。半傳統的裝飾畫框提供結構組成。
Lecturing on the characteristic of renowned poet and philosopher Jalaldin Rumi, this event poster focuses on the main subject of the "Sufi". To bring forth both Eastern ad western perspectives, the Persian word and Latin translation of the word are merged - creating a hybrid word-form (center). The visual of a Sufi Dancer shot from above sits behind these forms, further emphasizing the this aspect. The semi-traditional ornamental picture frame provides structure for the composition.

Q. 請問您認為該國最棒的是什麼？(如國家的特色或文化等) 您的創作是否受其影響？

A. 我很感激我見證了 (美國) 文化的融合，融合國際文化與傳統，當生活在受限制下的生活條件時，允許人們探索整個世界，所有的一切。同時也讓每個地方與國家增加了他們的傳統與對於當地文化的看法。更重要的是你擁有自由 (或者說是挑戰) 去推動自己探索未知的領域。

Q. 請和我們分享您喜歡的書籍、音樂、電影或場所。

A. 在音樂方面, Niyaz 樂團是我最喜歡的，一個真正的世界音樂能讓全球縮成一張專輯。書:It Is Beautiful - Then Gone by Martin Venezky 是本神奇的書, 不停地啟發著我。"DesignObserver.com" 網站是給所有設計愛好者的每天都必訪的一站。在印刷出版方面, Eye Magazine 真的是一本值得擁有和推薦給其他人看的雜誌。Cooper Hewitt Smithsonian Design Museum, 是我最喜歡的地方, 每當我在紐約都會在那停駐, 享受來自世界各地的設計。

Q. 請問您做過最瘋狂或最酷的事情是什麼呢？

A. 我人生中的每一刻都可能是瘋狂的事情, 所以我推薦以下三種:

潛水將不同於世界的規則、色彩和生物帶入你的生活。下一個是到土耳其和鄰國伊朗 (我的祖國) 旅遊, 替我揭示人類文明的古老文化。

Q. 請問您最近最想做什麼事情？是否已經著手規劃下一階段的目標或突破了呢？

A. 我喜歡太極拳和在綠色的森林裡放鬆。我也參與紀錄片的工作, 是關於伊朗平面設計的興起, 標題是 In-Betweenness (到我們的臉書專頁看看吧)。我會參加 DesignInquiry.net 的活動, 預計今年夏天過後結束, 這活動集合了我的母校加州藝術學院和其他世界各地的創意思考。但是, 然而我還是不斷地激勵自己, 廣泛的在藝術與文化上曝光, 讓我的創意掌握一切, 帶領我到任何可能的地方, 畢竟我的名字在波斯語中意味著「探索者」!

Q. 目前有許多行業正在被取代或是沒落, 請問您對於平面設計未來的發展有什麼看法？

A. 只要有人類的存在, 視覺傳達就會存在, 人們使用它們的視覺瀏覽他們的生活。我看見的是平面設計光明的未來, 特別是以獨特性與在地性的觀點來看。科技將成為持續學習的曲線, 我們必須適應。最有趣的是文化與設計的交會, 平面設計正在向傳統挑戰, 將現代藝術視為能傳達給大眾的一種流派。

Q. 你對生活的細節上有什麼堅持嗎？(像是上廁所時一定要看詩集之類的)

A. 人生是世界。視覺美感, 設計和其發展讓人生變得如此繽紛將每一次呼吸視為你的最後一口, 並選擇沒人走過的路。

Q. What is the best thing In your country? (likes features or culture) Have it ever influence your creation?

A. I appreciate the merging of (The United States) that I witness in this country. International cultures and traditions merge, allowing one to explore the whole globe, while living within the restrictions of the human condition. All this, while every locality and State adds its own heritage and perspective to local cultures. More importantly you are free - in-fact challenged - to push yourself and explore unchartered territories.

Q. Share good books/music/movies/places with us.

A. In music, the band "Niyaz" is one of my all-time favorite music, a true world music bringing the globe into one album. Book: The Amazing book "It Is Beautiful - Then Gone" by Martin Venezky is a continuos inspiration to me. The Web site "DesignObserver.com" is a one stop daily ritual for all Design enthusiasts, while on the print side, "Eye Magazine" is truly a publication to have and hold, and pass on to others. Cooper Hewitt, Smithsonian Design Museum is amongst my favorite place stop by to taste design from around the world and throughout the spectrum of time whenever I am New York City.

Q. What is the craziest or coolest thing you have ever done?

A. I look at my every moment as a potential for a "crazy / cool" event. So I recommend three here:

Scuba-diving brings a world with different laws, colors, and creatures to your life. Next traveling to Turkey and neighboring IranIran (my ethnic homeland), exposed me to the ancient cultures of the human civilization.

Q. What are the things you want to do most these days? Have you started to set up new goals or breakthroughs for next period?

A. I love TaiChi and relaxing in the greens of forest. I am also working on a documentary of film on the Rise of Iranian Graphic Design entitled "In-Betweenness" (check our Facebook page). I will be attending the (DesignInquiry.net) retreat later this Summer,collaborating with creative minds from my Alma mater (CalArts) and others around the globe. However, In general I am constantly pushing my self to be exposed a wider spectrum of Art and Culture allowing my creative side to take over and take me where it may. After all my name in Persian means "Explorer"!

Q. There are many industries are gradually being replaced or decline, what is your view on the future development of graphic design?

A. Visual communication will be around as long as there are humans, who use their visual senses to navigate their lives. I see bright futures in the realm of Graphic Design, especially from unique and local perspectives. Technology will be a constant learning curve we have to accept. The most interesting of all is the intersection of Culture and Design, where Graphic Design is challenging the traditional place of Modern Art as a genre that can communicate to masses.

Q. What is your insist on your life's details ? like toilet with your favorite poem?

A. Life is an earthly. Visual beauty, design and form make ones life more flavorful... breathe every moment as its your last and take the road less travelled.

平面設計在數位媒體時代中的未來展望

graphic design in the future of digital media

1983ASIA

劉兵迎 Liu Bing Ying

施元欣 Shi Yuan Xin

王瑞峰 Wang Rui Feng

王曉雪 Wang Xiao Xue

溫力 Wen Li

Andriew Budiman

梁海傑 Keat Leong

陳信宇 Chen Hsin Yu

吳穆昌 Wu Mu Chang

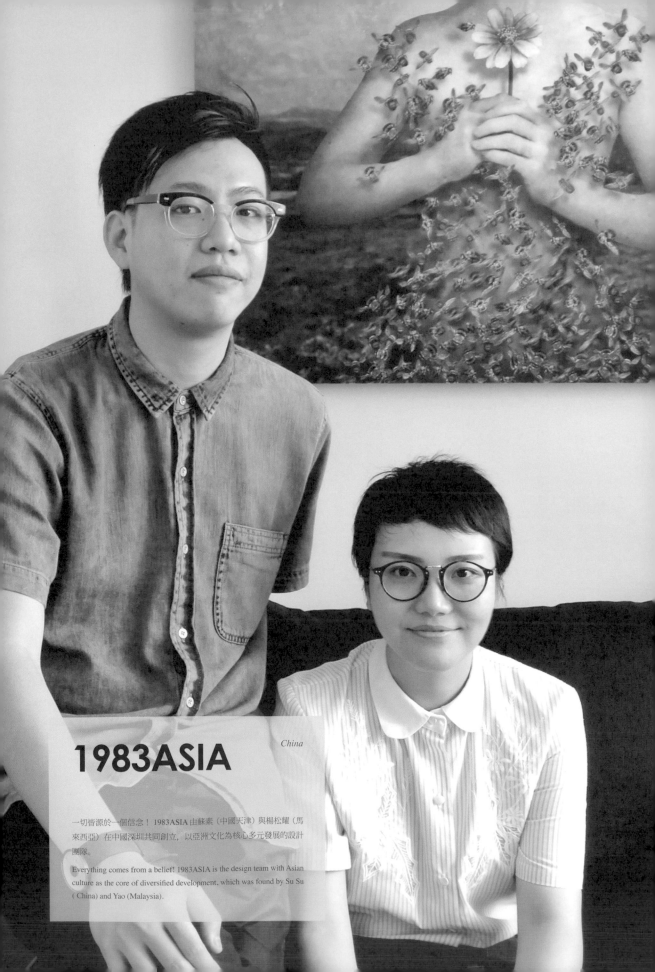

1983ASIA

China

一切皆源於一個信念！1983ASIA 由蘇素（中國天津）與楊松耀（馬來西亞）在中國深圳共同創立，以亞洲文化為核心多元發展的設計團隊。

Everything comes from a belief! 1983ASIA is the design team with Asian culture as the core of diversified development, which was found by Su Su (China) and Yao (Malaysia).

平面設計在數位媒體時代中的未來展望
graphic design in the future of digital media

黃 金 時 代

時代巨輪不停地轉動，許多變革都顯得勢在必得。但設計並不只是一門手藝，還包括看待事物的獨特切入點，以及創新性的思考模式，這種感理兼具的神經觸覺必然會在未來的世界越放光彩。

雖然世事萬變，我們會對消失的共同回憶感觸不捨，會比較新興與舊的好壞，甚至需要不斷的自我學習才能找尋生活出路。而改變並非匆忙地搭上時代的快車，雖然我們預測不了未來的千變萬化，我們唯一可以確定的是自己內心喜愛。

數位媒體時代可能會衝擊以紙為媒體的相關行業，甚至造成結構性失業等社會問題，但平面設計的輸出窗口並非只適用於一種材質，只不過是當下和紙媒的關係比較密切，這樣說起來雖然令人感到一絲難過。

設計是依附在商業基礎下茁壯成長的行業，人們溝通的窗口變換了，設計需求也自然而然的改變；但不代表誰可以取代誰。就好像電影業雖然也面臨網絡影站的挑戰，可是喜歡電影的人依然會購票入場，因為某些體驗是無可取代的；又或者因為某個優秀的導演出品，某個有期待的演員參與，某個吸引的題材我們也會選擇進入到影院觀賞。但同時也因為競爭對手的出現，電影業與相關產業會不斷豐富自身的價值去提高在人們心目中的地位。

因此，高質量的出品是面對萬變中不變的原則。可能我們心中還是會緬懷曾經的那段黃金歲月，那些平常垂手可得的日常在未來會變成年代經典，只是新的故事卻也已經在某個時刻開始了。

Golden Age

The age of the ship kept turning, many changes are wining in effective way.

Design is not only a craftsmanship. It also includes the unique starting point for the thing, as well as the innovative thinking mode. The perceptual and the rational combination neural sense of touch will inevitably be more glorious in the future world.

The world has changed, we will feel reluctant about the disappearance of common memories, and also, we will compare new and old, good and bad things. Sometimes we even need to constantly keep self-learning to find life way out. The change does not mean rush to take the express train. Although we can't predict the future, the only thing we can do is following the things that we really love to do from our heart.

The digital media era may impact the industry related to paper media, even cause the unemployment and other social issues. But the output window of the plane design is not only suitable for one kind material. It has a close relationship between paper media right now. This makes us feeling sad.

Design is the industry which depends on the business foundation. The window of communication has been changed. Design requirements are naturally changed as well. But it doesn't mean who can replace who. As though the film industry is also facing the challenge of network station, but people who really like film will still buy the ticket and go to cinema. because some experience is irreplaceable. A good director, a good actor or an attractive story may attract people go to cinema to watch movie. At the same time, because of the emergence of competitors, the film industry and related industries will continue to enrich their own value to improve the status of people's minds.

Therefore, produced in high quality is the only principle of facing the changing world.

Perhaps we have the memory of the golden years of the days we have. The usual readily day will become classic in the future. New story also began at some point.

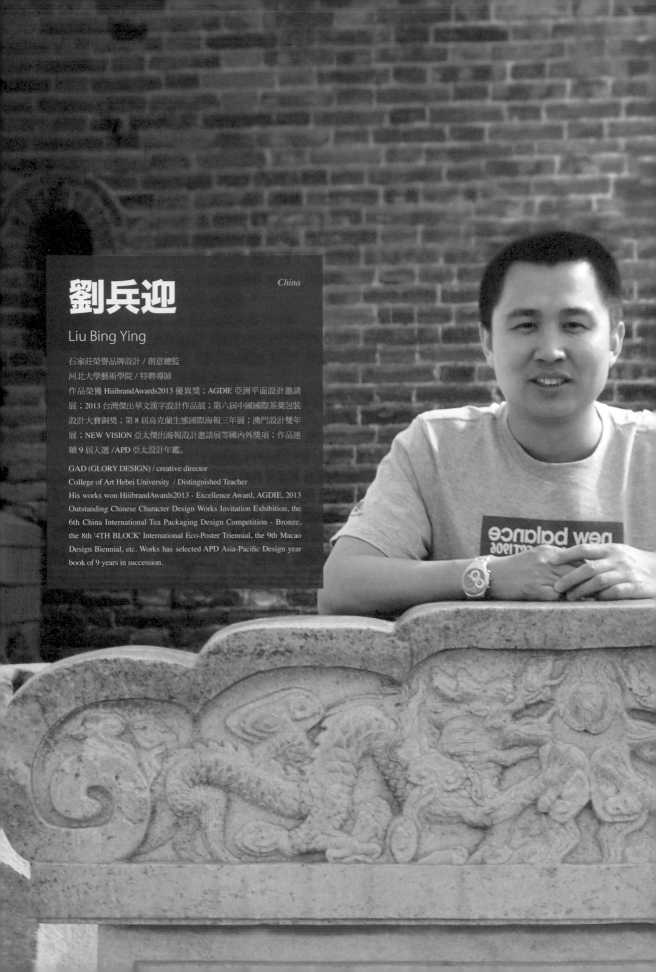

劉兵迎

China

Liu Bing Ying

石家莊榮譽品牌設計 / 創意總監

河北大學藝術學院 / 特聘導師

作品榮獲 HiiibrandAwards2013 優異獎;AGDIE 亞洲平面設計邀請
展;2013 台灣傑出華文漢字設計作品展;第六屆中國國際茶葉包裝
設計大賽銅獎;第 8 屆烏克蘭生態國際海報三年展;澳門設計雙年
展;NEW VISION 亞太傑出海報設計邀請展等國內外獎項;作品連
續 9 屆入選 /APD 亞太設計年鑑。

GAD (GLORY DESIGN) / creative director

College of Art Hebei University / Distinguished Teacher

His works won HiiibrandAwards2013 - Excellence Award, AGDIE, 2013
Outstanding Chinese Character Design Works Invitation Exhibition, the
6th China International Tea Packaging Design Competition - Bronze,
the 8th '4TH BLOCK' International Eco-Poster Triennial, the 9th Macao
Design Biennial, etc. Works has selected APD Asia-Pacific Design year
book of 9 years in succession.

平面設計在數位媒體時代中的未來展望

graphic design in the future of digital media

近年來網絡媒體與軟件技術的迅猛發展，既對傳統平面設計產生了巨大的衝擊，同時也給平面設計打了一針強心劑，給平面設計的發展帶來了前所未有的改變。首先，從互動交流角度來講，網絡的扁平化讓我們可以和當今全球最頂尖的設計師面對面溝通，可以第一時間獲悉各種全新設計方案的發布，第一時間了解更多前沿設計的走勢。即使你是在一個小小的城市，你一樣能與世界同步，與大師比肩。其次，從商業設計角度來講，全新的數位媒體讓我們從倡導"平面不平"一躍成為"平面必須不能平"，這明顯是網絡媒體發展與市場需求驅動的結果，利用全新的媒體與軟件讓我們的商業設計有了全新的表達方式，讓客戶與消費者有了全新的感受與體驗。第三，平面設計在網絡媒體時代需要全新定位與思考，這不是單純的加價法。平面設計行業不可否認是一種利用當下最流行的語言與元素來傳達訴求的職業，而傳統的平面設計已經無法滿足市場發展的需求，設計並非只是視覺的呈現，有更多細膩的層次是無法通過單一的平面來傳達，一名出色的平面設計師在當下更多的時候擔當的是"導演"的角色，是一種對資源的整合和對審美的整體把控，需要通過自我對產品和市場的理解，圍繞平面視覺的表現，用消費市場接受度最高的形式，讓視覺更準確、更時尚、更完全地表達。

In recent years, the rapid development of Internet and software technology not only made a sizeable impact on traditional graphic design ,but also gave a fillip to the graphic design , and brought unprecedented changes to the development of graphic design. First, from the perspective of interactive communication, network of flatting can bring us a face to face talk with the world's top designers, and can get us a first information about releasing of variety of new design scheme, we also can understand the trend of more advanced design by first time. Even if you are in a small city, you can keep pace with the world, place yourself on a par with the master. Secondly, from the perspective of commercial design, a new digital media make us from advocating "Graphic is not normal" become to "Graphic must be not normal", this is obviously a result of network media development and market demand driven, Using new media and software make our commercial design have a new way of expression, let customers and consumers have a new feeling and experience. Thirdly, graphic design needs a new orientation and thinking in network media era, this is not a simple markup method, the graphic design industry is undeniably a language and using the most popular elements to convey the aspirations of the occupation, and the traditional Graphic design already cannot meet the needs of market development, the design is not a kind of visual presentation, more exquisite level cannot be conveyed by single graphic design, an excellent graphic designer of then plays the "director" role at the presently time , it is a kind of whole controlling to the resource integration and the overall aesthetic, through the self understanding of the product and the market, focus on the visual performance in the consumer market, the highest acceptance form makes the vision more accurate, more fashion, more complete expression.

施元欣

Shi Yuan Xin

China

1983 年生於中國廣東省潮州市，2008 年畢業於韓山師範學院美術系獲學士學位。2009 年至今任教於中央美術學院實驗藝術學院。現生活、工作於北京。

I was born in 1983 in Chaozhou City, Guangdong Province, China. In 2008, I graduated from the Fine Arts Department of Hanshan Normal University with bachelor degree. Since 2009, I taught at the China Central Academy of Fine Arts Experimental School of the Arts. Now I live and work in Beijing.

平面設計在數位媒體時代中的未來展望

graphic design in the future of digital media

當今世界變化極大，科學技術日新月異，隨著科技的進步和網絡的普及，人們開始不滿足於以往的視覺審美範式。瞬息萬變的環境驅使人們前往探尋新的審美疆域，人類對未知領域的好奇心和探索欲促使其借用前沿科技手段來獲得嶄新的視覺經驗，通過視覺革新獲得更多審美享受。

我把平面設計中的兩種載體稱為虛擬（網絡媒體）與現實（紙媒體）。網絡媒體的優勢在於傳播速度快、動態信息多、呈現方式雜。紙媒體的優勢在於它自身可謂精神的物化，其自然屬性與人類相通，可供人們欣賞把玩，可觸可感的特性成為人類心靈的慰藉。數位媒體時代的到來改變了以往傳統的視覺傳播方式，也可以說是平面設計迎來一個新的增長點。從空間上來說，由二維平面化的實體空間延伸到三維立體化的虛擬空間；從展示過程上來說，由靜態化呈現向動態化展示轉變；從傳播方式上來說，由傳統的印刷產品轉化為更虛擬的形態進行傳播。兩者之間是相互依存的關係，折射出一種螺旋式上升的態勢。未來，面對這樣的態勢，我有足夠的信心。

我想，在人類的視覺審美經驗不斷提出更高要求的趨勢之下，平面設計跟隨時代積極應對，那許許多多的成功案例彷彿是一種證明，恰恰推動了平面設計的發展，這是毋庸置疑的。

World changing greatly, technology has advanced at a breathless pace. Along with the advancements in technology and network popularization, the previous visual aesthetic paradigm cannot satisfy what people need. Ever-changing environment drives people to explore new aesthetic territory. Because of curiosity and exploratory desire in unknown area, human attempt to use cutting-edge technology to obtain its brand-new visual experience and through visual innovation to gain more aesthetic pleasure.

I call the two kinds of carriers in graphic design as virtual (network media) and reality (paper media). The advantages of the network media are high communication speed, large dynamic information and variety of presentation. On the other hand, the advantages of paper media are that paper media itself is the materialization of human spirit. Its natural property alike with human beings, people can touch it and play it, the real and bodily feeling can comfort human mind. The arrivals of the digital media era have changed the old way of visual communication and bring the graphic design in a new growth point. In space, from two-dimensional spatial entities extended to three dimensional virtual space; in display process, from static presentation to dynamic display; in modes of transmission, from the traditional print products into a virtual form. The relationship between the two are mutually dependent relationship, reflects an upward spiral situation. And I have enough confidence to face this situation in the future.

What I think is, with an advanced requirement of visual aesthetic and aesthetic experience, graphic design should actively response with that. Many success stories are a kind of proof and push the development of graphic design, which is beyond doubt.

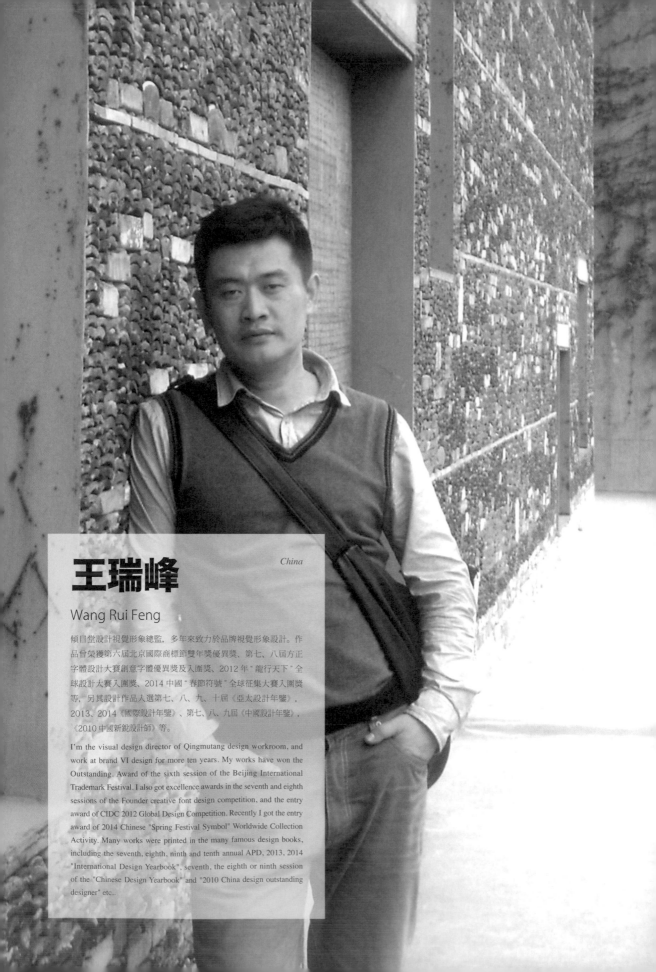

China

王瑞峰

Wang Rui Feng

傾目堂設計視覺形象總監,多年來致力於品牌視覺形象設計。作品曾榮獲第六屆北京國際商標節雙年獎優異獎、第七、八屆方正字體設計大賽創意字體優異獎及入圍獎、2012年"龍行天下"全球設計大賽入圍獎、2014中國"春節符號"全球征集大賽入圍獎等,另其設計作品入選第七、八、九、十屆《亞太設計年鑒》,2013、2014《國際設計年鑒》、第七、八、九屆《中國設計年鑒》,《2010中國新銳設計師》等。

I'm the visual design director of Qingmutang design workroom, and work at brand VI design for more ten years. My works have won the Outstanding. Award of the sixth session of the Beijing International Trademark Festival. I also got excellence awards in the seventh and eighth sessions of the Founder creative font design competition, and the entry award of CIDC 2012 Global Design Competition. Recently I got the entry award of 2014 Chinese "Spring Festival Symbol" Worldwide Collection Activity. Many works were printed in the many famous design books, including the seventh, eighth, ninth and tenth annual APD, 2013, 2014 "International Design Yearbook", seventh, the eighth or ninth session of the "Chinese Design Yearbook" and "2010 China design outstanding designer" etc..

平面設計在數位媒體時代中的未來展望

graphic design in the future of digital media

新探索 X 心希望

數位多媒體一詞如今已不再新鮮，它已悄無聲息的蔓延到我們生活的方方面面。在平面設計領域尤為明顯突出，導演了多方面的變革與顛覆，傳統格局已被打破，新的變局巍然成形。

在這場不見硝煙的演變中，我們應轉變觀念，積極探索，尋找破點，積極應對，才能明晰未來，生出希望。

一、破局

藝術界有句「筆墨當隨時代」，我認為用在平面設計也是通用的。當下讀圖時代的背景下，電商微商異軍崛起，帶來的是手機微信業的盛行，它的出現直接導致了傳統紙媒的全面萎縮。面對如此時局我們應調整心態，轉變思維，審時度勢，摒棄舊的觀念，尋找新的破局點。不破不立，只有破才能立，才能穩定心態。

二、探索

創新一詞時常在平面設計出現提及，新舊更替日新月異是自然法則，也有其發展規律，如何應對尋找出路，唯有不斷探索與創新，數碼多媒體的出現帶來的不僅僅是平面設計的發展瓶頸，我們應用多元的視角來觀察分析，不斷探求與平面設計相融合的新機遇、新挑戰。

三、生機

「沉舟側畔千帆過，病樹前頭萬木春」，新媒介、新思維、新行業都是新的，在其面前我們自己也是新的。新，這裡不是創新，而是嶄新的開始。改變自己才改變未來，從心開始，才能延生無限生機。

「臨淵羨魚，不如退而結網」，樂觀向上，迎對朝陽！

New exploration X The hope from heart

The term digital multimedia is now no longer fresh, it has quietly spread to every aspect of our lives. Particularly prominent in the field of graphic design, director of the various changes and subversion, the traditional pattern has been broken, the new change which is forming.

In the evolution of the see the smoke, we should change ideas, actively explore, looking for breaking point, positive response, to clear the future and hope.

First, broken

Art there is a "pen and ink when over time" I think in the plane design is universal. The moment under the background of the era of reading, electricity derivative military rise, is brought about by the mobile phone micro XinYe prevails, it directly led to a general decline of traditional print media. Faced with such situation we should adjust the mentality, change thinking, situation, instead of the old ideas, find new broken points. Nothing down, nothing up, only to break the state to stable state of mind.

Second, the discovery

Innovation is a word often appear in the plane design, the old and new replacement is changing laws of nature, also has its own law of development, how to deal with to find a way out, only the constant exploration and innovation. The emergence of digital multimedia brings not only the development of graphic design bottlenecks, view we used multivariate analysis, continuously explore and the integration of the plane design of the new opportunities and new challenges.

Third, Life

"Sinking ship side side thousand sails, tree ahead keeping green forever", new media, new thinking, new industries are new, before its our own's new, too. New, here is not innovation, but a brand new start. Change yourself to change the future, begin from the heart, can generate infinite vitality.

"The pond, not retreat and netting", optimistic upward, the sunrise!

王曉雪

China

Wang Xiao Xue

自由藝術家
2008 深圳大運會海報設計競賽優秀獎
2008 可口可樂瓶形設計競賽銅獎
2011 中國台灣國際海報設計優秀獎
2011 GDC11 入圍獎
2011 香港環球設計競賽銅獎
2011 日本 TDC 銅獎
2012 中國設計大展
2013 GDC13 入圍獎
2013 No.9 設計年鑑
2015 日本 TDC15

Freedom Artist
2008 Shenzhen University Poster Design Competition Merit Award
2008 Coca-Cola curved bottle design competition Bronze
2011 China Taiwan International Graphic Design Competition Merit Award
2011 Graphic Design in China (GDC) Finalist
2011 Hong Kong (HKDA) Universal Design Award Poster Design Bronze
2011 Japan Tokyo Type Directors Club (TDC) Bronze(The work
 exhibitioned at the ginza graphic gallery in Tokyo and in June at the
 ggg gallery in Osaka.)
2012 China Design Exhibition
2013 Graphic Design in China (GDC) Finalist
2013 The Work Have Been Selected In Asia-Pacific Design No.9.
2015Japan Tokyo Type Directors Club (TDC)

平面設計在數位媒體時代中的未來展望

graphic design in the future of digital media

走出安全地帶！

接到文章邀約的郵件，我第一個想法就是讀者到底想看什麼？讀者需要看到什麼？這種思考很重要，因為CTA本次活動的周期很長，在此一定是要在設計的學術界產生一定影響力，並且去注射活力的。於是，我開始閱讀CTA的資料，看到了策展人陳育民先生寫下的一段話中，我看到了一些關鍵詞：平面設計，數位媒體時代，新定位，多元...

由此，我看到了一些平面設計不安於現狀的因素開始存存了，也許已經存在很久了，對於設計，我們不斷的定義又不斷的推翻，而好多定義是可以同時存在的，是兼容並包，和而不同的。設計是一個多學科的領域，我們好像也聽過類似的說法，比如：藝術是一個多學科的領域，物理是一個多學科的領域，商業是一個多學科的領域...數位時代與傳統媒介伴隨科技的發展與社會的進步，交相呼應而不是相互抵消。

平面設計師堅定的保衛著傳統的學術陣地，排斥著互聯網的飛速而不完美，而又對各類新鮮的資訊津津樂道。新媒介並不可怕，所有的新媒介都將成為傳統媒介，平面設計師應該拿著固有的知識體系踏上新的旅程了，走出安全地帶，去尋找新的理想國，這個理想國可以是：危險的、動蕩的、刺激的、祥和的、溫柔的、充滿誘惑的、市井百態的...但絕對不是所有人都一個樣的。所有平面設計師都是複製人，沒有個性的，被片面的學說洗過腦的，對自我或外界缺乏好奇心的。對於當代的設計師，最好不要被概念畫地為牢，未來的我們確實可以成為有遠見卓識的人，建築師，搖滾樂手，藝術家，美食家，以及政客...

每個時代年輕人要做的事情和責任都是不同的，幾十年後的CTA訪談等待另一批佼佼者去做新的訴說。

Go out of the safety zone!

The moment I received the inviting email, the thoughts of what do the readers want to see, and what do they need to see came into to my mind. This is very important because it shall to be influential and to inject new blood into the academic circle of design in the long period of CTA. I started to read the data of CTA, and saw some remarks by Mr. Chen ,Yu-min, the chief curator. From where I saw some key words: graphic design, digital media era, new positioning, multielement...

Therefrom, I found some existing restless elements in graphic design, which may have been existed for a long time. With respect to design, we continue to define and to overthrow, and a lot of definition can exist al Ihe same time as they are inclusive, in unity but without uniformity. Design is a multi-disciplinary field, which is very familiar, such as art is a multi-disciplinary field, so does physics and business, and so on. The digital media era echoes with traditional media with the development of science and technology as well as the society, instead of cancelling each other out.

Graphic designers defend the traditional academic front firmly while reject the rapid-developing but imperfect internet, but they also take delight in talking about various fresh information. The new media is not that terrible, all new media may become traditional, so it's time for the graphic designers to set off a new journey with their own knowledge system, stepping out of the safety zone and looking for the new Utopia: it is perhaps dangerous, turbulent, exciting, peaceful, and alluring...but not the same for everyone as if all the graphic designers are cloning humans without personality, brainwashed by one-sided theory, lack of curiosity to selves and surroundings. For contemporary designers, it is better not to be restricted by notions, and we can indeed be architects, rock musicians, artists, gourmet, and politicians with visionary...

Youngsters have different things to do and different responsibility to take in each age, and decades later, the CTA interview will waiting for new ideas from another group of elites.

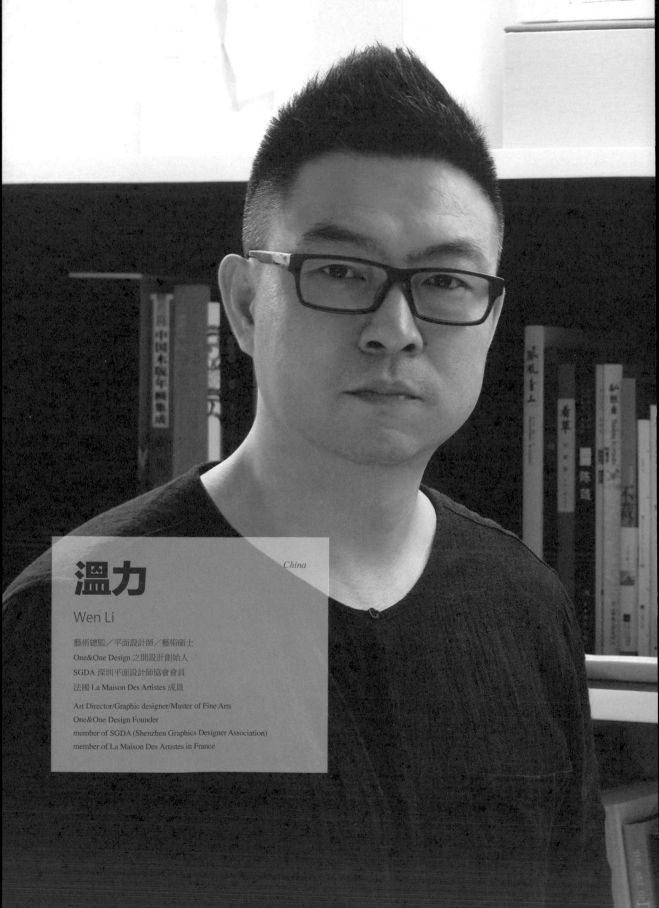

China

溫力

Wen Li

藝術總監／平面設計師／藝術碩士
One&One Design 之間設計創始人
SGDA 深圳平面設計師協會會員
法國 La Maison Des Artistes 成員

Art Director/Graphic designer/Master of Fine Arts
One&One Design Founder
member of SGDA (Shenzhen Graphics Designer Association)
member of La Maison Des Artistes in France

平面設計在數位媒體時代中的未來展望

graphic design in the future of digital media

早在上世紀 60 年代麥克盧漢（Marshall McLuhan）就提出，媒體即信息，媒體的演進深刻地影響著時代，也毋庸置疑地影響著未來，這一點在我們所處的當下尤為鮮明。平面設計作為一種與人們生活緊密相連的藝術存在和表達，在數位媒體、網絡媒體盛行的時代語境下，正在邁向「平面設計＋」的新維度。

縱覽平面設計發展史，它的上下文關系揭示，平面設計向來都賦有基石般的使命，它是美好、它是歌頌、它是感召力，它是強有力的嘲諷……但從某種意義上說，它總需要附著在某個主體之上。而今天，在「再微小的個體也有品牌」的口號煽動下，在「人人皆媒體」和「全民創業」的社會現實中，平面設計更是成為了一切的基礎，前所未有地被需要著，這也是我所說的「平面設計＋」時代到來的佐證，它意味著平面設計正在與當下媒體、甚至未來媒體的深度跨界。換個角度理解，平面設計的基礎原理始終不變，變的只是平臺和媒體而已。

平面設計在數位媒體時代的未來具體是什麼我無法清晰描述，但我相信它一定充滿無限可能，以「平面設計＋」的思維和實踐探索，在虛擬與真實相交的時空中，平面設計師與受眾不斷地角色互換，共同地解構與重建，我想，平面設計的未來終將動態地顯現。

In the 1960's, Marshall McLuhan said "The medium is the message", the evolution of media affect the age deeply, also affect the future without any doubt, now this is particularly obvious when we live. Graphic design as a kind of connection between people life and presence and expression of art, in the context of the era of digital media, online media prevailed, moving towards new dimensions of "Graphic Design +".

Overview in graphic design history of the context reveals, graphic design have always been endowed with the cornerstone of the mission as it is beautiful, it is praise, it is inspiring, it is a powerful irony......, But in a sense, it is always necessary to attach on as the basis. And today, instigated in the slogan "Even tiny entities also have brand." In the "everyone is media," and "people business" of social reality, graphic design became the basis for everything, needed never than ever. This is what I call the era of "Graphic Design +" coming's evidence, It means working with current graphic design media, and even the future of cross depth of. Change another point, the basic principles of graphic design is always the same, only change the platforms and media.

What is graphic design in the era of digital media is the future I cannot clearly describe, but I believe it must be full of endless possibilities. In "Graphic Design +" thinking and practice at the intersection of virtual and real space, graphic designers and the audience constantly roles were reversed, deconstruction and reconstruction together, I think, eventually appear dynamic graphic design in the future.

Andriew Budiman

Indonesia

Andriew Budiman 是設計合作聯盟 Butawarna 的設計師，Andriew Budiman 同時也是獨立工作室 C2O library &collabtive 和 Ayorek 知識平台的視覺總監。從 2011 開始負責成立、策展還有主導一項計劃 :Design It Yourself (DIYSUB) 泗水會議。2015 年初則開始策劃 Perak Project 展覽。

Andriew Budiman is a graphic designer at Butawarna design. He also works as Visual Director at C2O library & collabtive and Ayorek.org. Since 2011 he co-founded, curated, and directed Surabaya annual design conference; Design It Yourself (DIYSUB) Conference. In early 2015 he started curating Perak Project exhibition.

平面設計在數位媒體時代中的未來展望

graphic design in the future of digital media

從 21 世紀初我還在設計學校學習的時候，我就已經感受到科技以驚人的速度成長。在 2000 年初，我們使用 3.5 軟式磁碟片，但現在我們可以輕鬆的把 256G 的資料放在口袋裡的隨身碟，我必須說這是非常驚人的畫面。儘管討論超級人工智慧會讓人驚嘆——又或許是娛樂——好像不再只是科幻的題材一樣，我還是想討論關於設計師與實體印刷和數位媒體的關係。

回頭看 1995 年，大衛‧卡森出版了《印刷的終結》這本挑釁意味十足的書，說得好像我們只能反抗到底，或是對於科技新知抱持著畏懼。或許以前的人們會因為先進的思想而被處以火刑，思想或是科技超越了他們的時間與常識，相對來說現在的人們放鬆了多了（有好有壞）。以實體印刷的情況來說，我們可能沒什麼好擔心的，中國在西元前數百年前就發明了紙，比起軟式磁碟，紙根本就是科技倖存者中的霸主。

大衛‧卡森那杞人憂天的書出版 20 年後，我們到紙張仍然是普遍被使用著的媒材，而且可以說是以最吸引人的姿態生活在現代，數位可以與印刷串聯，我們發現許多老舊的印刷技術死灰復燃，真要感謝方便的數位檔案與散布。

高科技的印刷技術並沒有完全推廣到全世界，在我的國家印尼，對設計師來說，紙本印刷在不遠的末來都還算是蜜月期。只有在一些城市才能夠使用精美花俏的紙材與最新的印刷機，但印刷不只有最新最炫的科技而已，一些日惹的平面藝術家團體就自己手工製造，突破了印刷的界線，客製化的印刷，讓印刷不再是只有精美內容的產品，我們看到全球許多大型印刷廠的倒閉，也遇見蓬勃發展的小規模出版。

這可以代表很多意思，肯定地說，現今的資訊產出越來越凌亂及難以證實。或許同樣的情形也會發生在設計師及我們專注的能力上。在過去二十年間，有很多我們容易混淆的新專業設計名詞出現，而忘記我們專業的核心目的。身為設計師的我們，在這個千變萬化的媒體環境，擁有越來越多的角色去領導想法和信息，但策劃和連結是更加困難。它是可以被解決的，如果我們能集中精神去看清楚印刷和數位之間的關聯。如果你不介意的話，我一定要找到我的隨身碟，該死的紙堆。

Ever since I started my design school study in at the beginning of this century, I've been witnessing how technology speeds up at an astonishing pace. In early 2000s, we were using 3,5 megabytes data in a floppy disk, now we can easily carry a humongous 256 giga bytes data in a small flashdisk in their pocket. The storage capacity has expanded by about 74898% only within 13-14 years. Quite a breathtaking illustration I'd say. While discussion about super artificial intelligence making humans obsolete could frighteningly—and perhaps entertainingly—feel like no longer a sci-fi material, I'd rather discuss about designer's relationship with print and digital medium.

Looking back in mid-90's, when David Carson published his provocative title, "the end of print", I feel that we tend to be either addicted to confrontation, or we just have acute phobia about the coming of new technology and information. Perhaps in the olden days people could get burned to death for advancing information, ideas or technology ahead of their time and consensus, it seems people are relatively very relaxed now (for better or worse). In the case of paper, we probably have nothing to worry about. Invented probably way hundreds years BC in China, paper could be a juggernaut of medium survivor compared to the floppy disk.

20 years after the alarmist publication, we still see paper being commonly used as a medium, and is arguably living its most attractive moment in today's environment. Digital can make a solid tandem for the prints, as we see the revival of many old print techniques, thanks to more accessible digital documentation and distribution.

Since the distribution of an advanced, high-end print techniques arc not evenly distributed around the globe, in a country like mine, Indonesia, paper could also be considered honeymoon moment for designers in the nearby future. Only limited cities in Indonesia can enjoy some access to a selection of fancy paper stocks and the latest technology of print machinery. But print isn't always about the latest flashy technology. Some graphic artist collectives in Yogyakarta are famous for doing DIY-hack to push the boundaries of print exploration. Paired with a print-on-demand, print now can be more an item of curated and well crafted contents. While we see many global print mass media shutdown, we also encounter many smaller-scale publications flourishing.

It can mean many things, but it is safe to say that today's information production is getting more and more fragmented and hard to verify. We might say the same thing happens to the designers and our ability to focus. We're easily confused with many new terms of design specialization born in the last two decades, and forget our profession's core aim. As designers we have an increasing role to shepherd ideas and messages in this ever-changing media landscape, but curating and connecting them get harder. It can be tackled if we can concentrate and see clearly the connection between print and digital. Now if you'll excuse me, I have to find where I put my flash disk, damn these stacks of paper.

梁海傑

Malaysia

Keat Leong

梁海傑的人生用在探討藝術、設計與動態圖像的數位創作過程。在得到電影與動畫學位後，開始了動態設計的創作職業生涯，之後，他待在新加坡與台北的動態設計工作室。

目前他在吉隆坡是獨立的創意總監，他還在摸索數位藝術的新境界，試著從轉換螢幕上的像素到畫布，產生實驗性的視覺效果。這些創作表達出感謝與反思，如同展開一段心靈之旅。梁海傑的作品在當地展出，作品也被《Asian Creatives Book》、《Advanced Photoshop》、《Motion Graphics Served》收錄。

Keat Leong explores the process of digital crafting in art, design and motion. After graduating with a degree in Film and Animation, his career began with creating motion designs that mesh beautiful aesthetics and fluid animations. Since then he has worked with motion design studios in Kuala Lumpur, Singapore and Taipei.

Currently, he is based in Kuala Lumpur as an independent creative director. He also explores the realm of digital fine art, translating experimental visuals from on-screen pixels to the canvas. These visuals are expressions of gratitude and reflections to being on a yogic journey. Keat's art was exhibited locally and published in Asian Creatives Book, Advanced Photoshop UK and Motion Graphics Served.

平面設計在數位媒體時代中的未來展望
graphic design in the future of digital media

超越二維空間的平面設計

平面設計擁有方便又強大的電腦與數位裝置，平面設計在現代走向了一個有趣的階段。我感覺到明顯的改變，因為現在影像已是我們日常生活的一部份，螢幕開始逐漸取代海報或廣告招牌之類的傳統印刷媒體，螢幕也從不能帶著走的電視轉化成可攜帶的個人化智慧型手機和平版。在這個從紙本轉移到像素的世界裡，我們身邊的數位媒體同時也不斷成長。

什麼是數位媒體的本質呢？它是動態的，可以讓內容動起來、具有互動性、可以針對輸入的內容做出反應，它可以呈現聲音與動畫等元素，而且隨著科技發展，數位媒體可已越來越豐富。數位媒體不再像是二維的紙本，它是非常獨特的媒體，它因為科技而存在於螢幕上供人觀賞，數位媒體有太多太多的可能性，因為數位平台存在著多維空間。

平面設計已經因為新的維度而擴展到全新的領域，舉例來說，動態設計擁有時間和動態兩個元素，App 與網業設計擁有互動的元素，裝置藝術則包含了空間、時間與互動，我認為這些都算是平面設計的一種。但是平面設計仍持續在擴展、接收、結合其他新的元素或媒材，因此，平面設計正在超越只有長度與寬度的二維空間。

無獨有偶，設計的過程也開始改變了。設計師必須考量到印刷圖像以外的事情，有許多因素都要納入考量：空間、時間、聲音、動畫以及互動，觸及所有的設計領域，也就使設計範圍擴大，為了做出多媒體設計，設計師要擁有多項才能，或者與非設計領域的人才合作，像是工程師、動畫師、軟體工程師等。無論是個體或者是團體，為了數位媒體，擴展看來是必要的，意思就是我們要跨越到新的領域——要比以往做更多的學習、探索和實驗。

Graphic Design Beyond Two Dimensions

Graphic design is moving through an interesting phase with the power and convenience of computer and digital equipment we have today. I feel an obvious shift because videos are now part of our everyday and screens are beginning to replace print media like posters and billboards. Screens are also becoming mobile and personal with smartphone and tablet. It is a change from televisions, which does not move with us. With this shift from paper to pixels in the environment, digital media is also growing around us.

And what is the nature of digital media? It is dynamic and allows content to move. It is interactive with programming. It is responsive with input. It can present elements like sound and animation. And as technology develops, it can be even richer in media. Digital media is no longer two-dimensional like paper. It is a very unique media that only exists with technology and visible on screens. There are so many new possibilities with digital media because multiple dimensions can be presented with digital platforms.

Graphic design is already branching out to new areas by receiving new dimensions. For example, motion graphics receives the dimension of time and animation. App and web design receives the dimension of interaction. Art installation receives the dimension of space, time and interaction. I see all these as graphic design too, but it is widening, adapting and combining with other dimensions or medium. It is graphic design going beyond two-dimensions of just length and width.

As this happens, the design process is changing too. Designers should consider other aspects beyond just a single print image. There are more aspects to choose from like space, time, sound, animation and interaction. For all the new graphic design areas, the common aspect is the design scope also widens. Designers are becoming multi-talented in order to create multimedia designs. Or another way is to collaborate with non-designers such as programmers, animators, software engineers and more. Either as an individual or a group, it looks like expansion is needed for digital media. And this expansion also means we are going beyond to a new space – learning, exploring, and experimenting much more than before.

陳信宇

Taiwan

Chen Hsin Yu

台北人。雲林科技視覺傳達設計系碩士班畢。曾任 "DENTSU(電通)" 台灣分公司創意部職位，專長範疇包括品牌、廣告、字體、書籍、編排、包裝等各項平面設計事務。曾入選靳埭強設計獎、莫斯科金蜂獎、墨西哥海報雙年展、IF 概念設計獎等國際獎項。並榮獲2014 紅點設計獎、2015 IF 設計獎、20 屆時報金犢獎金獎、2012 數位典藏與數位學習商業應用競賽首獎、第十三屆交通安全海報創作大賽金獎、2013 Adobe 卓越設計大獎榮譽獎。近年作品更收錄於第8 屆、第 9 屆 APD 亞太年鑑設計專書、2014 國際設計年鑑之中。

Taipei citizen. Graduated with a Master from National Yunlin University of Visual Communication Design. Served as DENTSU Taiwan branch creative department position. Expertise includes branding, advertising, fonts, books, presentation, packaging and others thing of graphic design. Was selected in KAN TAI-KEUNG Design Award. The Golden Bee in Moscow, The International Biennale of Poster in Mexico, iF Design Award……. Won the 2014 Red Dot Design Award. 2015 IF Design Award, 20th Times Young Creative Awards, 2012 Digital Collections and E-learning Business Applications Competition First Prize, 13th Traffic Safety Poster Contest Gold Award, 2013 Adobe Design Achievement Awards Honorable mention ADAA. Works are included in Asia Pacific Design No.8 and No.9, 2014 Excellent International Design Yearbook in recent years.

平面設計在數位媒體時代中的未來展望

graphic design in the future of digital media

以自身經驗及認為來說明，定位上分為兩個部分。紙本媒體來講，材質給予的觸感與立體化的呈現是現階段數位媒體無法取代的地方，也是優勢之一。且平面單純的圖樣及文字呈現或許能藉由數位媒體的傳達，但真實樣貌（如大小及顏色）卻會受到載具的大小、校色影響，容易無法保有設計師最初想傳達之本意。

而數位化的誕生，此時恰能提供設計者另一思維及應用，例如能將平面設計結合擴增實境變為 3D，甚至利用平面上的 QR 碼，增加更多可能。且紙本不會受到電力或訊號的影響，給予觀賞者接收的訊息也較數位媒體能專注、單一（不會大量訊息湧入，也不會有上一頁這按鈕可以點選），因此紙本之平面設計還是有它其重要性。

另以數位媒體來講，隨著科技不斷推陳出新，呈現載具越來越多元，數位浪潮下的設計師將可不必死守單一畫面呈現，藉由數位化的功能越漸增加，平面設計將可以靜轉動，如能藉由增加影音效果及互動環節為文字和影像之外創造更多的樂趣和想像空間。

最後，平面上的訓練，例如布局、美學、或如何精簡卻有力量，是我們設計者自身該有的基本功。將這部分練好，不管轉化於哪些媒介，都將能發揮。而如何將想傳達的內容及美學正確傳達給觀賞者，永遠都是重要的課題，即使身處數位時代也一樣重要。

In my own experience and think to illustrate the positioning is divided into two parts. In terms of paper, the material given to the touch and three-dimensional rendering of digital media at this stage can not be replaced, also is the one of the strengths. And the simple pattern and text presented by digital media may be able to convey, but the real face (such as size and color), it will be effected by the vehicle's size, color correction, can not keep designer originally intention what he want to tell.

And the digitization coming just to provide another thought and application for designers, such as graphic design can combine augmented reality into 3D, and even use QR codes on the plane, adding more possibilities. And the paper is not attected by electric power or signal, giving the viewer the message focus and single than the digital media (not a lot of information into, there will not be Previous that button can click), and therefore the graphic design on paper still has its importance.

In terms of other digital media, as technology continues to introduce new, more diverse of presentation vehicle, the next wave of digital designers will not have to hang on a single screen showing, by the number of bits of the function more increase, graphic design will be able to static into dynamic, such as audio and video can be increased and interactive sessions to create more space for fun and imagination beyond text and images. By increasing the audio effect and interactive sessions to create more space for fun and imagination beyond text and images.

Finally, the training of plane, such as layout, aesthetics, or how to streamline but also have power, it is a basic skills what designer should have. Enhancing this part, no matter what the media can play in transformation. And how would like to convey the right content and aesthetics to the viewer, it is always an important issue, even if living in the digital age just as.

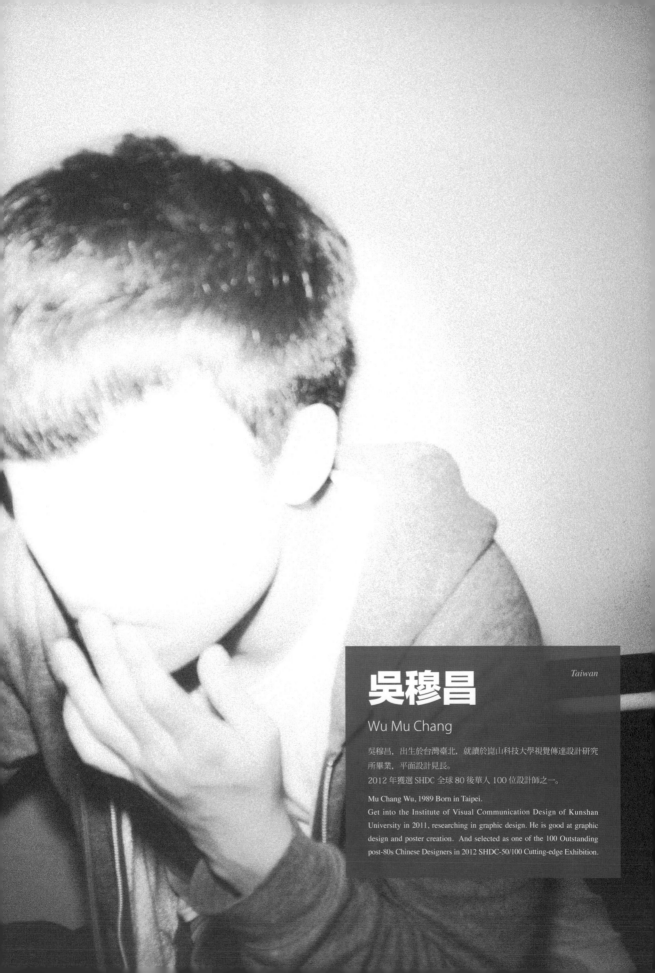

吳穆昌

Taiwan

Wu Mu Chang

吳穆昌，出生於台灣臺北，就讀於崑山科技大學視覺傳達設計研究所畢業，平面設計見長。
2012 年獲選 SHDC 全球 80 後華人 100 位設計師之一。

Mu Chang Wu, 1989 Born in Taipei.
Get into the Institute of Visual Communication Design of Kunshan University in 2011, researching in graphic design. He is good at graphic design and poster creation. And selected as one of the 100 Outstanding post-80s Chinese Designers in 2012 SHDC-50/100 Cutting-edge Exhibition.

平面設計在數位媒體時代中的未來展望

graphic design in the future of digital media

我想對於所有從事平面工作的人而言，生活日常的記錄絕不僅止於文字，信手捻來的紙張所書寫的除了敍述性的字眼外，更常見的便是以圖代文的方式描繪出當下所見所聞，將抽象的思想和理論的內容予以形象化的表現而留下更勝於文字的深刻印象，這種無中生有的具象化過程，自然將人類經驗所無法觸及或經由思考而理出的答案，給了最美好的詮釋。尤其在現今數位媒體發展快速的時代下，設計師在詮釋與溝通上有了更多的媒介可作為發揮，科技媒體的日新月異與全球化的交互影響，紛紛給予我們在表現上有更大的自由度和創造力，百花齊放的設計風格更相互彰顯了語言視覺化後的溝通效能與國際化趨勢，但仍有一點比較不確定的是，在這樣的便利下，數位媒體終究是否只淪為一種工具則不得而知。但確定的是各種藝術流派、設計風格的興起與沒落，應都隱隱的牽連著那個時代的社會脈絡，猶如一面鏡子，而我們是否能從這面鏡子當中去反映出自身亦或是社會大眾的需要而不是一味的處於追逐他人腳步向前邁進才正是需要思考的課題，樹立屬於自己的時代風貌、設計脈絡，不是淪為未來教科書上所記載的某一個時代、一群人所追逐的設計風格，它可能曾風行一時，但也不足探討。

For every graphic designer, I think, verbal language is not the only way to document the days. Besides descriptive words written on random papers, graphic designers are more used to put what they see and hear down by pictures. We embody abstractive concepts and theories, and make them more impressive than words. The visualization naturally generates the best definition of what human experience cannot reach or answer by rational thinking. In this particular fast-developing digital media era we live in, designers have more media to use on their communication and interpretation. The interaction between the constant-changing technologies and globalization provides more flexibility and creativity on our designs. The blooming designing styles have manifested communication efficiency and globalization after language visualization. However, facilitated by the convenience, what we are not certain about is whether will digital media become nothing but a tool. But we are certain about the rise and fall of art cliques and styles have all subtly reflected the society of an era. These cliques and styles are like mirrors. Our mission is to try to see our, or the society's, needs from the reflections, and not to simply follow others' tracks. We have to establish the style of our age and the logic of our design. We should not become a trend that only fancies an era or a certain group of people, and then soon become just a few words in textbooks. The trend might mean something at a time, but it does not worth discussing.

新視角
系列講座

New Vision
best reviews of
lectures series

中國 China

1983ASIA「迷色東方」

1983ASIA

一切源於一個信念！
1983ASIA 由蘇素 (中國天津) 與楊松耀 (馬來西亞) 在中國深圳共同創立。多年主導項目的經驗，也成就了多個品牌和我們自己；但一次又一次的喜悅過 後，留給我們的是無盡的沉思 ... 亞洲成長的我們所處的 "實體世界" 是一個基 於西方文化為標準衡量的世界。我們自身的 "亞洲身份" 漸漸被變得模糊，同時也必須要重新學習如何和這個 "世界" 相處 文化的趨同讓我們感到 "全 球化與國際化" 的缺憾「。亞洲傳統文化在西方的脈絡中有時候是羈絆」我 們亦驚覺，只有尋根溯源方能解決內心的矛盾。基於自身的亞洲血統與設計 師的身份，我們嘗試通過研究亞洲文化，打破觀念的界限，並用藝術設計展 示我們的體驗與成果；把看不見的 "文化" 轉化成充滿亞洲魅力的視覺與產品，在現今 "世界" 中找尋丟失已久的喜悅與幸福。

It comes from a faith.
1983 ASIA is co-founded by Su Su (Tianjin, China) and YAO (Malaysia) in Shenzhen China. After years of experience of handling projects, we made several brands also achieve ourselves. However, after the joy come again and again, it left us endless thought. We grew up in Asia which was measured by western culture. In this case, the identity of Asian is getting vague. We used to let the treasure of us go, but we have to learn how to reunite the world. The cultural convergence left us regret for globalization and internationalization."Sometimes, traditional Asian culture is a fetter of western."We are inspired astonishingly that only tracing to the source can solve the inner contradiction. Based on Asian and designer, we tried to break the bound of concepts and used a rt design to show our experience and achievement through studying Asian culture. Turning invisible culture into glamorous Asian visual product is the lost-for-long happiness that we reach for in the world.

大家好！我們是 1983 ASIA；楊松耀來自馬來西亞，蘇素來自中國天津。我們倆都是 1983 年生，生肖豬，因此我們公司的形象創意來源於充滿喜感的豬鼻子。我們共同工作十餘年，為了能做我們想做的設計，4 年前我們選擇了共同創業。創業初期我們一直在思考一個問題：「什麼是我們獨有的而又熱愛的？」

這裡給大家分享一個故事。日本酒開始引進口吹玻璃製成的一升酒瓶是在明治時期。從此，只要提到日本酒就想到一升酒。一升雖重，但一手撐住瓶頸，另一手撐起酒瓶下方倒酒的姿勢，可說是日本酒文化重要的部分，也是日本人的樂趣。日本酒杯和瓶之間的關係，對現代而言很不方便，卻是非常重要的人際溝通形式。一切以合理為優先考量的觀念，使生活越來越方便，但許多傳承的文化卻不知不覺的消失。一路以來看過這麼多海報，我常想是不是有一個方法可以稍微區分一下，也許能有簡單的基準去評判是否為好的海報，我自己會分成三個類型。

因為這樣的例子，讓我們有了一個決心：我們想做的事情是嘗試將「文化」注入到「設計」，從而帶動「商業」，影響「社會」。也就是研究亞洲文化，並把這些寶藏轉化成現代人能接受的視覺，注入到商業推廣上，從而推動文化價值在社會中的腳步。給大家分享一個有意思的案例。The Happy 8

是馬來西亞一家高品質的連鎖民宿。我們接到這個案子的時候，做了大量的資料收集與分析，發現一個重要的關鍵：所有的星級酒店似乎都長一個模樣，除了豪華就是豪華。」但是對旅者來說，他們其實更希望體驗的是獨特的地域文化。最後我們和客戶達成共識，通過文化研究入手此次的設計。

在這裡簡單介紹一下馬來西亞，馬來西亞是個獨特的國家，可以說是亞洲的縮影。這裡住著三大民族，人口最多的是馬來人，接著是華人還有印度人。他們來自不同的文化根源：爪哇文化，中華文化，印度文化 雖然回教是馬來西亞的國教，但他們有選擇信仰的自由權力，如佛教、道教、基督教等等，這些都深深的影響他們的藝術表現形式。而且由古至今，麻六甲港口都是各殖民國家相爭之地。英國，葡萄牙，荷蘭，日本 這些國家都在馬來西亞留下許多豐富的歷史痕跡，各種文化在這裡相互影響交融，同時也因為馬來西亞獨特的地理位置影響，人們特別喜歡純度很高、極為鮮豔的色彩。我們蒐集了種種資料，尋找馬來西亞的文化特色，當我們正苦惱沒有一種文化能代表馬來西亞的時候，卻驚喜的發現，這份多元的，具有包容性的，伴隨著喜悅感的不正是馬來西亞文化嗎！

這裡的人們喜歡鮮豔的色彩，源於馬來西亞位於地球赤道位置，沒有四季之分；日照強，折射出純淨的天空與

1983ASIA

Hello everyone! We are 1983ASIA. YAO is from Malaysia and Su is from Tianjin China. Both of us were born in 1983, the year of the Pig. And that's why we set our company's image as humorous pig nose. We have worked together for over ten years. In order to do the design we want, we start our own business 4 years ago. At the early stage of our business, we kept thinking on a question: what is something unique adorable?"

Here's a story. The glass-made container of O'sake, in volume units divisible by 180 mL (agō), the traditional Japanese unit for cup size, was introduced in Meiji period. Therefore, when it comes to O'sake, its volume unit is agō. Despite the fact that agō is heavy, many meanings are embedded in the design. One hand can be hold on the top of bottle, while the other hand can severed under the bottom of the bottle. That is the important part of Japanese wine culture and the joy for Japanese people. Though the use of the cup and bottle of O'sake is inconvenient in modern society, the relationship between these two containers is a vital way of communication. The idea that take ration as priority can make life more convenient, but the culture is gradually vanished.

Due to this example, we're determined to combine culture with our design, and promote it to influence the society. That is, we will translate the treasure of Asia culture into the way that can be acceptable for modern people,

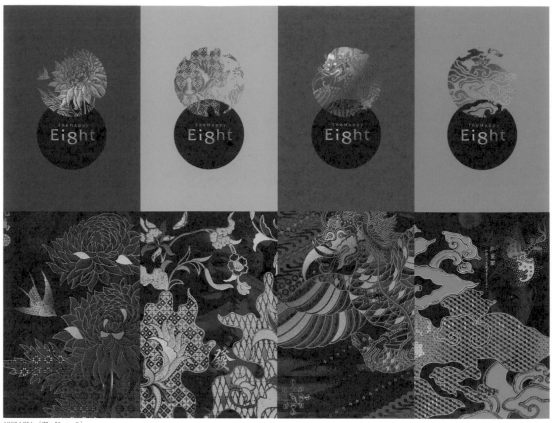

1983ASIA〈The Happy 8〉

海。他們熱情,人與人之間相互尊重,追求共同歡樂是他們的生活理念。

在這個激動的時刻,第二個挑戰迎面而來。The Happy 8 作為定位高端的連鎖品牌,每家分店都有自己的特色與故事。我們需要設計一個既統一而又多變的品牌形象。在這裡,我們作了一個不合常理的思考模式,不從標誌開始設計,而是從品牌整體視覺風格切入。我們希望不瞭解馬來西亞的朋友看到這些視覺,能感覺到他獨特的美,然後嘗試去讀懂他;將傳統的文化帶入現代生活。

我們一直對許多事物抱持懷疑的態度。包括西方資本社會帶來的實用設計潮流;影響亞洲至深的日本美學;還有許多權威性的比賽定下的設計標準;以及被許多設計大師論證過的設計觀點。

「這個時代是否具有更多可能性?」我們帶著這份好奇心開展了另一個項目—AsiaColor 迷色東方。這是 1983 ASIA 與色空間共同創辦,以研究亞洲文化為核心的生活用品品牌。我們提出一個問題:「在西方主導的東方世界,我們應該如何看待自己?」今天給大家展示的一些作品,從品牌設計,包裝設計,產品設計,吉祥物設計,海報創作……都是我們試圖吸收文化的養份,轉化成有營養的設計。我們將作品分享到網上,收到許多國外朋友的良好反應,這些鼓勵成了我們繼續往下走的能量。

每個設計師都有屬於自己的路,很高興今天能和大家分享我們的心路歷程。希望我們今天能帶給大家一些疑問, 1983 ASIA 未來會繼續以亞洲文化為核心發展,希望可以通過不同的形態和大家見面。感謝大會舉辦了一場那麼棒的活動,謝謝!◢

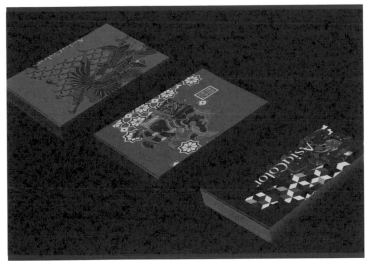

1983ASIA 〈*AsiaColor*〉

and promote it to the society. Here's an interesting case. The Happy 8 is a high-quality chain hotel in Malaysia. As we took the case, we did abundant research and found a key point. All the 5 stars hotels looks exactly the same. Luxury and luxury. But for the traveler, they expects to experience unique regional culture. Therefore, the clients and we achieved consensus to redesign the hotel with culture research.

Let's briefly introduce Malaysia. Malaysia is a unique country, the epitome of Asia. There are three races living on this country. The major is Malaysians and along with Chinese people and Indians. They are from different roots of culture, such as Java, Mandarin and Indian culture. Despite the fact that Islam is the state religion in Malaysia, they are free to choose their religions, such as Buddhism, Tao, and Christianity, which deeply influences their performance of art. From then until now, Strait of Malacca is the strait that raises tensions between colonizers. Britain, Portugal, Netherland and Japan. These countries left abundant heritages on this land. Different cultures infuses

with each other. Malaysian People likes pure and bright colors due to the unique geographic location. As we were worried that nothing can represent Malaysia, we surprisingly found that multiple and inclusive culture with joy. Isn't that Malaysia culture?

People like bright colors because Malaysia is located near the equator. No differences between seasons. The sun is strong, which reflects pure sky and sea. People are passionate. They respect with each other. Pursuing happiness together is their philosophy.

At that exciting moment. Here comes the second challenge. The Happy 8 is positioning as a high-quality chain hotel. Every branch hotel has its own story and characteristics. We need to design a united and changeable brand image. Therefore, we think from an unreasonable way: we begin with key vision instead of logo. We expect that people who don't understand Malaysia culture can feel its beauty and try to read it. We expect to bring tradition into modern life.

uspect many things, including the

trend of pragmatic design brought by western capital society, Japanese aesthetics which greatly influences Asia, the standards set by authorities and the design viewpoint scritiqued by design masters.

"is there more possibility?" We are curious about it. And we, 1983 ASIA, cofound with Colorful Home to create Asia Color, the brand that focus on Asia culture. We raise a question: "How should we see ourselves in a western-leading East world" The works we present today, from brand design, package design, product design and mascot design and poster, are the design that we absorb from culture and transform it into new meaning. We put our works online and receive great response from foreign friends, which encourages us a lot.

Every designer has his path to go. We are glad to share our stories with you. We expect that we can give you some questions.1983 AISA will focus on Asia culture and meet everyone with different way. Thanks for having such a wonderful activity. Thank you! ◢

馬來西亞 Malaysia

LIE「每天發想一個小點子」

LIE

LIE 是「每日小點子」的縮寫，它是來自馬來西亞吉隆坡的平面設計工作室，在 2011 年由 Driv Loo 所創立。LIE 的工作內容包含各式各樣多元的視覺傳達專案。每天不斷地嘗試並且尋找嶄新的方式，替客戶提供創新又漂亮的解決方案，並以相同的態度處理自身的專案企劃。不僅固於傳統規範或模式，我們相信設計總是會有更多探索的空間。

LIE is an acronym of Little Ideas Every day, a graphic design studio based in Kuala Lumpur, Malaysia. Founded by Driv Loo in 2011, LIE works across a diverse range of visual communication projects.

Constantly practice and seek for fresh approaches every day, provide innovative, beautiful solutions for clients, as well as self-initiated projects. Not sticking with the norm or patterns, we believe there are always room to explored in design.

大家好，我們是馬來西亞的 LIE Design，LIE 這個名字就是 "Little Ideas Everyday" 的縮寫，使用這個名字的原因是，幾年前我在大的廣告公司工作，覺得自己工作的範圍很大，自己負責的部分很小；相對來說，工作室可以讓我親手做設計的任何環節，對我而言，我是比較喜歡做這種小的設計，除了更人性化，還可以直接與別人溝通。

Driv: 這是幾年前我做的名片，在名片上有個 D 的鏤空，變成一個笑臉，當我將這個名片交給別人的時候，大家都會覺得很可愛，這就是我在設計上得到一些小小的成就感。在新加坡工作的時候接到一個案子叫做 KamikazeKaraage，意思是自殺式的炸雞，我的 Idea 很簡單，我將一些幾何圖形組合成一隻雞的形狀，然後炸好以後分解，幾何圖案重新組合成英文字，我覺得很逗趣又直接，雖然結果不被採用，但我自己很喜歡。因為商業考量，這類的作品比較難被接受，所以幾年前我們成立小型的工作室，希望把這種小小的精神繼續延續下去。

我先介紹一下我們這幾年做的工作。

Mustard

Mustard 是芥末，他是製作網頁的公司，一般想像芥末就是淋在大亨堡上充滿線條感，魚是我們先設計標準字，然後在字中間加上黃色的調味料。這樣的設計，只要修改黃色線條的排列，就可以運用在標示不同的職位，這種小小的點子讓我們感到很開心。

TeamTech

這個公司專門替大型商場做裝置藝術品，以前的 Logo 是寫實的雕像，後來我們重新幫他 rebrand，因為公司名稱有兩個 T，我們先做出臉型，再把兩個 T 字結合起來，變成比較簡約的風格，方便之後運用在名片等識別上。

新萬利

這是一間頗有歷史的馬來西亞餐館，販賣馬來西亞特色食物肉骨茶。近期開了一間分店，主打年輕市場。我們設計的 Logo 是用插畫表現，去迎合現在年輕人喜歡的感覺，我們把這類型的插畫應用在菜單上，既簡單又好玩。

Miracle Watts

這是我朋友的公司，除了方向指引系統，還有做室內設計，我覺得朋友是個很萬能的人，所以我想替他設計萬能的名片。採用一些 M 跟 W 為字首的單字，組合成新的東西。並且用蓋印章的方式，讓每張名片有不一樣的感覺。

唱給十年後的自己

這是中國好聲音第一屆冠軍李琦的專輯《唱給十年後的自己》，唱片設計。

我們的想法是可以做一個大型封套，裡面塞滿了明信片、寫過的信給十年後的自己，用明信片的方式畫出歌詞裡的意境。封套裡有海報、CD、一些

LIE "Little Ideas Everyday"

Hello everyone, we are LIE Design from Malaysia, LIE is an abbreviation of "Little Ideas Every day." The reason for using this name is that I used to work at a large advertising company and I could hardly control the work allowing my will. Relatively speaking, studio is the place where I can do every part of design with my hand. For me, I prefer to do this little design as it is more humanizing and I can communicate with others directly.

Driv: This is the card I made a few years ago, the card has a hollow in a D, and into a smile, when I give this card to someone else, everyone feel very cute, and this is my design get some small sense of accomplishment. When working in Singapore received a case called the Kamikaze Karaage, meaning suicide fried chicken, my idea is very simple, to combine some of the geometric shape into a chicken, then decomposition after fried, geometric patterns reassembled into English letters, I feel funny and direct, although the results are not to be used, but I love it.

There are the business cards I design a few years ago. With a D-shaped-hollow on cards which turn into a smile face. When people received my card, they always thought it was adorable, this is a little sense of accomplishment which I got from the design. Once upon a time, I got a project named Kamikaze Karaage, it means a suicide fried chicken. My idea was easy, I combined some geometric shape into a chicken, then decomposed it after being fried, and reassembled geometric patterns into English words. I thought it is funny and simple, but in the end the customer did not adopt it. Because of commercial considerations, such work is more difficult to be accepted, so a few years ago we found a small studio, hoping to continue this little spirit.

I would like to introduce what we have done in recent years.

Mustard

Mustard, is a company making web pages, in general imagination mustard and pour over big bite with full contours, we design standard characters of fish first, and then added the yellow seasoning in the middle of words. This design, as long as modify the yellow line arrangement, it can be indicated in different positions, small ideas like this will make us feel very happy.

TeamTech

The company specializes in doing the installation art for the malls, their Logo was a realistic statue before, then we rebrand again. As the company's name has two letters "T," we made the face first, and then combined the two T letters into relatively simple style, it was easy to be used on business cards and other identification.

New ManLee

This is a really historic Malaysian restaurant, selling Malaysian food specialties Bak Kut. Recently they have opened a branch which target to the young people. We designed the Logo with illustration style to cater the feeling what young people like now, we have applied this kind of illustration form on the menu, it is simple and funny.

Miracle Watts

This is my friend's company, in addition to design system of directions, they also do the interior design. I think my friend is

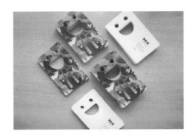

LIE Driv

LIE 〈KamikazeKaraage〉

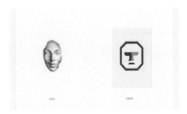

LIE 〈TeamTech〉

LIE 〈Miracle Watts〉〈New Manlee〉

LIE 〈新萬利〉〈New Manlee〉　　LIE 〈唱給十年後的自己〉〈The Future Me〉　　LIE 〈GOOD VIBES FESTIVAL〉

信紙讓買的人寫信一封信給自己。

GOOD VIBES FESTIVAL

我們替馬來西亞音樂節做 LOGO 和海報，海報以有趣的插畫增加節慶的感覺，一些人物和風景插畫帶出節慶興奮的氣氛，另外我們用剪紙和摺紙做出實體，拍照後又呈現出不同的感覺。

其實我們會一直自我要求嘗試做出不同的東西，除了平時的工作之外，我們也會主動做一些關於生活、文化方面的設計，我們覺得設計本身的不只存在於商業的範圍，它同時也是與人溝通的工具，所以我們希望能透過這些小小的設計感染到整個大環境。在 2009 年吉隆坡設計週，我們做了一系列的海報，把將馬來西亞的美食——椰漿飯、雲吞麵、沙嗲等美食做成有設計感的海報，展覽當時有一個從外地回到新加坡的人看到這系列海報就買了回去，他說在歐洲生活時

如果懷念東南亞美食，就可以看看這些海報。此外，我們也會蒐集生活上的玩具，重新組合，擺在一起就會產生許多好玩的畫面。除了食物、玩具，音樂也是生活中很重要的一部份，我們幫一個馬來西亞獨立音樂廠牌十週年演出設計海報，標題是 "The beats go on"，我們畫了一顆心臟，透過版面編排，讓多張海報接在一起的時候能看到心臟的跳動。

在 2011 至 2014 年期間我們策畫了一個展覽，主題是「吃本地水果」，這個主題在馬來西亞很普遍，幾乎每個馬來西亞的小學生美術課都要以此為主題畫畫，我們邀請一些不同領域的人重新詮釋他們小時候美術課的主題，第一屆展出的作品有海報、剪紙、立體作品。因為反映良好，我們再邀請更多設計師，將作品集成冊，後來也到新加坡展覽。從小學生的美術課

題目延伸跨國的展覽，也帶給我們某種程度的感動。展覽之後，我們最近正在積極做一個企畫，想要多做一些關於本土文化的設計，收集馬來西亞老街裡比較有趣的景色，之後我們可能會轉化成一本書或是網站，記錄關於這個城市的故事。◢

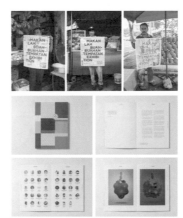

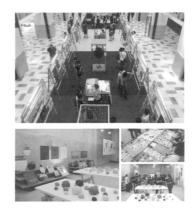

LIE 〈吃本地水果〉〈*eating local fruits*〉

LIE 〈The beats go on〉

LIE 〈吉隆坡設計週〉〈*Kuala Lumpur Design Week*〉

a very omnipotent person, so I want to design omnipotent business card for him. I used some letters as the prefix of M and W, combined into something new. And used the way like sealed, which make each card has a different feeling.

The Future Me

This is an album from Li Qi who is the champion of The Voice of China season 2. My idea is to m1ake a large envelope stuffing with postcards and letters, also, we drew the illustrations for lyrics like postcard. The envelope also have poster, CD, some letter for people to write to themselves in ten years later.

GOOD VIBES FESTIVAL

We designed Logo and posters with interesting illustration for Malaysia Music Festival to increase the festive feeling. The illustration of characters and scenery could brings the excitement atmosphere of festival. Moreover, we created the entity by papercuts and origamis.

In fact, we have always try to demand ourselves to do things different, except usual work, we design for something about life and culture. We feel that the design itself does not just exist in the business, it is also the tool to communicate with people, so we hope that through these little design we can infect the whole environment. In Kuala Lumpur Design Week 2009, we created a series of posters which use the Malaysian cuisine - nasi lemak, wonton noodles, satay and other food to do design, there was a person back to Singapore from other place to buy it when saw this series posters in the exhibition, said that if he miss Southeast Asian when back to the Europe, he could look at the posters. Furthermore, we also collect toys of life and reassemble it to create a lot of fun pictures. In addition to food and toys, music is a very important part of life, too. We once designed poster for the 10th anniversary performance of Malaysian independent music label which titled "The beats go on." We drew a heart as the main visual, let the posters connected together through the typesetting, you can see the beating of the heart.

During 2011-2014 we had planed an exhibition "eating local fruits," the theme is very common in Malaysia, almost every Malaysian primary school students have to draw according to this theme at painting class. So we invited a number of people come from different areas to reinterpret this theme. At first, we displayed posters, papercut and 3D crafts and created an immense response. So we invited more designers and collected their works into a book, then exhibit in Singapore. From primary school students' art subject extends to the transnational exhibition project, this exhibition really impressed us a lot. After the exhibition, we are now doing a project about local culture design, we will collect interesting scenery in Malaysia streets then transform them into a book or a website, to record the stories about this city. ◢

馬來西亞 Malaysia

梁海傑「尋找自己」

梁海傑 _Keat_

梁海傑的人生用在探討藝術、設計與動態圖像的數位創作過程。在得到電影與動畫學位後，開始了動態設計的創作職業生涯，之後，他待在新加坡與台北的動態設計工作室。

目前他在吉隆坡是獨立的創意總監，他還在摸索數位藝術的新境界，試著從轉換螢幕上的像素到畫布，產生實驗性的視覺效果。這些創作表達出感謝與反思，如同展開一段心靈之旅。梁海傑的作品在當地展出，作品也被《Asian Creatives Book》、《Advanced Photoshop》、《Motion Graphics Served》收錄。

Keat Leong explores the process of digital crafting in art, design and motion. After graduating with a degree in Film and Animation, his career began with creating motion designs that mesh beautiful aesthetics and fluid animations. Since then he has worked with motion design studios in Kuala Lumpur, Singapore and Taipei.

Currently, he is based in Kuala Lumpur as an independent creative director. He also explores the realm of digital fine art, translating experimental visuals from on-screen pixels to the canvas. These visuals are expressions of gratitude and reflections to being on a yogic journey. Keat's art was exhibited locally and published in Asian Creatives Book, Advanced Photoshop UK and Motion Graphics Served.

我的名字是梁海傑，朋友都稱呼我為 Keat。我是來自馬來西亞的數位創作藝術家，我喜歡用處理影像的方式創作。我今天要分享的是：「在這一年，我尋找自己」，這是一個分享，沒有要教什麼東西，因為我本身也還在一直學習當中，所以今天我要分享我在去年的心路歷程。

先説一下我的背景，2006 年我在馬來西亞學習動態與影像設計，動態圖像與平面設計的差異就是它加入了時間的元素，這段期間我學習怎麼做 3D 和動態，但是我大學畢業後從事的是截然不同的網頁設計，投入了與以前不一樣的環境。後來又在新加坡做動態圖像，也進步了很多，那時動態圖像就成為了我的特色，後來因為我想朝比較平面設計的方向前進，便來到台灣工作一段時間。我感覺自己搖擺不定，好像在不同的船之間跳來跳去，可是心裡覺得好像少了什麼東西。

雖然我很開心能有機會做動態圖像，但是心已經不在這上面，我還想做別的事，我不知道我在找什麼，可是我知道如果我繼續往動態圖像走下去，我就不是我自己了，所以我在 2014 年離開台灣，回到馬來西亞，我知道我要去尋找自己可以做什麼。那時候我覺得我好像離開了地球，飄向無垠的太空，我不知道可以找到什麼，但是我很開心能夠去尋找新的事物，我做這個簡報的時候找到老子的名言，我覺得很適合我當時的狀況。"When I let go of what I am, I become what I

might be." 意思是「當我放開我以為的身分，我成了我可能成為的人。」

我像是太空人自由自在地在外太空探索，任何案子我都盡量去嘗試，像是識別與商標，我幫職業是瑜珈老師的朋友設計 LOGO，在做識別的時候，我發現這也是一種藝術，因為這可以長時間使用，可能十年、可能五年，我覺得這是有一點難度的，在設計 LOGO 的時候，要花時間去了解客戶的需求，因為沒人教我做 LOGO，所以我是自己慢慢摸索學來的。之後自己開始學習設計網站，期間也有接到設計 Styleframe 的案子，而我沒有想到自己也有機會參加畫展，展出自己的藝術品，我覺得很自由，能夠做不同的東西。

然而接到越來越多案子，我發現自己的時間越來越不夠，沒辦法一邊做設計，一邊做藝術創作，這讓我非常地緊張，於是我就問朋友：到底要做設計還是藝術？我的好朋友告訴我，其實兩邊都可以做，因為設計也是包含在藝術裡面，我覺得有道理，於是我一邊做設計，一邊做藝術創作，我發現藝術與設計有幾個不同的地方：一、藝術是要表達自己，設計是要表達客戶的需求。二、藝術要了解自己，設計要了解客戶。三、藝術是要先做出作品才可能有人買，設計則完全相反，要先有客戶你才能設計。四、藝術創作能完全遵照自己的意願，設計則不一定。

My name is Leong Hoy, a digital artist from Malaysia. Friends call me Keat. I like to create works by image processing. What I am gonna share today is "Finding Myself in 2014". This is a sharing. Nothing to teach cause I'm still learning as well. Today I am gonna shrae the way I've been through last year.

Start with my background. In 2006, I learned dynamic image and graphic design in Singapore. The difference between dynamic image and graphic design is the element of time. During this period of time, I learned how to do 3D and dynamic images. However, what I do after graduated from college is web design, which is a

different environment from the past. Then I did dynamic image in Singapore and made a progress. Doing dynamic image has become my specialty. After that I worked in Taiwan for a period of time 'cause I'd like to do graphic design. I felt I'm floating from different boats but lost something in mind.

Despite the fact that I were happy to do dynamic image, I were not into it. I wanted to something, but I didn't what I'm looking for. I knew that if I keep on dynamic, I'm no longer myself. Therefore, I left Taiwan in 2014 and came back to Malaysia. I knew that I'm looking for something I can do. I felt like leaving the

earth and flying to the universe. I had no idea what to find, but I were happy to find something new. There's a quote that can describe the condition of mine during that time: "When I let go of what I am, I become what I might be."

I felt like an astronaut freely discovering in space. I tried different cases, such as CIS and trademark. I design LOGO for a friend of mine who's a yoga instructor. When designing trademark, I find it can be a kind of art. Trademark can be used for a long, maybe half of a decade or a decade. I find it can be challenged. Therefore, it takes some time to understand

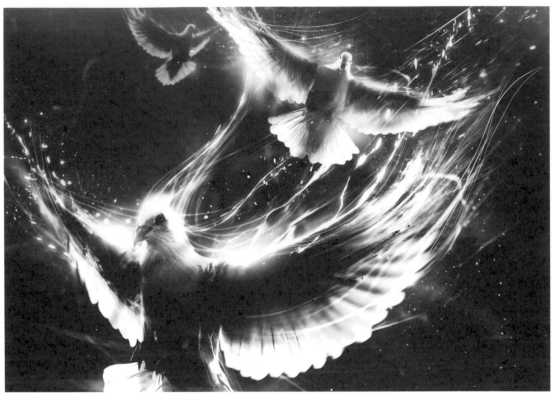

Free Ⅰ

〈Free Ⅰ〉是我 2013 年的個人創作，後來又創作了〈Free Ⅱ〉，我用這兩幅作品第一次參加展覽，很幸運的這兩幅畫都有人願意買，這是我意想不到的事。因為這兩幅作品放在自己的 Behance，於是有美國的客戶委託我替網站上的科學文章創作插畫，我很高興自己的作品風格能被欣賞，而且自己的畫能結合設計與科學，我覺得很酷。後來我嘗試用 3D 做字體設計，這些作品有機會被刊登在雜誌，作品被刊在雜誌上後，新的客戶委託我設計電子音樂活動的 LOGO，甚至做了海報，因此又發現自己原來還能做海報，而其中替一個日本樂團做的海報被刊在《Asian Creatives Book》，因

為這本書，被陳育民老師邀請參展，於是我就在這裡了。

尋找自己的過程中，其實好像一直在迷路，但是我一路上學到了許多事物，心裡非常感謝！今天來到這裡演講，也是想知道自己有沒有這個能力，沒錯，這是我第一次演講。最後，尋找自己就是看清楚自己，可以了解自己，感謝在座聽演講的你們、陳育民老師，還有松耀跟蘇素，今天聽到你們的演講讓我湧現出許多靈感，Thank you！◢

the need of clients. Ilearned how to design logos by myself 'cause no one can teach me. After that, I learned how to design website and got the case like Styleframe in that time. I have never expected that I can have my own exhibition to demonstrate my own works. I feel free to do different things.

However, the more cases Iget, the shorter time I have. I can't do design and art simultaneously. It made very nervous. I asked my friends, "design or art?" My friends told me that I can do both because design is part of art. That makes sense. Then I do design and art at same time. I find

Free Ⅱ

art some differences between art and design. First of all, art is to express yourself, design is to express the need of clients. Second, art for yourself, design for client. Third, art is that people buy your works after you make it. Design is totally different. You get your client first and you design. Fourth, art follows your heart, design depends.

"Free I" is my work in 2013. Then I create "Free II". I took these two works for my first exhibition and fortunately I got my buyers, which is beyond my expectation. I put these two works on Behance, an online portfolio website. US client appoints me to illustrate for scientific essays. I was very happy that my works can be appreciated. It is really cool that my wok can combine with science. Then, I tried to make font design with 3D. After my works were published on magazines, new clients appointed me to design electric music's logos and posters. I found that I can do posters after that. One of my works for a Japanese band has been published on "Asia Creative Book". Therefore, I was invited by Chen, Yu-Ming for the exhibition. And there I am.

The way to find myself is like getting lost for a long time. However, I learned many things on my way and I appreciate that. The reason why I'm here for the speech is to know if I can. Yes, that my first speech. Finally, finding yourself is to looking yourself and understand yourself clearly. Thanks for you guys, Chen, Yu-Ming, Song-Yiau and Su-Su. The speeches of you inspire me. Thank you! ◢

新加坡 Singapore

吳威「不完美,不規則」

吳威 *Winnie Wu*

吳威被形容是亞洲當代平面設計最前端的領導人物,大量地專注在藝術產業之創作,她在印刷與排版設計上的敏銳與創新最為人熟知。她是 KALEIDO 工作室的創意總監,KALEIDO 最近正逐漸邁向提供全面性的設計規劃與策展建議服務。

Winnie Wu is profiled as an emerging leader at the forefront of Asian contemporary graphic design with a body of work largely focused in the arts industry, and is best known for her peculiar sensitivity and innovation in print design and typography. She is the creative director of studio KALEIDO, a progressive full-service design practice and imprint currently based in Singapore.

大家好,我叫吳威,我的設計工作室是 STUDIOKALEIDO,通常接案的時候是由我一人負責大部分的設計工作,有時候也會跟藝術家或作家一起合作。我喜歡這樣的工作模式,因為不用接大型的案子,相對起來可以做比較個人化的設計。為什麼主題是「不完美,不規則」的原因在於我是新加坡人,有很多人認為新加坡人保守,他們對新加坡的印象是整齊乾淨,很難找到一些不規則、不完美的東西,可是對我來說那些太完美的東西是反而是我不喜歡的,放眼整個亞洲,新加坡的設計雖然很好,但就是規矩了一點。新加坡的主要語言是英文,設計風格也是屬於比較西方,所以雖然新加坡在亞洲裡,卻很難找到亞洲的風格。

大部分的設計師就是在大學念完平面設計後到業界工作,但我自己沒有讀完大學就自己開了設計工作室,在學校就自己接過許多案子,開始成立工作室的時候,除了設計的工作,我們還做了許多其他的事情,例如展覽、與許多插畫家、作家、當代藝術家們一起辦展覽,因為看起來好玩,吸引了許多覺得好玩的年輕設計師們。「The art of rebellion 造反有理」在這個展覽裡,我們找了 20 幾位插畫家,給他們一個成語作為題目,讓每個人自由創作。我們辦這類展覽的想法是希望能打造藝術社會,如果有一個地方可以讓作家或是插畫家展覽,這是很好的藝術推廣平台。而「Synesthesia」這個展覽是我們集合插畫家、設計師和作家共同創作作品,先讓作家寫一小段的詩,

插畫家再從詩裡尋找靈感創作。在其他展覽中我們還有邀請當代藝術家或是平面設計師等,透過展覽我們認識了許多藝術相關的創作者。

因為從展覽認識了許多人,後來我也會替藝術工作者設計相關的手冊、海報。〈M-TROSPECTIVE〉這張海報是替一位當代藝術家慶祝十週年所設計的作品,他的要求很高,在低預算之下,海報必須兼具購物袋的用途,如果有人要買書就能放在購物袋裡拿回家,我自己實驗做出可以摺成漂亮信封袋的摺法,另外將他的每個作品做成小 icon,在主視覺裡可以清楚地表達出每件作品創作的年份,這是我個人很喜歡的作品。而《10X10》這本刊物是將一些青年作家與年長作家在工作坊的創作集結而成的一本書,我把刊物截成兩邊,變成雙向的書,可以同時閱讀年長作家和青年作家對於創意的思考。由於在新加坡的藝術創作容易取得資助,所以有許多國外的藝術家會來新加坡辦展覽,我曾經替一個韓國藝術家設計書冊,因為他的作品風格很不一樣,所以我把書分成六種尺寸,完成這本書後,很多人都喜歡,並希望我設計這種有點不平凡的書冊。

有時候,如果你的格式有一點不規則,提案的時候客戶會比較容易接受,因為比較抽象或誇張的平面設計很難被新加坡的客戶通過,所以這種不規則的方式不但比較有趣,同時還能符合客戶的要求。新加坡普遍喜歡黑或白色的平面設計,但我喜歡很重的顏色,這次展出

Winnie Wu "Out of Line"

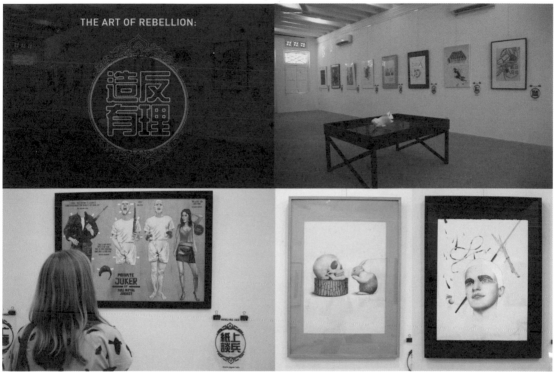

〈 造反有理 The art of rebellion 〉

Hello, my name is Winnie Wu, STUDIOKALEIDO is my design studio, as usual, I response all the design works, sometimes I cooperate with other artists or writhers, I love the work stander likes this because I don't need to take large cases and this way I can do personal design more than large case. Why I choose " Out of Line " as my theme is because that I am a Singaporean, a lot of people may think that we Singaporean are conservative, their impression of Singapore was neat and clean so they are hardly find something out of line, but for me "perfect" is what I really don't like. Look around the whole of Asia,

Singapore's design are pretty nice while have so much rules. Because the main language of Singapore is English and the style of design from Singapore belongs to Western much more, so it is difficult to fine Asian style from Singapore's design.

Most of the designers work in the industry after they graduated from college of graphic design but I did not finish college then started my own design studio. I have take many cases when I were a student, after setting up my studio. In addition to design work, we also do a lot of things such as holding exhibitions with many illustrators, writers, contemporary artists, many young

designers would join us because it looks fun. "The art of rebellion rebel" is an exhibition that we found several illustrator, giving them an idiom as a topic let them create things freely. We hope to create an artistic community through the exhibition, if there is a place that allows writers or illustrators show their creations, it would be a good art-promotion platform. Another exhibition "Synesthesia," exhibited works which are created by illustrators, designers and writers, first we have the writhers write a short poem, then illustrators should look for inspiration from the poem. In other exhibitions, we also invite contemporary artists or

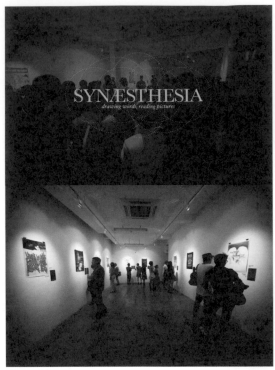

〈Synesthesia〉

〈M-TROSPECTIVE〉

的海報〈It's one talk〉就很難在新加坡出現，而且他們會覺得海報上的字體抽象難以閱讀。

不是一開始就可以做不規則的設計，所以我建議平面設計師開始的時候要先學習規則才能打破那些規則，相較於藝術家，設計師還是需要有專業度以及基礎的設計原則。有些設計師追求讓作品做到最完美，不過我覺得世界上沒有百分之百的完美，不需要一直跟隨這個業界的想法。另外還有一個想法，我覺得設計師們因為共同的生活方式與話題，設計風格會變得越來越相似，不要墨守成規才能夠得到新的靈感，所以要離開自己的圈子，試著跟不同行業的人交流。透過今天的分享，希望我的路程可以讓你們找出自己的不正路，不要走上跟別的設計師一樣的路。◢

graphic designers, etc., so we met a lot of art-related creators through the exhibition.

Due to the exhibition, we met a lot of people, then I started to design brochures or posters for artists. <M-TROSPECTIVE> is a poster for a contemporary artist to celebrate the tenth anniversary of his design work, in the condition of high demands with low budget, the poster must be used as shopping bag, too, people can put the book into this bag to take home if they want to buy the book. I did the experiment to make beautiful folding of bag, more, I transformed his works into many small icon so it can articulates the year of every creations in the main visual, this poster is one of my favorite works. In another case, 《10X10》 is a publication which combines the creations of young writers and old writers in the workshop, I cut

the publication into two sides and you can look at this book from both side, thus, you can understand the thinking of creativity from old writer and young writer at the same time. Since artists in Singapore are easier to get funding, so there are many foreign artists would come to Singapore to held the exhibition. Once I have ever designed book for a Korean artists, because his works have many different style, so I divided the book into six sizes, after I finishing this book, so many people said they love it and asked me to design this kind of unusual books.

Sometimes, the clients will accept the design easier if your format seems have a little irregular, because it is hard to be accepted by Singapore's clients if the designs are too abstract or exaggerate, so this irregular way of format is not only more interesting, but also able

〈10X10〉

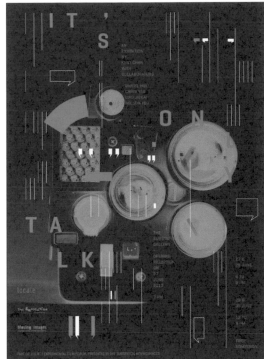

〈It's one talk〉

to meet customer requirements. Clients of Singapore generally prefer graphic design with black or white color, however, I like heavy color. In this exhibition, my poster <It's one talk> is difficult to appear in Singapore, they might think that the font of this poster is abstract and difficult to read.

I don't think we could do irregular design in the beginning, so I suggest graphic designers to learn the rules first then break the rules, compared to artists, designers still need to have profession and basic principles of design. Some designers pursuit of the perfect work, but there is no 100% perfect in the world, you don't need to follow the idea of the industries. There is also an suggest, I think the designers' style would become more and more similar because they have common lifestyle and topic, so try to break the rules so you can get new inspiration, leave your circle and try to communicate with different industries. Hope my way could help you make your road "out of line," and not to walk the same path with other designers. ◢

台灣 Taiwan

陳育民「談設計生涯的現實與理想」

陳育民 *Chen Yu Ming*

現任教於國立高雄應用科技大學文
化創意產業系擔任助理教授、AAD
亞洲視覺藝術交流平台執行長、香
港設計中心會員。
作品曾榮獲德國 iF 設計獎、2010 和
2012 兩屆亞洲最具影響力大獎平
面設計類銅獎、HKDA 環球設計大獎
海報設計優異獎、加拿大 APPLIED
ARTS 國際競賽海報設計類入選獎、
中國國際海報設計雙年展入選獎、香
港 IDN 國際數位設計競賽入選獎等重
要獎項。曾擔任 2010 年張藝謀杜蘭
朵公主、雲門舞集、誠品書店、國光
劇團、技嘉科技等知名品牌擔任視覺
設計。作品被香港文化博物館、香港
設計中心、廈門美術館等機構典藏。
曾負責 2013AAD 亞洲視覺藝術交流
展、KHDF 高雄設計節、遇見新亞洲
──2014AAD 亞洲視覺藝術交流展、
誠品設計小講堂、2014NEW FORM
國際平面設計探索台灣區擔任策展人。

*Now teaching as the Assistant Professor
in National Kaohsiung University of
Applied Sciences Department of Cultural
and Creative Industries, and serves as the
Chief Executive of AAD Asian visual arts
exchange platform. Also, he is a member
of Hong Kong Design Centre.*

*Won iF Design Award in Germany, Design
for Asia Awards Communication Design
Bronze 2010 and 2012, HKDA Global
Design Awards Merit in Graphic, Applied
Arts Design Awards in Canada Poster
Judges', China International Poster
Biennial Judges', IDN(International
Digital and Design Awards) in Hong
Kong Judges' and other important awards
so on. Visual Design works: Durandot
opera show by Zhang Yimou, Cloud Gate
Dance Foundation, Eslite Bookstore,
GuoGuang Opera Company, GIGABYT
and so on, Chen's works were collected
by Hong Kong Heritage Museum, Hong
Kong Design Centre, Xiamen Art Gallery
and etc., he has took charge of AAD ASIA
Visual & Design Exhibition 2012 and
2014, HKDF Youth Innovation Design
Festival, the Eslite Forum, and the curator
of New "Form" International Invitational
Graphic Design Exhibition 2014.*

我相信各位心中跟我一樣,其實都會有個理想在後面支撐著現實,我有一份理想存在,有一種比錢、比名聲、比工作職位、比工作內容還要更重要的理想存在,我沒辦法說清楚那到底是甚麼,可是那是支撐我從 18 歲至將近 38 歲,經過 20 個年頭繼續走下去的原因。這個講座談的是「在設計與非設計,在現實與理想之間」,在現實面部分,其實設計業在這幾年是越來越惡化,我覺得這個惡化的過程會造成設計師在生存上非常的困難,這是在現實面上需要跟大家做分享的。

對我而言設計師要面臨很多困境,這會讓你的設計工作越來越難,我認為第一個困境就是軟體快速的演進,讓設計工作變得容易上手,很多設計師的工作已經可以輕易的被取代,而且軟體讓沒有學過設計的人也容易上手,這表示有一些作品已經不需要花錢聘請設計,拜強大的軟體所賜,設計師的工作開始被軟體取代,當專業可以被軟體取代的的時候,我們能做甚麼?這也是站在第一線在做設計的我一直在思考問題。第二個困境是設計師的薪資待遇逐漸惡化,我發現這個問題不只發生在台灣,在此次邀展的過程中,我也詢問過其他國家的設計師,因為軟體真的太強大了,設計師做的事情不斷的被簡化。第三個困境:設計市場行情因同業競爭設計使利潤降低。我認為逐年降價的設計師占多數,有些客戶會同時找多家設計師報價,當越來越多客戶這麼做的同時,利潤會因為同業的競爭逐漸降低,你的工作內容、需求並不變,但你得到的報酬卻越來越少。第四個困境是客戶的需求與要求不斷提高,而這是全球化跟網路發達的必然,客戶從網路看到更多更好的作品,相對的要求就更高,當設計難度越高,需要投入的時間就越多,這些是我自己在設計的工作上不斷遭遇的事情。

如果不開始改變設計生態的困境,台灣市場將會走向泡沫化。在不合理的狀態持續一段時間後,越來越多人會選擇離開這行業,如果將付出與投注的成本算進去,其實是不成正比的,在產出一個作品之前,都是要花很多時間與金錢去作自我學習,因此在這個階段想跟大家分享一個想法,如果在未來你想走設計這個行業,無論是在哪個設計領域上,你必須要清楚的體驗到這個現實。

如何突破困境?在設計生涯裡面,如果想要開公司,想要在這個行業裏面賺到一定程度的錢,想要獲得一些好的客戶與一定品質的生活,就必須再好好的設計與思考面向下功夫。

一、創造需求:我們的創造力一直都是處在被動狀態,客戶提出需求我才提出創造,如果我在這行業是靠創意、創造能力以及專業來賺錢,那就應該思考:既然市場是這樣,

Chen, Yu-Ming "The Reality and Ideal of Designing"

I am convinced that everyone here more or less holds the same view with me that behind every reality, there is an ideal. I hold an ideal, which is significant than money, fame, position, and job content. I can't clearly describe it, but it is really the reason supported me to go on in these 20 years, from 18 to nearly 38 years old. This sharing session is talking about "designing or not designing, between the reality or the ideal." The reality is that designing has gradually worsened these years. And I consider designers will be though to survive during this process. This is the reality I would

like to share we you.

To me, designers have to deal with different predicaments, and this will make your designing work harder and harder. The first difficulty is the rapidly progressing software. These software make designing handier, but meanwhile, many designers would be easily replaced. With such handy software for people have not learned design meaning that some of the works no need to hire designers anymore. Thanks to powerful software, designers begin to be replaced. When specialty can be superseded by software, what can we do? As a

designer on the front line, this is what I have been thinking. The second difficulty is the payment of designers has gone lower. This condition does not just happen here in Taiwan. I had asked about the payment of designers in other countries while curating, and the result is that designers' works had been simplified ceaselessly because the powerful software. The third difficulty is that profits keep decreasing due to horizontal competition in the designing market. I consider that designers with lower payment year after year are in majority. Some customers will ask for designing

困境.o2
設計業
逐漸消

那何不去創造一個新的行業別或是開發新的市場，如果覺得在目前處境真的非常的糟糕，就更應該開始去思考這件事，開始去創造出新的行業別，而不是去滿足現有的市場。例如：插畫家開美術材料行，以自身專業提供顧客最準確的需求，更能說服顧客購買商品。或是工業設計師開設餐具家飾店，與傳統產業合作，工業設計師出點子與傳統產業原有的技術與產品結合，重新發展一個新的可能性。無論如何，我們要去突破困境，所謂突破不一定是解決現有的問題，而是去找到一條新的路。

二、重新定義：學設計的人越來越多，或許你可以重新去定義你自己，與設計師變成合作關係，簡單來說就是做設計師的生意。像是從競爭關係變成供應商合作關係，設計師

身分的供應商可以從自身的專業判斷更多事情，處理東西的細膩度也會有差異。你也可以試著開設經紀公司，這個時代不缺設計師但缺案子，如果有間經紀公司讓設計師們的工作跟收入穩定，那他也會越來越賺錢，甚至可以幫一些自家品牌的設計公司找到更多的通路。另外，設計通路與出版也可以嘗試，很多設計師都一直在找通路，但多數通路並不好入門，其中一個原因就是老闆並非這個領域的人，所以並不太了解這個領域，導致在談通路的時候會有點受挫，如果由設計師自己變成通路，他們豐富的創造力就能讓這個通路變得更多元化。

我從這個現況去整理一些設計師必須去面對跟思考的一些問題，如果目前的狀況不做改變，未來台灣的設計的市場可能會泡沫化，可是如

何避免？我覺得應該去思考這個問題，我也提供我自己的觀點，同時把自己的專業跟經驗做一個轉化，我認為下個世代每個行業都需要做設計，因為每個行業都需要轉型，並且在轉型的過程中透過設計來找新的路。◢

quotations from different designers at the same time. When more and more customers start to do so, the profits will decrease because of the competition between craft brother. Designers are paid lower with exactly the same working content and requirements. The fourth difficulty is the upgrading costumer requirements. This is a certainty in Internet world. Customers get to read more good designs on the Internet, so their requirements raise accordingly. When design gets harder, more time will be consumed. All the above are things I keep encountering constantly in my work.

If not changing the predicaments in design, Taiwan will soon be heading toward the burst of designing market bubbles. After a time being treated unreasonable, more and more designers will choose to leave this industry. You have to spend much time and money self-learning before an opus is created. If counting in the investment, actually it is unworthy. So, now, I am sharing a thought with you. If you plan to join design industry, and no matter which domain you choose, you have to understand thoroughly of the reality in this industry.

How to get through the predicaments? If you plan to open a company, earn to a degree of money, receive some good customers and have a quality living in your design career, you have to think more deeply and work harder in thinking.

1.CREATE DEMANDS. Our creativity is often passive. When customers offer requirements, we then suggest a creation. But if you are earning money with your creativity, creation and specialty, you have to start thinking things like " why not create a new business or new market?" If you have noticed that you're in a challenging circumstance, then you ought to start thinking how to create a new business, rather than satisfying current market. Here are some examples. Illustrators may open art supply stores. In that case, the illustrator could offer customers the best recommendation with own profession and showing better persuasiveness. Another example. Industrial designers may open home-decoration stores. By cooperating with tradition industries, industrial designers come up new ideas to link with tradition techniques or products, creating a brand new opportunity. We have to overcome difficulties, anyhow, don't always think of solving current problems, but try to discover a new path.

2.RE-DEFINDING. Since people learning design is increasing, you may redefine yourself cooperating with designers. In short, to do designers' business, transforming the relation from competition to cooperation. As a supplier with designer background, he/she can judge things by own specialty, and there may be exquisite differences while handling things. You can try to open an agency. It is a world that lacks case jobs, not designers. If there is an agency to stabilize designers' works and incomes, it would earn more money that way. For further, it may even help open more marketing channels for some own-branded design companies. Besides, designers may try to cooperate with publishers. Many designers are always searching for channels, but most of the channels are hard to enter. One of the reasons is that the owner of the publisher is not in designing domain, so they don't really understand this area, leading to the frustration while consulting. If designer is their own channel, their rich creativity may vary the channels.

I arrange some questions that designers may have to face and consider from the current situation. If not changing the condition, Taiwan will soon head toward the burst of designing market bubbles. How to avoid states like that? I think this is a question worth pondering. I have proposed my own opinions according to the transformation of my specialty and experiences. It seems to me that every industry next generation need designing, because they need transformations, which will find them new possibilities. ◢

青團隊「設計師的待客之道」

青團隊 Jing group

青團隊有著多元化的設計經驗，成員來自國內知名設計公司、品牌公司、國際科技公司，亦曾服務於國立藝術館及接洽政府專案 等，經驗十足。他們重視與企業主交流，了解品牌與產品間的故事；認真看待每個案件，就像回到初心般的熱忱；對此，以一貫的態度，是青團隊凝聚的原因。

Jing group has a wide range of design experience. Members from the well-known design companies, brand, international technology company, and has served on the National Museum of Art, also approached the government project, etc. full of experiences.

They focus on the communication with the client, to understand the story of the brands and the products. They take each case to heart, with the enthusiasm just like back to the beginning. Thus, the consistent attitude is the reason link jing group together.

大家好，我們是青團隊，由五位志同道合的好朋友組成，最初是在鄭中義老師的公司「青本設計」實習。我們認為設計師應該要保持最大的熱忱，為客戶提供最大的服務，然後幫客戶解決問題，也因為這樣子的理想，我們青團隊就成立了。

造夢者 Dreamer

我們長期跟不同的客戶溝通後，發現其實很多客戶都會有共同的訴求，例如希望品牌能表達專業、領導的概念，或者是賣有機商品的客戶希望我們的包裝能有自然清新的風格。這些訴求似乎能夠套用到任何品牌，然而如此一來卻少了一些感動人心的特質，所以在設計前我們都會花很多時間在思考，希望能賦予品牌一個理想，或是一些感動。因為這些夢想、精神、故事等元素包覆在整個形象外面，我們才更能夠感動人心。我們將客戶很簡單分成四種特質：

第一種：「客戶清楚自己要什麼且知道怎麼做。」

第二種：「客戶清楚自己要什麼，但不知道怎麼做。」

第三種：「客戶以為自己知道，但心裡不知道。」

第四種：「我什麼都不知道，你告訴我後，我再決定怎麼做。」

通常新的客戶會落在一、二之間，三是少數，四的部分我們通常都直接推掉，因為我們覺得這樣子的客戶還沒做好想要做品牌或做設計的準備。我

們的客戶之一「雪峰」屬於第二種類型，客戶希望能賦予這個品牌一個更專業的形象。

雪峰就是奶泡粉倒在飲料上面的造型，它就會呈現一種山峰的意涵。我們思考要怎麼將「山」這個符號以及「頂尖」的概念結合在品牌裡，後來我們想到爬山，當你征服一座山之後，看見太陽升起，陽光照耀在一望無際的景色之中，當下的場景應該是非常觸動人心，所以我們幫他下了一個主標「日照山峰，觸動人心。」第二個案例就是，客戶清楚自己要什麼，也知道怎麼做。「自然食」是使用在地最天然的食材，所製作而成的一個寵物鮮食包，他們希望狗狗能多吃鮮食，同時也希望這個品牌能賦予健康、讓狗狗非常開心的機能。我們為品牌賦予了一個主張，就是「毛小孩的蔬果樂園」。狗狗在蔬果樂園裡，就能享受最純真快樂的時光、享受蔬果樂園的美食。在包裝設計上，我們將狗狗開心的表情融入這個品牌的包裝。我想要表達的是，設計師的待客之道到底是什麼？其實不外乎就是，要對案子保持一些熱忱、想的比客戶更多、站在客戶的角度去解決問題，最重要的是要為品牌去塑造一個感動人心的理想，有這些理想，他們的品牌才能夠更觸動人心。

自造者 maker

我下「自造者」這個標題，表示從我們從造夢者再回到更本質的自造者的階段去製作。用「創新」這個詞去形

雪
峰

PANTONE 127 PANTONE 409 PANTONE 412

青團隊 〈雪峰〉 *Jing group* 〈TOP INNO〉

圖片由青團隊 facebook 擷取　*the pictures origin from Jing group's facebook*

Hello everyone, we are "Jing group" composed of five designers who used to intern at "Qing-Ben design." we think that designers should keep their enthusiasm to provide service to clients and help them solve the problems. We established Jing group because of this ideal.

After a long-term communication with different clients, we discovered that in fact a lot of clients have common aspirations, for example, they want to express professional or a concept of leadership, some clients who sell organic goods want us design nature and fresh style on

packaging, but these aspirations seem to be able to apply to any brand thus have some shortage to touch customers' heart. So, we spend a lot of time on thinking before design, hoping to give the brand some ideal or some moving. With the elements of dreams, spiritual, and stories covering the entire image, we are able to touch people's hearts. We classify our clients into four qualities:

The first: "Clients know what they want and how to do."

The second: " Clients know what they want but do not know how to do."

Third: "Clients thought they know what they want, in fact they are not."

The fourth: "Clients do not know everything, you got to tell them how to do."

New clients are generally being the first type or the second, less client are the third type, if the clients belong to the fourth type, as usual, we would directly turned them down because we think they are not ready to do brand design well. Our client "TOP INNO" belong to the second type, they want to give this brand a more professional image. "TOP INNO

青團隊 〈雪峰〉 *Jing group*〈*TOP INNO*〉

圖片由青團隊 facebook 擷取　*the pictures origin from Jing group's facebook*

容是滿直接的方式,為了趣味度我們轉換它的排序,也就是「新創」。其實新創團隊在整個國際上是一個非常主流的新創業模式,在設計師前輩謝榮雅的演講中說:「設計者要成為決定性的角色,可能要提升到戰略性的位置」他提到一個新創裡面很關鍵的要素,就是讓設計師不只是單純做表面上的設計,而是進到一個企業裡面。自造者運用了募資等方式,或用設計這個強項去補足資金的成本,這些新興的小公司,帶給我們一些新的想法,我們都可能進入到邁向 3.0 或邁向 4.0 的設計階段。

前陣子有一群人執行了一個設計計畫,他們從國外交流回來之後,發現我們的美學意識沒有普及到每個層面,他們認為台灣人很沒辦法直接進到美術館裡面去,但會去花很多時間在念書,所以他找了一些設計師去美化課本,除了增加學生專注力,同時

替他們的美學教育從小扎根。他們並非設計領域的人,可是他們能媒合不同產業,讓設計師和工程師、社會的教育家直接的交流,以往設計師與客戶的關係只是單獨的點對點,但是現在我們從合作的新創團隊了解到目前的產業現狀,也得以增進自己的思維、改變自己的想法,我們可以跟更多的團體合作,也許能推廣或協助新興的產業,讓設計更新穎、與更多人交流,達到更多的可能性。◢

" is a shape of silhouette when pilling baking powder on the beverage, so we started to think how to combine the concept of "mountain" and "top" into this brand, then we found the word "Climbing," when you stand on the mountain top, see the sun rises and the golden sunlight covers the spectacular landscape in front, So, we made a title:" Sun lights on mountains, heart moving moments." The second type: Clients know what they want but do not know how to do. "Natural 10" is a fresh pet food company who respects pets' healthy diet and happy life, they hope the dog can eat fresh, also, hope this brand can give a function with healthy and happiness. We gave this brand a slogan: "A vegetable paradise for furkids." In the vegetable paradise, all the furkids can enjoy the best time and enjoy the nature food. After

青團隊 〈自然食〉 Jing group〈NATURAL 10〉

圖片由青團隊 facebook 擷取　　*the pictures origin from Jing group's facebook*

giving spirit to this brand, we put the seeing happy face of furkids to packaging design. All we want to express is: what is designers' hospitality? In fact, it is to keep the enthusiasm to projects, and think much more than the clients, stand in clients' shoes, the most important thing is to shape a touchable main idea for clients' brand, so their brand will be able to touch people's heart more.

I set the "maker" as title means that it represents we are being back to the more fundamental stage from dreamer. It is a direct way to describe it with this word: "innovation," so we upside down the word order to create some interest, the word is "start-up." Actually this kind of new companies is a very popular business model in the world. The senior designer, Jung-Ya Hsieh, once said that: 'The designers should become a decisive role and be elevated to a strategic location,' he referred to a critical elements of start-up: designers do not simply do the design on the surface, they should inside into a business instead. The maker used the self-made fund-raising or design to make up the capital cost, these start-up companies have inspired us and gave us some new ideas, we may enter into 3.0 or 4.0 stage. of design.

Recently, a group of people carried out a design project, they discovered that our esthetic consciousness does not spread to every level when they came back to Taiwan from foreign exchange, they thought the Taiwanese spend a lot of time in studying, so they got some designers to beautify textbooks, in addition to increasing students' concentration, it also help rooting people's aesthetics from an early age. They are not designers but they can matchmaking different industry, so designers and engineers, educator could communicate one another, in the past, the relationship between designers and customers is just a point to point, but now not only we can understand the current status of industry by cooperate with start-up companies, but also to enhance our thinking and change our minds. We can cooperate with more groups to promote or assist emerging industry, or make our design more innovative, we can communicate with more people and achieve more possibilities. ◢

台灣 Taiwan

彭冠傑「海報！海報！」

彭冠傑 *Peng, Guan-Jie*

彭冠傑 (Jay) 是一位以臺灣台北為根據地的平面設計師。於澳洲墨爾本皇家理工學院畢業之後，他便開始承接各類型案件，同時也繼續進行個人的設計創作。他的作品曾收錄於 APD 亞太設計年鑑（中國）、Asian Creatives（日本）、亞洲青年創作平台（香港）、新平面雜誌（中國）、Imprint 2（中國）等設計出版物中。

Jay Guan-Jie Peng is a graphic designer based in Taipei, Taiwan. After the graduation from RMIT University (Royal Melbourne Institute of Technology, Australia), he starts to work as a freelancer and also keeps working on self-initiated projects. Some of his projects have been published in international design publications such as Asia Pacific Design annual a.k.a. APD (China), Asian Creatives (Japan), Apportfolio Asia (Hong Kong), NEW GRAPHICS magazine (China), Imprint 2 (China), etc.

謝謝今天大家的參加，這算是我的第一次在公開場合去分享自己的想法，今天我設定的演講主題是「海報！海報！」。

我先自我介紹，我算是比較年輕一代的設計師，我是 JAY 彭冠傑。大學念政大廣告，後來對平面設計很有興趣，所以我之後申請獎學金到澳洲念平面設計研究所，這一路身分的轉換帶給自己許多改變，現在我是接案的設計師。今年是我學習設計的第十年，從事設計工作第六年，然而我對於海報這件事情心裡還是有很多疑問，像是海報的理念、或是海報該何去何從？在新媒體的出現後，很多人不會實際輸出，而是繳交電子檔。這件事帶給我很多想法，在學習工作的過程中與同行、前輩們討論時，他們也會丟一些問題問我，但我不一定能在當下推舉出答案。我今天就把我自己得到的答案給大家分享，也會丟問題給大家繼續思考。

海報是什麼？

對我來說，海報是什麼？如果我們查維基百科，它會說：「海報是一個單張、可張貼的宣傳印刷品。」我自己則認為海報是一個框架，如在場我們看到每張海報都有長方形的框架，以攝影的角度來說就像是一個取景框，設計師有權力決定取什麼樣的景。

然而其實框不一定要是長方形，設計師劉銘維替台新藝術獎設計的作品，它就是不規則形狀的海報。海報為什麼一定要四四方方的呢？海報當然可以長的不規則，它可以是圓形、三角形、任何形狀。如果海報能跳脫長方形這個框架去，會變得很不一樣。

一路以來看過這麼多海報，我常想是不是有一個方法可以稍微區分一下，也許能有簡單的基準去評判是否為好的海報，我自己會分成三個類型。

1. 功能型

活動海報、商品海報（廣告）、電影海報，這些海報功能性很強，有明確的時間地點等資訊提供給受眾。例如五金行替莎妹劇團製作的戲劇宣傳海報，就有非常多的資訊，功能性強，同時又做得很美。另一個例子是全聯廣告平面稿，他並不是要販售全聯的某個商品，而是想販售一個形象，因為中年族群飽和，所以他們想讓文青世代去消費，這張海報的確打動我身邊許多朋友。

2. 創作型—議題海報

讓設計師設定一個議題去創作，在設計學校也是很常遇到的題目。廖恬敏 2009 年的作品〈Animal Rights〉，得到紅點大獎。此張海報訊息明確，以角色互換的概念，呼籲大家不要購買皮草。我相信只要是設計系學生都曾做過議題海報。可是我對這件事存在一個疑問，當大家都在做議題海報的時候，他們有讓該看到這訊息的人看到嗎？實際上，它的目標對象是有能力購買奢侈品的人，不是那些會去看展覽的設計師。然而這些千金小姐怎麼會去逛設計展，怎麼會去購買設計書？我對這些事情抱持著疑問。如果是這樣，那麼作為一個設計師，該如何去改善這樣的現象？因為大家都在做議題海報，可是卻沒有打動他要的目標對象。

Thank you for your participation. It's my first time to share my idea in public. Today's topic is "Poster! Poster!"

Allow me introduce myself. I'm Jay, a designer in young generation. I graduated from Cheng-Chi University, and my major is Advertisement. Due to the interest in graphic design, I studied in graphic design graduate school in Australia with scholarships. The switch of identity provides me many changes. I'm a freelancer. Despite the fact that it's the 10th year for me to study design and my sixth design work, I have many questions in mind, such as the idea of posters and what to do with poster? With the emergence of new media, people present works with digital files instead of hard copies. It gives me many ideas. During the process of works and the discussion with others, they give me some questions but I can't always answer these questions. Therefore, I am gonna tell you the answer of mine and give you guys other questions to think.

What's a poster?

What's a poster? Wikipedia describe it as following descriptions: "A poster is any piece of printed paper designed to be attached to a wall or vertical surface." As for me, I consider a poster as a frame. Take the poster "Taishin Arts Award Exhibition" designed by Liu,ming-wei as example. The poster has a rectangle frame, which is similar to the frame of a picture from the perspective of photograph.

Designers can decide how to frame it.

I see many posters in my life and wonders how to classify them. Perhaps there's a simple standard to judge whether it is a good poster. I'll classify in 3 ways.

1.Functional

Event posters, commercial posters and movie posters are functional posters. These posters provide clear information for the receivers. For example, the poster, designed by Five Metal Shop, for Shakespeare's Wild Sisters Group's new play is functional and elegant. The other example is poster of Pxmart. They don't want to sell a specific product in Pxmart but the image of it. They want to let young people shop because the market for middle-aged group are saturated. The poster truly touches many friends of mine.

2.Creative-issue poster

It's a common project for designers and students in design school to design a poster for a specific issue. Liao, Tien-Min won Red Dot Prize in 2009 with the work "Animal Right". It delivers the message "not to buy fur" with the idea of the switch of roles. I believe that students from design school have made issue posters. However, I keep doubt on this. Do they deliver the message to people when they design the poster? As the matter of fact, the target are the people who can buy those luxuries instead of designers who see the exhibition. How can those rich people go

to see the exhibition and buy the design books? I keep doubts on these things. If that's true, how can a designer do to improve this phenomena? Everyone designs issue poster but nobody touches the target people.

3.Experiment

What I infer to is the visual effect, font experiments created by designers. The works I present this time belong to this type. I did the experiment in my free time. It doesn't have strong function or present issue. It's merely interesting visual effect. BODY LANGUAGE, made by Liu, Yu-Hsien in 2013, is a work that use female body movement to assemble words. The work is not functional but a creation that the designer made in life. However, it's necessary for designer.

How to make a poster?

How to make a poster? This is a common question for freshman in graphic design area. Take me as an example. I studied Ads. Therefore, I think in a rational way with ads creativity.

1. Concept development and implement of 5W1H

What is "What does the poster try to convey?" Why is "why do I convey this message?" Who is "who is the target?" Where is for "where the poster will be seen?" It can be on the screen, mobile phone, tablet or without hard copy. Therefore, I consider it's an important issue for designers in next generation. It's related to technology. You must think where the poster is presented. When

3. 實驗型

我指的是設計師本身創造的視覺效果、字體實驗。像我這次參加的作品也是屬於這個類型，在我工作閒暇之餘去進行的試驗，但他不具有很強的功能性或議題性，純粹是很有趣的視覺效果。劉育賢 2013 年的作品〈BODY LANGUAGE〉，他拍了一個女生的肢體動作，並拼湊成字體。它並不具有很強烈的功能性，這只是設計師在生活中進行的創作，但是這對設計師來說其實是必要的。

如何做海報？

如何做海報？這是剛踏入平面設計領域的人常見的問題。我的背景是念廣告，所以我發想的思維與邏輯偏向理性，而且偏向廣告創意式的發想。

1. 發想與執行 5W1H

What 要說什麼？這張海報想傳達什麼？Why 為什麼要說？我要傳達這個訊息？

Who 對誰 是誰？ Where 在哪裡說？這牽涉到海報使用的媒介，可能在螢幕上、手機、平板裡，甚至不會有實體的印刷，所以在哪裡說，我覺得是下個時代的設計師要很關注的事情，它與科技息息相關，你必須要思考將海報呈現在哪裡。When 什麼時後說？以及 How 要如何說？要用什麼手法表現形式 插畫 拼貼 攝影 字體 …… 會與你想說的訊息緊密連結。

2. 是否要建立自己的風格？

我曾經有一段時間糾結過這件事情，現在我認為不用刻意強求這件事情，因為作品會反映你的心境、性格、背景、知識。而且設計師或許不需要風格啊，我們將來是要替客戶解決他丟給我們的問題，協調客戶的想法。假設我要幫一個飲料品牌做 LOGO，如果我把很強烈的風格帶進去，也許就沒辦法呈現這個品牌的調性。所以有

時候不一定要在風格上面做太強烈的堅持。另一點是我覺得有時候設計師這個角色有點模糊，今天是一個海報設計展，我們參展的作品是我平常自己的創作，在當下我的角色更接近藝術家。我不一定是設計師，因為我沒有客戶，我是用自己的想法去創作的。

3. 自發性創作？

設計師是否要自發性的創作？我覺得一定要，而且幫助真的非常大。因為在你少了客戶，所得到的局限是相對少的，你可以把它做得很好玩。另一方面是可以增加經驗，例如你對於唱片設計有興趣，但是你沒有相關的經驗，那你就可以自己去模擬。比如說你可以替某某歌手重製唱片，其實我有很多例子都是他將自己模擬出來的作品投遞設計公司。第三個幫助是可以輔助正式案件，像我的習慣是將這些試驗放在一個資料夾裡，等到有一天我工作卡住的時候，就把資料夾打開檢視，運用過往的實驗解決工作上的難關。

自己的作品

這次展出的試驗型海報 (註 1)，是自我宣傳用的一系列作品。回國的時候，我覺得自己需要名片，所以我替自己做了個 icon 頭像。後來想著該怎麼把它延伸出去，似乎可以在畫面上拼湊不同的元素。利用插畫手法搭配各種不同的平面元素比如網點、字體、隨筆亂畫，就發展了一系列的海報，效果還蠻有趣。另外，這件作品 (註 2) 算是為了這次講座做的，我訂的主題是海報海報，我心裡跑出一個想法：海報海報感覺像無線電的呼叫呼叫，他是一個訊息的傳遞。無線電是個不太穩定、有時後會收不太到訊號的傳輸方式，我覺得這跟設計師在做的事情有點像，我們做了很多漂亮的平面設計，卻不能確定我們的訊息到底有沒有傳達到我

們目標對象的腦海裡。也許他收到的東西，跟你想要傳達的根本就不是同一個概念。前陣子在玩的視覺效果有點像 " 雜訊 "，電子視訊壞掉故障就會產生畫面的分割，色版也會跑掉。其實這個很適合被結合在海報的概念裡面，所以就完成這一張海報。

結語

設計一開始在技術上的進步是很快的，可是想法上的進步很慢。你要一直累積東西、閱讀才會慢慢有心的想法出現，我自己也還在學習，可能將來有機會我再分享的時候，答案又會有所改變，希望大家也能回去思考，在作品中得到你自己的答案。◢

is "when to say" how is "how to say" The way you present, such as illustrator, resemble, photograph or fonts will closely connect to the message you try to deliver.

2. Do I need to establish my style?

I have considered about this thing for a long time. Now I don't think it's necessary to care about this in purpose. The work will reflect your mind, characteristics, background, knowledge. Besides, designers may not need to have their own style. We solve the problem that clients give to us and coordinate their thought. If I'm going to design a log for a beverage brand, it's possibly that I can't present the style of the brand if I put strong style of mine. Therefore, sometimes we don't need to put too much emphasis on the work. The other point is that the vague role of the designer. The work I present in today's poster exhibition is the work of my. The role of myself Is closer to the artist instead of a designer. I create the works by my thoughts because I don't have clients.

3. Agentive creation

Does designers need to have agentive creation? I think the answer is YES and it really helps a lot. First of all, the lack of client means the lack of limits. You can make it very fun. On the other side, you can enhance your experience. For example, if you're interesting in CD design without relative experience, you can simulate by yourselves. You can duplicate for a singer. I have many cases like that. Thirdly, it can assist your formal cases. Take me as an example. I put some experiment works in a file folder. When I'm stock on work, I open the folder and solve the problem with this works.

My work

Myexperiment postersin the exhibition (See Notice 2) are a series of collections for self-promotion. When I came back to Taiwan, I thought I need my business card. Therefore, I made my icon for profile picture. Then, I considered how to extend it and found that it can be assemble withdifferent elements. Combined illustrations with different graphic elements, such as dot, font and graffiti, I created a series of posters and found it's interesting.

Besides,the work (See Notice 3) is made for the speech. The topic today is Poster!Poster! I came up with an idea. When you call "Poster!Poster!"it like the calling on the radio. It's the delivery of the message. Radio is an unstable transmission way that sometimes lacks signals. I find it's similar to the thing that a designer do. We create many beautiful graphic design, but we're not sure whether the message deliver to the target audience. Perhaps, the message he receives is different from the message you try to deliver. When the electric webcam is broken, it will show the clusters on the screen, and the colors will present in wrong way, which is like the disturbance in visual effect. This concept is suitable to the poster, so I made the poster.

Conclusion

It's easy to make technical progress at beginning when doing design, but the progress on mind is slow. The new thoughts will gradually come up after you read and accumulate your works. I'm still learning. Maybe the answer of mine will change in the future. I hope everyone to think and find your answer in your work. ◢

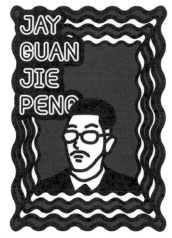

1 彭冠傑 *Peng, Guan-Jie's* 2014

2 彭冠傑〈海報海報〉 *Peng, Guan-Jie*〈*Poster!Poster!*〉

Creative Talk in Asia 亞 | 洲 | 創 | 意 | 對 | 話

Sept.2015 VOL.2 創刊於 *104.04 since 2015.04*

總編輯 *Chief Editor* 陳育民 *Chen, Yu-Ming*

編輯團隊 *Editing Team* 張立妍 *Chang, Li-Yen*
 張唯琳 *Chang, Wei-Lin*
 張譽靜 *Chang, Yu-Ching*
 陳怡璇 *Chen, Yi-Xuan*
 程婉菁 *Cheng, Wan-Jing*
 林峻瑋 *Lin, Chun-Wei*

出版者 *Publisher* 陳育民 *Chen, Yu-Ming*

地址 *ADD* 台灣 , 807-72 高雄市三民區汾陽路 20 號一樓 *1F.*
 No.20, Fenyang Rd., Sanmin Dist.,
 Kaohsiung City 807, Taiwan (R.O.C.)

電話 *TEL* *+886-926-600-147*

出版時間 *Publishing Time* 104 年 10 月 *Sept. 2015*

國家圖書館出版品預行編目 (CIP) 資料

CTA 亞洲創意對話 . VOL.2 / 陳育民總編輯 . -- 高雄市 : 陳育民 ,
民 104.10
 面； 公分
中英對照
ISBN 978-957-43-3014-0(精裝)

1. 設計 2. 創意 3. 亞洲

960 104024846

CTA 亞洲創意對話 Creative Talk in Asia
cta.taiwan.02@gmail.com